PAINTING LITTLE LANDSCAPES

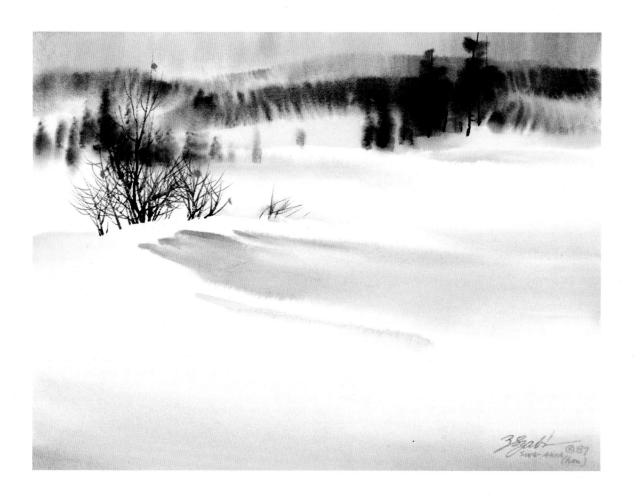

PAINTING
LITTLE LANDSCAPES

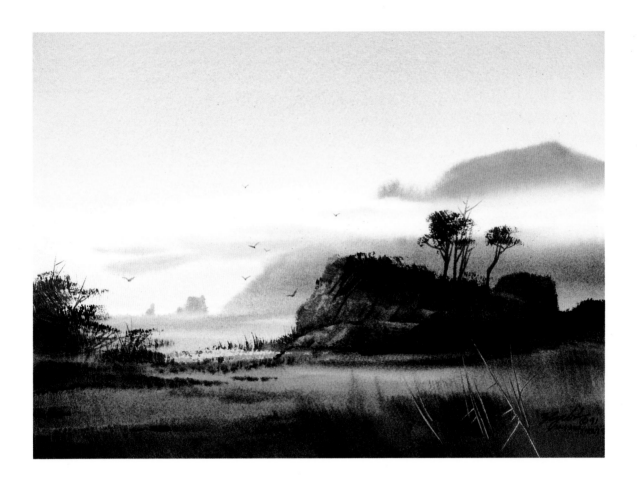

ZOLTAN SZABO

WATSON-GUPTILL PUBLICATIONS / NEW YORK

*As a small token of my appreciation to the wonderful people
of the United States of America and Canada who contributed
so much to my artistic development and to my life in general,
I gratefully dedicate this work.*

Art on first page:
RELUCTANT COMPROMISE. 11½ × 15″ (29.2 × 38.1 cm),
300-lb. D'Arches Cold-Pressed Paper.

Art on title page:
VIEWPOINT. 11½ × 15″ (29.2 × 38.1 cm),
300-lb. D'Arches Cold-Pressed Paper.

First published in 1991 by Watson-Guptill Publications, a division of BPI
Communications, Inc., 1515 Broadway, New York, N.Y. 10036

Library of Congress Cataloging-in-Publication Data
Szabo, Zoltan, 1928–
 Painting little landscapes : small-scale watercolors of the great
outdoors / by Zoltan Szabo.
 p. cm.
 Includes index.
 ISBN 0-8230-3685-5
 1. Landscape painting—Technique. 2. Watercolor painting—
Technique. 3. Small painting—Technique. I. Title.
ND2240.S948 1991 91-11937
751.42′24—dc20 CIP

Distributed in Europe, the Far East, Southeast and Central Asia, and
South America by RotoVision S.A., 9 Route Suisse, CH-1295 Mies,
Switzerland.

Manufactured in Singapore

First Printing, 1991

1 2 3 4 5 6 7 8 9 10 / 96 95 94 93 92 91

CONTENTS

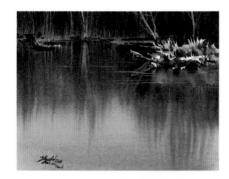
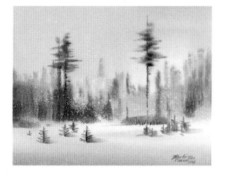
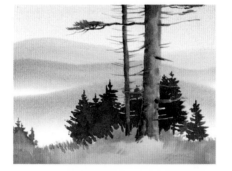
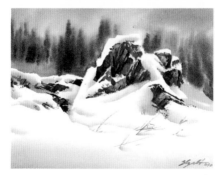
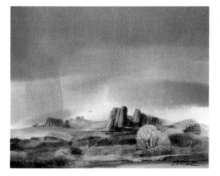

INTRODUCTION

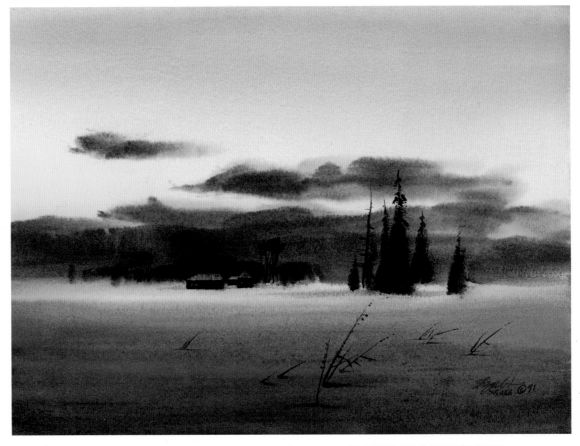

THE SURVIVORS. 11½ × 15″ (29.2 × 38.1 CM), 300-LB. D'ARCHES COLD-PRESSED PAPER.

My purpose in writing this book is to reveal to you the pleasures and technical advantages of painting watercolor landscapes on a small scale—no larger than about 10 × 11″ (25.4 × 27.9 cm). While a small painting requires the same amount of attention as a large one to be equal in aesthetic quality, there are some technical differences that can be used to your advantage. First and foremost, the drying time for small paintings is considerably less. This means that you must work quickly to stay in control, particularly when you work with a wet-in-wet technique. Harsh, undesirable backruns (pigment left by the brush that backs up to create a sharp edge) show up more frequently because you are working within a smaller space, but fortunately are easier to spot

because the whole surface can be kept under observation at once. Another difference is that the sediment deposited on the paper by granular pigments as they dry appears proportionately coarser than it would in a larger format. The texture of the paper also seems rougher for the same reason. With some knowhow, you can exploit these effects when they are appropriate to specific subject matter like the textures of snow or sand.

Painting in a small format enhances the ease and spontaneity of producing several variations of the same theme because the work takes relatively little time to complete. Take advantage of this fact and experiment. Try daring new ideas and unusual techniques in rapid succession. Little

miracles can happen in a very short time if you let them.

Each chapter in the book consists of a series of demonstrations that focus on painting landscape: water, mountains, trees, snow, rocks, sky and clouds, and flowers and close-ups. Most of the paintings that follow were based on my own reference photographs; some were done on location, without photos. Whatever my source of reference, before I paint I like to organize my thoughts and ideas, and so, at the start of each demonstration, I offer a brief compositional analysis of the photograph and of the scene before me. In this book I share this process of "imagineering" with you as we go. I urge you to try to visualize your finished painting before you start. Not the details, of course, just your main goals. A small thumbnail sketch is one way I check to see if I am going in the right direction with my thoughts. Even if I bypass the sketch, I still plan my work mentally.

Every demonstration also features the palette of four to seven colors I used for the painting with an explanation of why I chose those hues, their unique physical characteristics, and how they interact. I also discuss the more specific roles the colors play as my painting develops. After you have read several of these explanations, they may sound repetitive; however, I feel that this is the best way to convey the subtle complexities of the pigments. Whenever I talk about mixes I try to single out the dominant colors. If you want to achieve consistent results it is important to note not only the colors I use but the amounts of each hue in any given combination.

At the end of the first five chapters, I offer a few photocopies of some of my own photographs. They are somewhat crude at first glance. This is intentional, because I want you to use your own wonderful imagination to make up the missing information. You will have to make creative decisions. You can paint these as exercises following my suggestions or you may choose any technique and color combination from the other examples in the book, or select another approach entirely. This way the resulting watercolor will not be just a copy but an imaginative exercise utilizing your newly gained knowledge.

TOOLS AND PALETTE

One of my favorite sizes for small paintings is 10 × 11″ (25.4 × 27.9 cm). This paper size is economical; I can cut six pieces out of one 22 × 30″ (55.9 × 76.2 cm) imperial sheet without wasting any paper. I like to work on cold-pressed D'Arches paper, but not exclusively. I mount the paper onto a piece of Masonite with masking tape. The tape keeps the paper flat while I work.

For small paintings I use only a few tools: a ¾″ flat, natural bristle brush for blending wet edges; 2″, ¾″, and ½″ flat, soft-bristle brushes; a small No. 4 rigger brush; and a couple of No. 5 round brushes. To these I add three thin, slanted hog-bristle brushes. For small paintings, I love a combined sable and synthetic No. 12 round brush. I also have an old, worn No. 5 oil brush that I use for wet-lifting dry color, and I occasionally use a small, dull-pointed palette knife.

I use two containers of water. I keep one on each side of me. The one on the left will stay clean throughout the painting. I use this only when I have to wet the paper or blend an edge cleanly. The water dish on my right is for mixing.

I use a paper pad made of a bunched-up roll of toilet paper without the cardboard center core to control moisture in my brushes. Because this paper will fall apart when wet, I wrap it into several layers of lint-free paper towel that will not break down into loose particles.

I squeeze my watercolors, usually Winsor & Newton, onto a plastic palette of my own design a few days before I need them, and let the mounds dry. Before beginning to paint I moisten only the colors that I select for each specific painting. This way I don't pollute large blobs of expensive pigments with others as I mix them. Only the premoistened top layers of my chosen colors are affected; the paint underneath remains dry and clean.

The tools I use are old friends and their nature is familiar to me. It makes no difference whether you work with your own equipment or try out some similar to mine. For the paintings in this book, I used several different brands of fine watercolor paper and, in addition to my usual Winsor & Newton Artists' Water Colours, tried out a few other brands of paint. All brands of pigment and paper differ somewhat from one another, so don't expect the same behavior from two products of the same name made by different manufacturers. The best way to know which ones will work best for you is to try several and compare them. I would like to offer only one sincere recommendation: Buy the best quality paper, paint, and brushes you can afford; cheap bricks won't build a good house.

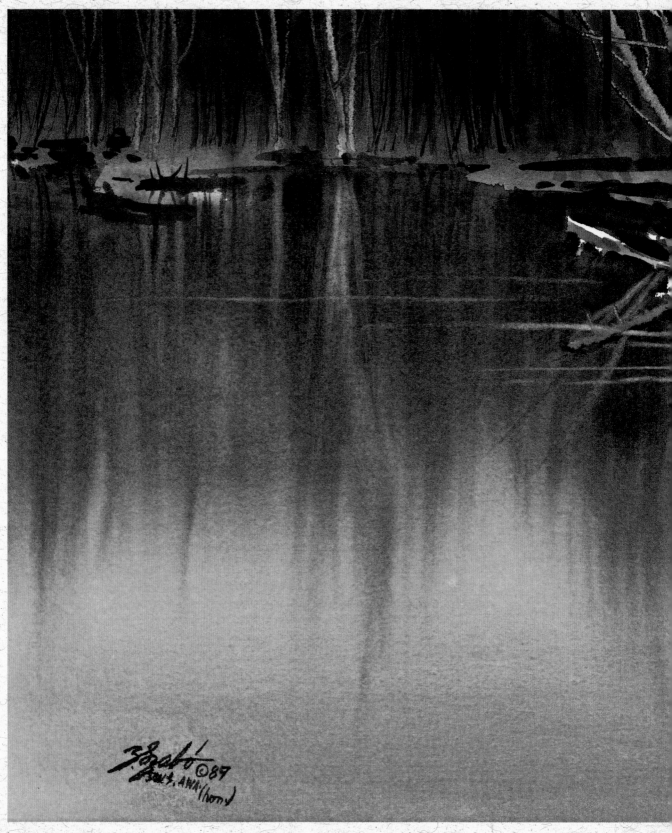

MIRROR PLAY. 11½ × 15″ (29.2 × 38.1 CM), 300-LB. D'ARCHES COLD-PRESSED PAPER.

WATER

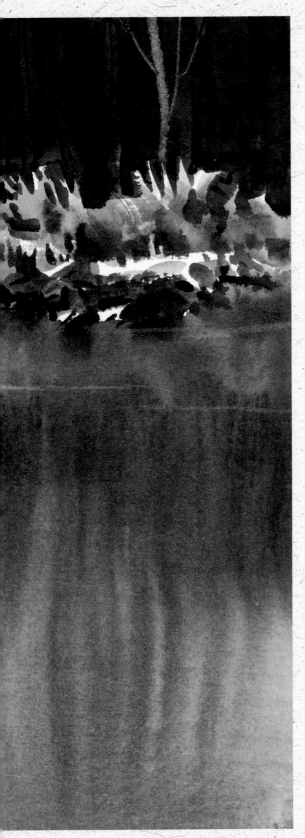

Water's many forms vary according to the environment. In this chapter I will demonstrate how I paint oceans, still and moving water, shallow water, and ice.

When painting water you must first identify the relationship between its local color and any reflection appearing on its surface. Local color is determined by minerals and other matter dissolved in the water, as well as by the color of the bottom. Natural and artificial pollutants absorb light and lower water's reflective quality; thus, the more pollutant in the water, the lighter a reflection will be, and the darker the water's local color, the better it reflects. In still water, an object and its reflection relate as if the water were a mirror. The direction of the reflection as well as its length depend on the position of the object that is being reflected. For example, a pole standing straight up in the water will be the same size as its reflection. When an object leans away from you, its reflection is foreshortened; conversely, an object leaning toward you is itself foreshortened, in which case its reflection gets longer.

Windswept bodies of water appear to be devoid of reflections, but in fact the reflections have been broken up into countless tiny waves resembling the facets of a mosaic. Breezes often create zigzag configurations and other graphically strong design elements you can use to enhance your composition, create the illusion of depth, and connect elements of interest on opposite sides of the painting.

Waves vary in both shape and size, appearing larger when close to the viewer and smaller as they recede. The face, or front, of a breaking wave shows a lot of local color and very little reflection because less light reaches it. The top, or back, shows a lot of reflection and little local color. Ocean waves get their color from the minerals and salt dissolved in the water and from the reflection of the sky. To capture the feeling of crashing surf, paint negatively, putting down color around the areas of pure white paper where you want to depict splashing foam. Use drybrush strokes and spatter to indicate motion.

The top of a waterfall is treated as still water unless it is part of a fast-moving river. The falling water is light in color and should be painted with fast brushstrokes on wet paper to convey rapid motion. The base of the falls foams and splashes and can be treated as ocean surf. This foam then dissolves in a marblelike pattern into smooth, flowing water.

Ice reflects only when its surface is wet or newly frozen. It is lighter in color than water, so its reflections are very faint and light.

OCEAN WITH HIGH SURF

The color of the ocean is determined by the color of the sky reflected on the water's surface, as well as by what is in and under the water, including dissolved salt and minerals. When you paint the ocean, it is wise to paint the water and sky in colors that harmonize with each other to avoid an irritating clash. Use a single, dominant color that will unify the painting and define its mood. If you carefully observe a seascape, noting the sky, clouds, and the water's local color, you can easily select the dominant, or "master," hue.

The five following demonstrations of ocean scenes will explore different types of conditions that affect the local color of the water. This first demonstration is of high surf. The other demonstrations will cover a sunny beach, a stormy sky with choppy waves, surf pounding a rocky shore, and a simplified design with shallow reflective puddles.

The rugged rocky shoreline and the pounding, splashing surf offered a challenge. The contrast between the dark, rough rocks and the light mist behind it suggests power and movement.

PALETTE

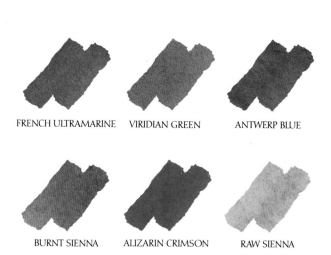

FRENCH ULTRAMARINE VIRIDIAN GREEN ANTWERP BLUE

BURNT SIENNA ALIZARIN CRIMSON RAW SIENNA

The combination of colors I've chosen for this painting allows me to use a lot of neutral colors right next to some bright ocean hues. French ultramarine will deepen my greens whenever I mix it with viridian green. Mixed with burnt sienna, a reddish brown, French ultramarine will make a beautiful neutral brown-gray as well. In this painting, I do not use French ultramarine in its pure form anywhere; it is always mixed. Where the brown is very dark, particularly between the rocks, I use Antwerp blue and alizarin crimson because French ultramarine and burnt sienna are not dark enough. Raw sienna is a sedimentary color that ranges from quite transparent (as in my usual brand, Winsor & Newton) to opaque according to brand, so you have to check each one. I use it on the sand and in the foreground, as well as in a few places in the waves. I haven't used alizarin crimson by itself anywhere; it is mixed into my darks.

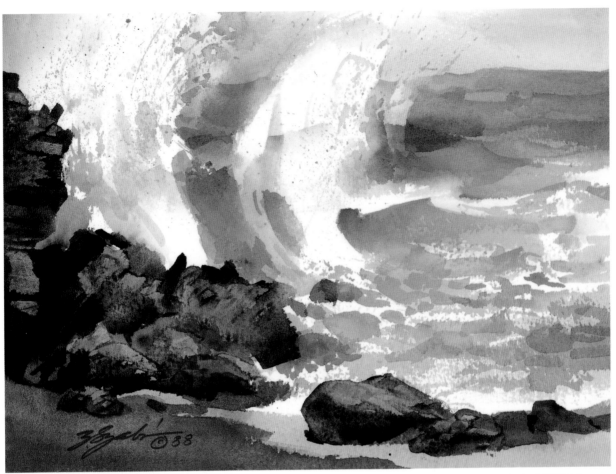

HAPPY SHOWER. 8 × 11″ (20.3 × 27.9 CM), 400-LB. D'ARCHES COLD-PRESSED PAPER. PAINTED ON LOCATION.

PAINTING

I do most of the painting on dry paper with conventional glazing techniques. First, I paint a light gray wash to indicate the distant sky, extending it into the middle ground. Next, I paint the bright green-and-blue waves rolling behind the surf. As one color dries, I glaze another on top of it, keeping all these hues very transparent, darkening the color of the water very gradually.

I choose the dynamic force and energy of the ocean for my center of interest in this painting, as embodied by the waves crashing on the rocks at the shore. Dynamic force is indicated by a little spatter and fast brushstrokes. My color consists of viridian green and French ultramarine with just a little burnt sienna. To depict the sweep of the vaporized crashing surf, I leave the splashing white breakers as pure white paper to create strong contrast with the color of the ocean. I work on wet paper

and apply a series of rapid brushstrokes next to the breakers. When all this is done, I paint the foreground rocks in high contrast with the ocean, applying rich pigment to define their silhouettes. At this point speed is essential; while the paint is still wet, I use a palette knife immediately to add rugged texture to the light sides of the rocks. If the paint sits on the paper too long it may stain the fibers, making the knifemarks less apparent and thus reducing the textural effects. Painting in a small format facilitates speed, a real advantage when using a palette knife. When working on a small scale like this, use palette knives that are also small—ones that will produce strokes that are in proportion to the size of the elements in your composition.

The diamond pattern in the water is a pleasant complement to the larger, powerful white shape of the surf.

The rock's shadows in the foreground are done with French ultramarine and Antwerp blue, alizarin crimson, and burnt sienna painted in a very rich, liquid tone. These shadows of the rocks are the last details I add on top of the raw sienna wash, which finishes the painting.

In a small painting, the compositional responsibility is no less than that required by a larger one; the proportions are simply smaller. The splashing white surf is complemented by the horizontal rhythm of the waves back in the distance. Color variation and value contrast (high chroma against neutral/ light against dark) are both important components of this subject. The rocks are painted not as individual forms, but as dark units that supply necessary contrast with the very bright, white shapes of the surf. The action looks fast, just the way water moves.

SUNNY SKY AT BEACH

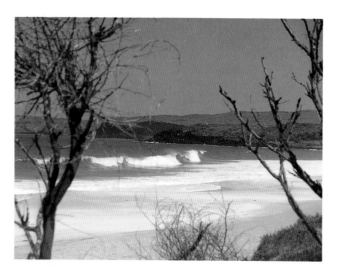

This next ocean demonstration is painted from a photograph of a sunny seashore. The sky is blue. There is a very high contrast between the water and the sand; in fact, there is a little too much. After analyzing the photograph, I do a small pencil sketch with a 6B graphite stick. A graphite stick is capable of giving a wide range of values and shapes very rapidly. To improve on the photograph's composition, I raise the horizon and move the big tree from the left side to the right so that it appears to cuddle the bright surf in the distance.

PALETTE

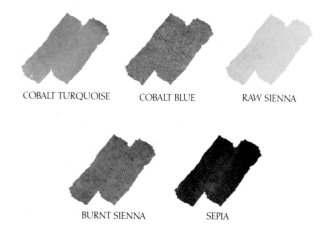

COBALT TURQUOISE COBALT BLUE RAW SIENNA

BURNT SIENNA SEPIA

Cobalt turquoise is a very opaque color that, when diluted, is a rich greenish blue. It is my base for the Pacific water. Cobalt blue added to cobalt turquoise is the combination for my sky and for the darker modeling of the water. Raw sienna and burnt sienna mixed with the two blues become the color of the distant hill. The foreground sand area of the beach is raw sienna and burnt sienna. The tree itself is a combination of burnt sienna, a little bit of sepia, raw sienna, and cobalt turquoise.

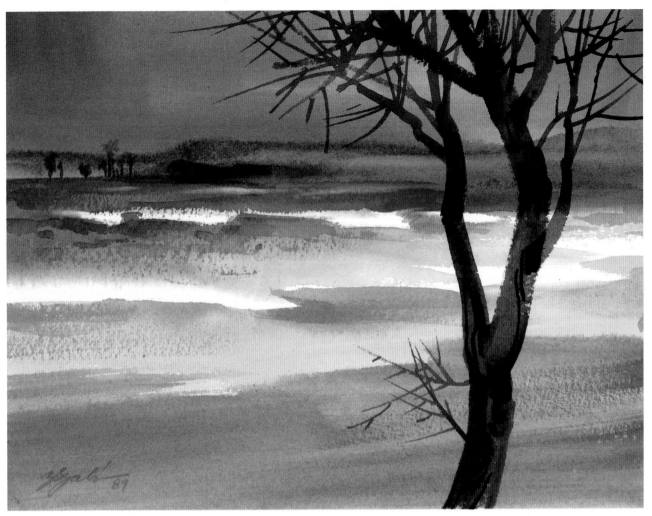

EMERALD BATH. 8 × 10¾″ (20.3 × 27.3 CM), 300-LB. D'ARCHES COLD-PRESSED PAPER.

PAINTING

I start the painting on dry paper, rapidly moving a 2″ brush across the sky area, blending cobalt blue and cobalt turquoise on the paper as I go. These colors blend fast and smoothly, giving a wet-in-wet effect. Into the bottom edge of this damp wash, I paint a burnt sienna, sepia, and cobalt turquoise combination. I push the brush upward into the wet blue wash, making the lighter warm colors replace the blues, indicating shoreline shrubs and rocks in the distance. It is necessary to move the brush very fast to achieve a smooth and clean blending of sky colors on the dry surface. The small size of the painting area allows for more sponta-

neity. Next, I move to the ocean with a light tone of cobalt turquoise and raw sienna, leaving a few white foamy surf shapes as negative space to contrast with the water. On the lower edge of the painting, I blend these colors. I add the sand color, raw sienna and burnt sienna, to the foreground and model it with a 2″-wide bristle brush. The ocean area is now dry, and I go back and add a darker, deeper value composed of cobalt blue and viridian green. To these colors I add a touch of raw sienna at the left side where I need a warm, greenish influence.

After all these washes are dry, I paint in the big vertical tree cross-

ing the painting from the bottom to the top, adding the details of tiny branches. This tree shape is painted as a wet wash in a dark value mixed from a combination of burnt sienna, cobalt blue, and some sepia to add variety. While this color is still wet, I charge it with raw sienna here and there. I keep the color a medium-dark value, and with a small rigger brush, I finish the fine branches at the top. Where the larger limbs cross into the tree trunk, I add a faint barklike design. As a finishing touch, I put a few lonely-looking palm trees into the distance to add scale and local definition to the background shoreline.

STORMY SKY, CHOPPY WAVES

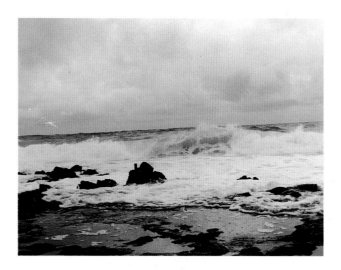

I am working from a photograph I took on a day when weather conditions were stormy and the ocean's waves were rough. The waves are dancing and are broken into greenish diamond shapes surrounded with white foaming edges. To enhance them, I need to simplify the composition.

In my pencil sketch I simplify the design by reducing the number of rocks in the foreground. I emphasize the sky's dark, moody quality, and allow the waves to become the center of interest. I also lower the horizon somewhat below the center mark.

PALETTE

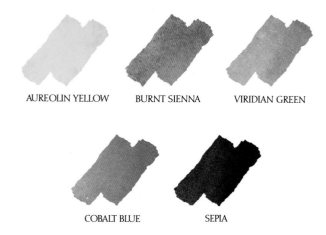

AUREOLIN YELLOW BURNT SIENNA VIRIDIAN GREEN

COBALT BLUE SEPIA

I combine aureolin yellow and cobalt blue to get a quiet green. Burnt sienna is a neutralizing agent that assumes great importance when mixed with cobalt blue or viridian green, both of which are much weaker colors. Sepia is only an accent color here, and plays an important role in the way I render the dark submerged rocks in the water.

14

EMERALD BATH. 8 × 10¾″ (20.3 × 27.3 CM), 300-LB. D'ARCHES COLD-PRESSED PAPER.

PAINTING

I start the painting on dry paper, rapidly moving a 2″ brush across the sky area, blending cobalt blue and cobalt turquoise on the paper as I go. These colors blend fast and smoothly, giving a wet-in-wet effect. Into the bottom edge of this damp wash, I paint a burnt sienna, sepia, and cobalt turquoise combination. I push the brush upward into the wet blue wash, making the lighter warm colors replace the blues, indicating shoreline shrubs and rocks in the distance. It is necessary to move the brush very fast to achieve a smooth and clean blending of sky colors on the dry surface. The small size of the painting area allows for more spontaneity. Next, I move to the ocean with a light tone of cobalt turquoise and raw sienna, leaving a few white foamy surf shapes as negative space to contrast with the water. On the lower edge of the painting, I blend these colors. I add the sand color, raw sienna and burnt sienna, to the foreground and model it with a 2″-wide bristle brush. The ocean area is now dry, and I go back and add a darker, deeper value composed of cobalt blue and viridian green. To these colors I add a touch of raw sienna at the left side where I need a warm, greenish influence.

After all these washes are dry, I paint in the big vertical tree crossing the painting from the bottom to the top, adding the details of tiny branches. This tree shape is painted as a wet wash in a dark value mixed from a combination of burnt sienna, cobalt blue, and some sepia to add variety. While this color is still wet, I charge it with raw sienna here and there. I keep the color a medium-dark value, and with a small rigger brush, I finish the fine branches at the top. Where the larger limbs cross into the tree trunk, I add a faint barklike design. As a finishing touch, I put a few lonely-looking palm trees into the distance to add scale and local definition to the background shoreline.

STORMY SKY, CHOPPY WAVES

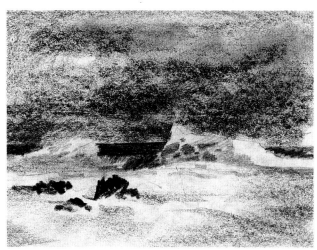

I am working from a photograph I took on a day when weather conditions were stormy and the ocean's waves were rough. The waves are dancing and are broken into greenish diamond shapes surrounded with white foaming edges. To enhance them, I need to simplify the composition.

In my pencil sketch I simplify the design by reducing the number of rocks in the foreground. I emphasize the sky's dark, moody quality, and allow the waves to become the center of interest. I also lower the horizon somewhat below the center mark.

PALETTE

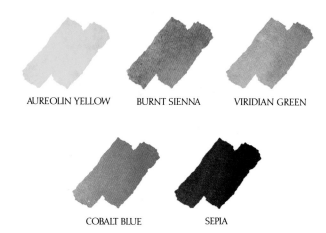

AUREOLIN YELLOW BURNT SIENNA VIRIDIAN GREEN

COBALT BLUE SEPIA

I combine aureolin yellow and cobalt blue to get a quiet green. Burnt sienna is a neutralizing agent that assumes great importance when mixed with cobalt blue or viridian green, both of which are much weaker colors. Sepia is only an accent color here, and plays an important role in the way I render the dark submerged rocks in the water.

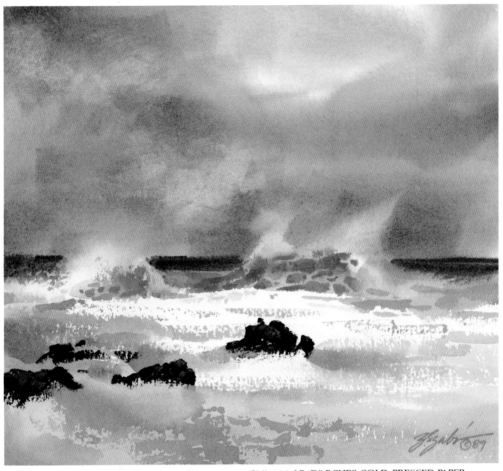

SEA DIAMONDS. 10¾ × 9¾" (27.3 × 24.9 CM), 300-LB. D'ARCHES COLD-PRESSED PAPER.

PAINTING

To begin, I wet the top two-thirds of the paper and paint the sky with cobalt blue and burnt sienna with a little bit of viridian green, allowing them to mix directly on the surface. I vary the dominance of these colors to create the illusion of rolling and blending clouds. Before this wash dries, I touch the area with tissue in a few places to create sharper and lighter cloud formations. I have only seconds to blend the colors necessary for the stormy sky. It is easier to judge the timing correctly for tissue blotting on a smaller surface because a small wash is more likely to stay evenly moist than a large one. Before the sky wash is dry, I paint in the foreground's grayish green color with a large 1½" soft brush held sideways, almost parallel with the surface. I rapidly drag the color to give a dry-brush sparkle to the negative whites by painting

the pale grayish green next to them. Then I go up to the edge of the horizon to paint the dark water. I apply sepia with cobalt blue and a little touch of viridian, mixed so rich that the pigment holds its edge even though the color in the sky is still somewhat damp. When the condition of the paper is damp like this, it will enable the dark color to blur just enough to give the illusion of distance.

Next, I paint the waves using a greenish color dominated by viridian green, to which I add French ultramarine and a hint of sepia. These shapes are painted with a cleaner and fresher green color than the foreground water. After this color dries, I drop the green diamond shapes into the waves, allowing the negative shapes around them to connect into a hint of foam. This pattern is part of the wave's struc-

ture as it rolls over. I pay a great deal of attention to leaving the white shapes sparkling clean right next to the greenish waves. The bottom edges of the waves are somewhat curved to make it seem as if the white water is rolling lazily toward the shore.

Onto this wash, I paint the dark silhouette of the rocks with sepia, burnt sienna, and a little cobalt blue, and immediately use my palette knife to give it a rocklike texture. The values of the rocks end up medium-dark and dark. I finish by further modeling the foreground water with some loose drybrush strokes. The water becomes dominated by a grayish green color of medium value. The placement of the drybrushed shapes right next to the rocks gives the impression that the rocks are surrounded with active water and white splashes.

SURF ON A ROCKY SHORE

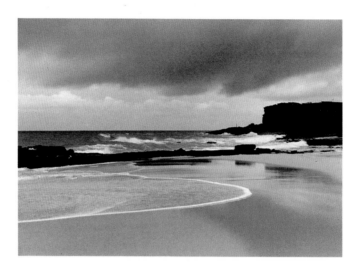

This demonstration was painted from a powerful photograph of surf on a rocky shore. The scene is dramatic in mood and color. The breaking waves contrast nicely with the dark rocks and the shallow foam makes an interesting pattern on the sand. I plan a few compositional changes. I raise the horizon from the center to a higher level. I decide to lighten the sky and focus on the foreground and the middle ground where the darks are surrounded with whites.

PALETTE

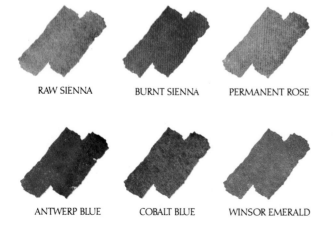

RAW SIENNA BURNT SIENNA PERMANENT ROSE

ANTWERP BLUE COBALT BLUE WINSOR EMERALD

I use a heavily diluted Winsor emerald, normally a very opaque green, to give Antwerp blue a green sparkle. Burnt sienna combined with cobalt blue gives me a strong gray that when mixed with some permanent rose will make a warmer gray. Permanent rose and cobalt blue mix into a mauve that I use for the distant background.

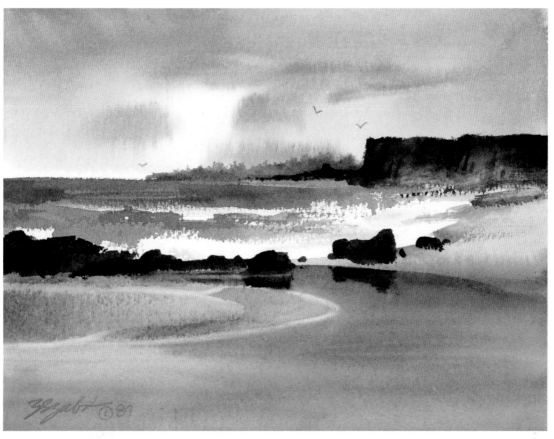

CLEAN SWEEP. 7½ × 10″ (19.0 × 25.4 CM), 400-LB. D'ARCHES COLD-PRESSED PAPER.

PAINTING

I begin by wetting the top portion of the paper for the sky. I add cobalt blue, a little touch of Antwerp blue, and burnt sienna mixed with permanent rose, allowing them to blend very lightly on the paper.

Before the sky color is dry, I add the silhouette of a distant tree-covered hill. This medium-value wash is somewhat darker than the sky but lighter than the foreground. The mauvish gray trees must be painted fast so that their edges can seep into the still-damp sky. Working on a small scale gives me better control of the rapid brushstrokes details such as these require.

At this point, I paint the water in a light tone using Antwerp blue, a touch of cobalt blue, and a small amount of Winsor emerald, leaving the dancing waves white and unpainted. The foam on the shoreline is left as a white negative shape with an indefinite edge. I allow the water area to dry, then I apply the large rocks in the middle

ground with a dark combination of burnt sienna, Antwerp blue, permanent rose, and cobalt blue. I allow the colors to blend loosely so that the dominance of the different colors varies. I finish the rocks with a very heavy brushstroke of Antwerp blue, permanent rose, and burnt sienna to show the modeling and vertical slant. When the color of the water is dry, I add darker definition onto the lighter washes. This time I use a little more Winsor emerald and Antwerp blue together to give me darker values, which provide just the contrast I need to make the white spaces more dramatic.

I continue with the sandy foreground, a beach sprinkled with rocks, with a raw sienna–burnt sienna combination, with a tiny touch of permanent rose and Antwerp blue. The middle ground on the right side is painted with raw sienna and burnt sienna in a light value. In the foreground, I use a darker value of this

combination plus a little bit of cobalt blue and a touch of permanent rose.

When the sand area dries, I paint in the silhouette of rocks protruding from the sand. I also paint the greenish, blended tone of the water on the surface of the sand where the waves roll in. I make the color darker where the sand is very wet and lighter where it is dry. This color comes from a little touch of Winsor emerald and Antwerp blue, rapidly drybrushed from the left side to the right. I follow with a hinted reflection of the rocks in the wet sand.

After everything is dry, with a small, very wet No. 5 oil-painting brush, I apply pressure to scrub out the white rim on the water where the waves are rolling into the sandy foreground. This shape—the white foam—must not be as light as the light value I have used in the middle ground, where I want my center of interest. I finish the painting by adding a few birds in the distance.

EMPHASIZING SIMPLE SHAPES

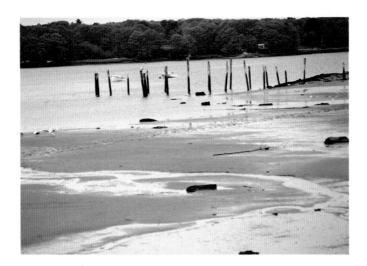

In this demonstration I emphasize simple, strong shapes and the painting's design qualities. I start with a photograph that has a somewhat off color combination but gives a good impression of a seashore where the sand is very flat and the tide shows interesting water patterns. There are a few posts in the sand, and a forest hides in the background. A pencil sketch is not necessary because the only compositional change I intend to make will be to shorten the foreground to emphasize the posts and the forest. I also intend to use a richer, more unified color scheme.

PALETTE

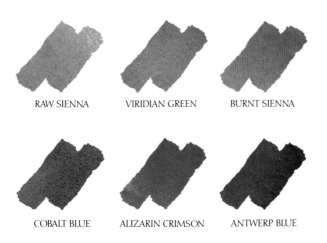

RAW SIENNA VIRIDIAN GREEN BURNT SIENNA

COBALT BLUE ALIZARIN CRIMSON ANTWERP BLUE

Raw sienna and burnt sienna supply me with the warm colors in the foreground sand, and in the background to some degree as well. Alizarin crimson gives a reddish influence I use when I need a little more than what burnt sienna can offer. Cobalt blue and viridian green, with the help of Antwerp blue, give me all the range of greens and blues that I could possibly need.

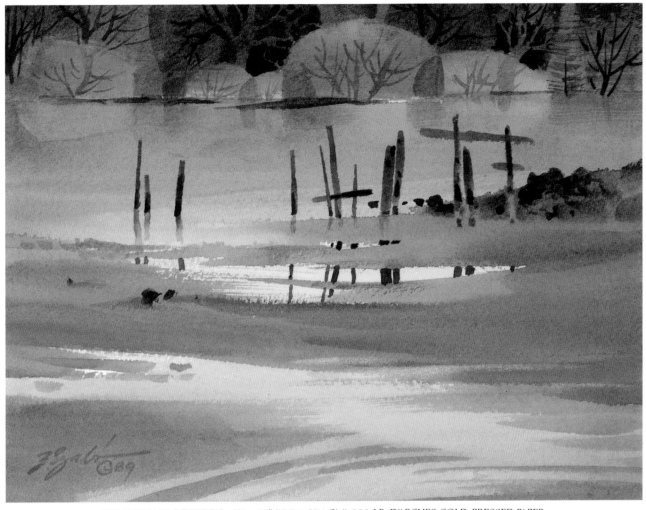

BEAUTY MARKERS. 7½ × 10″ (19.0 × 25.4 CM), 300-LB. D'ARCHES COLD-PRESSED PAPER.

PAINTING

I start on dry paper with a large 2″ soft-haired synthetic brush, applying a wash of neutral gray to the middle ground, where the forest will be, and to the foreground area as well. Before this wash dries, I paint the trees in the background as soft, rhythmical, repetitive shapes, gradually adding definition in the form of negative and positive branches and trunks to create some visual excitement in the background. The human eye is incapable of seeing a large area at once; however, because I am painting on a small surface, I am able to view the section as a unified whole and make my design judgments accordingly.

As I move forward, I indicate a pale hint of reflection on the somewhat breezy pattern of the water. As I approach the middle ground, the paper is dry. Working rapidly with a 1½″ flat short-haired bristle brush, I apply the color of the sand using raw sienna and burnt sienna with cobalt blue. With these brushstrokes, I model the sand with these granulating sedimentary colors, leaving some spaces gray to depict reflective puddles.

Next, I paint some rocks on the right side of the shore with a dark value of permanent rose, Antwerp blue, and burnt sienna. I use a small No. 4 round brush. I use the same brush to paint the scattered wooden poles that supply repetitive vertical shapes. I follow with the reflections in the puddles soon after. I have to paint the images first in order to know exactly where their reflections belong. A fast check of the painting reveals that the reflection next to the trees has dried a little too light. To correct this I add more color close to the water's edge. I add a few dark horizontal lines representing wet sand to create more contrast between the forest and the water, and then sign the completed painting.

PAINTING STILL WATER

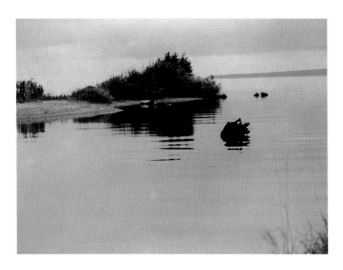

The surfaces of lakes may be smooth and thus very reflective; rippled by breezes, causing blurry reflections; or choppy, with large waves and no apparent reflections.

For this first of four lake paintings, let's pretend to travel to the shores of a gentle lake that is highly reflective.

The first problem with this photograph is that the color is monotonous and lacks excitement. I will add sunset colors to the horizon and increase the overall contrast. To be consistent, I also need to add color to the shrub-covered sandy point, my center of interest. The weeds in the corner are distracting and their shape doesn't relate to anything, so I will leave them out of my painting. Even in still water there is a slight current, and the rhythm of the rippling waves is very pleasant. Because I intend to change the shape

of shrubs, I will need to change their reflection in the waves as well. Last, the small blue shape representing a distant point at the top left edge of the picture is too small and will have to be changed.

In this first planning sketch (top), my center of interest is a horizontal shape in the middle of the picture. Sky and water occupy an equal amount of space, but symmetry is not what I want. The stumps and their reflections help, but not enough. In my second sketch (bottom), I raise the horizon higher than it is in the photograph. I draw both distant points at the entrance of the bay above the trees and move the small, dark stump closer to the foreground. This improves the compositional balance. I darken the value of the water to indicate its depth. This sketch will work.

PALETTE

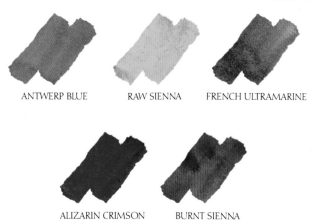

ANTWERP BLUE RAW SIENNA FRENCH ULTRAMARINE

ALIZARIN CRIMSON BURNT SIENNA

Antwerp blue is a very transparent, cool, weak blue. I use it generously in the sky, in the water, and in the foliage. Raw sienna is a granular pigment with a deep yellow hue, good for textured washes. It makes a rich, natural green when combined with Antwerp blue. Burnt sienna, a reddish brown color, has enough yellow in it to make a dark, mellow green when mixed with Antwerp blue. Mixed with French ultramarine, burnt sienna makes a pleasant neutral gray. Alizarin crimson is a gentle, delicate color. Because it is a transparent, cool red, it makes great mauves when mixed with French ultramarine, and good oranges when combined with either of the two siennas.

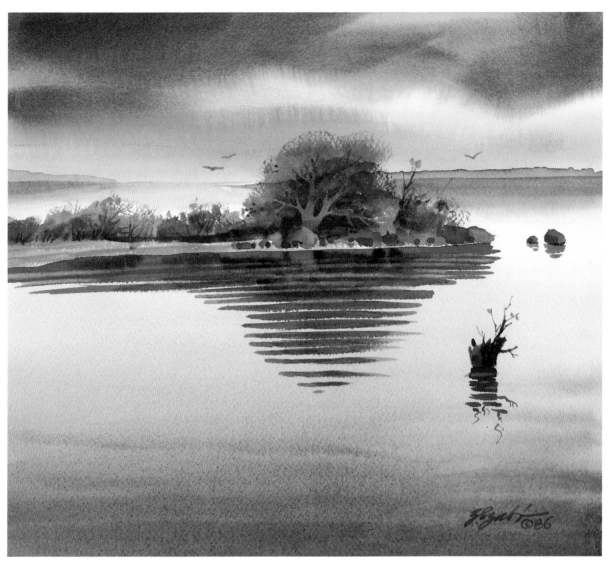

REFLECTING RHYTHM. 10 × 11″ (25.4 × 27.9 CM), 140-LB. D'ARCHES COLD-PRESSED PAPER.

PAINTING

I start on a wet paper. Because the paper is thin, I have to establish my soft shapes while the surface is still shiny wet. I start with the cleanest, brightest colors in the sky—the oranges, reds, and mauves—allowing them to blend freely. While the paper is still wet, using a ¾″ brush, I paint the water with a combination of burnt sienna, French ultramarine, and Antwerp blue, working from the bottom up. I do not lift my brush, I just move it sideways, back and forth, creating a graded wash. Next, with the same brush loaded with more of the same combination and much less water, I paint the soft waves into this damp wash. Then I

let the paper dry and flatten out.

After the paper is dry, I paint in the two distant points. I leave their top edges sharp, and blend the bottom edges by painting into the freshly applied pigment with a wide, damp, thirsty brush. I let the color spread out and go soft. After giving this time to dry, I repeat the procedure, but this time I start at the sharp waterline where the color overlaps in double layers. I blend the bottom edge of these brushstrokes as well.

Now I am ready for my center of interest. First, I establish the lacy shrubs by holding the brush almost flat, with the tip of it facing toward the

bottom of the painting. The brush is richly loaded with plenty of raw sienna, burnt sienna, and some alizarin crimson. I add a little dark green mixed from Antwerp blue and raw sienna. The rocks on the shore have a shot of French ultramarine. The tree trunk is a negative shape; I paint the dark color around it.

I paint the waves and add some dark reflections to the wash close to the shore while it is still wet. When the painting has dried, I lift out a few highlights from the waves with a scrub-and-blot technique. I finish the two distant rocks, the stump, and their reflections, and the painting is complete.

AUTUMN SHORES

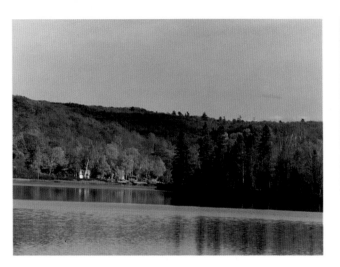

The reference photograph I used for this demonstration is underexposed. However, the image provides interesting patterns and the opportunity for a good composition. You can't tell in the photograph but the sky was actually blue. There was much higher contrast than the photo shows; nature was much more exciting.

For a value study, I make a pencil sketch using a 6B graphite stick. I raise the horizon somewhat, and add more interest to the background by exaggerating the whiteness of the building at the shoreline, and its reflection. I also indicate a little better balance between the dark middle ground evergreens and their reflection in the water. I move them to the right, leaving more room for the building and the shoreline, making them a stronger center of interest.

PALETTE

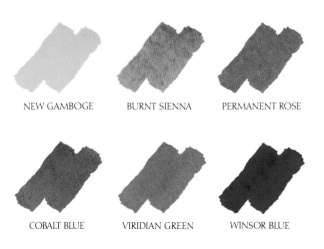

NEW GAMBOGE BURNT SIENNA PERMANENT ROSE

COBALT BLUE VIRIDIAN GREEN WINSOR BLUE

New gamboge will give me the autumn glow on the sunny forest; burnt sienna complements it and helps to model it; permanent rose adds red to the forest and some mauvish influence to the water and the sky. Cobalt blue, a gentle hue, is part of the sky. If I need any grays, I mix cobalt blue with burnt sienna. Winsor blue is a very strong, staining color that works well when I need to create areas of deep value. I can mix a very deep evergreen color with viridian green, winsor blue, and new gamboge. Viridian green is transparent, sedimentary, and very gentle in nature. It is a great complement to my composition because it acts as a buffer between the contrasting clash of the blue and the yellow next to each other.

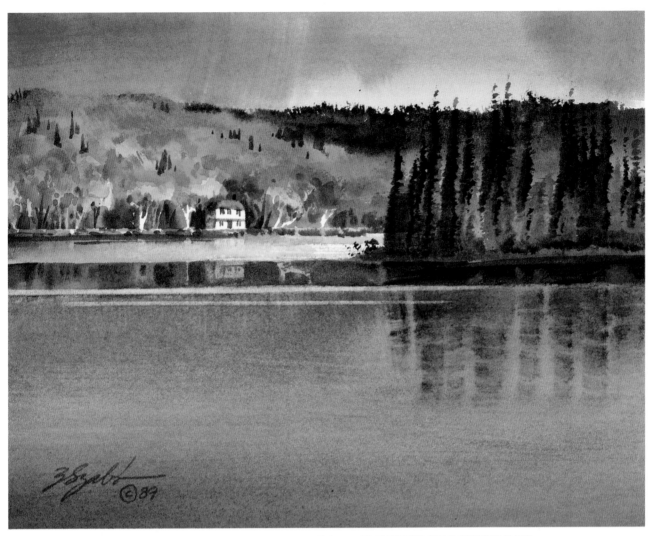

GOLDEN PATH. 7½ × 10″ (19.0 × 25.4 CM), 300-LB. D'ARCHES COLD-PRESSED PAPER.

PAINTING

I start with the sky on a dry surface, using a 2″-wide bristle brush loaded with cobalt blue, Winsor blue, and a little viridian green.

Next, I paint in the large mass of the distant autumn forest and the shaded hill behind it. I leave white space near the water's edge for the trees and the building. Next, using a ¾″ soft-haired synthetic brush, I follow with the details at the forward shoreline of the brightly lit part of the autumn hillside, including the little house and a few white birch trees.

Later, I paint in the evergreens at right. For the autumn colors, I use new gamboge, burnt sienna, and perma-nent rose, as well as some Winsor blue and cobalt blue. I do a lot of glazing. For the darker evergreens, I paint on a dry surface using a 1½″ slanted flat-bristle brush very richly loaded with new gamboge, burnt sienna, viridian green, and Winsor blue. Next, I paint in the breeze-rippled water in a light value mixed from a combination of cobalt blue, viridian green, new gam-boge, and burnt sienna.

While the wash representing the foreground water is still slightly shiny wet, I paint in the reflection of the dark trees and the glow of the reddish or-ange forest combined with the local color of the breeze-swept water. After this wash is dry, I paint in the band of darker water that is less affected by the wind. The reflection in this section will be clearer, with more of the forest's colors and less of the water's local color. This portion of the water has to be treated as a wet-in-wet area. The brushstrokes must be fast and consis-tent. The small paper makes my job much more enjoyable because there is less chance to make a mistake.

Last, I lift out some light strips in front of the band to complete the paint-ing. These strips are not in the photo-graph; I added them to improve the contrast between the light and dark reflections of the water.

DISTANT REFLECTION PATTERNS

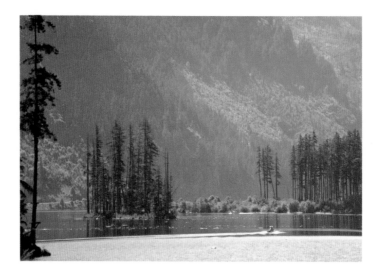

I am painting from a photograph of a large lake in the mountains with a small island and broken reflections caused by the wind on the surface of the water. The subtle values of the high mountainside in the distance and the trees on the island emphasize and accentuate the reflection pattern on the water. The trees add vertical influence as they combine with their reflection in the water. This is reduced somewhat by the design of the reflections. I do not need to make a sketch. The subtle changes I plan to make from the photograph can be made directly on the paper, as if I were painting outside. I intend to make the reflection pattern more dominant than it is in the photograph, expanding my composition.

PALETTE

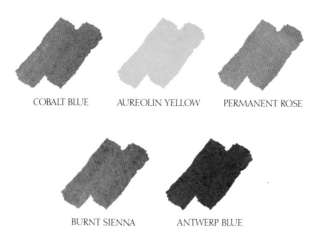

COBALT BLUE AUREOLIN YELLOW PERMANENT ROSE

BURNT SIENNA ANTWERP BLUE

Cobalt blue is excellent when you need an atmospheric color in the background of a painting. Aureolin yellow contributes to the fresh green on the shrubs, along with cobalt blue and burnt sienna, which warms up the color. Permanent rose adds a mauvish hint to the distance as well as to the water. Burnt sienna and Antwerp blue combined supply a dark color for the tall evergreens on the island.

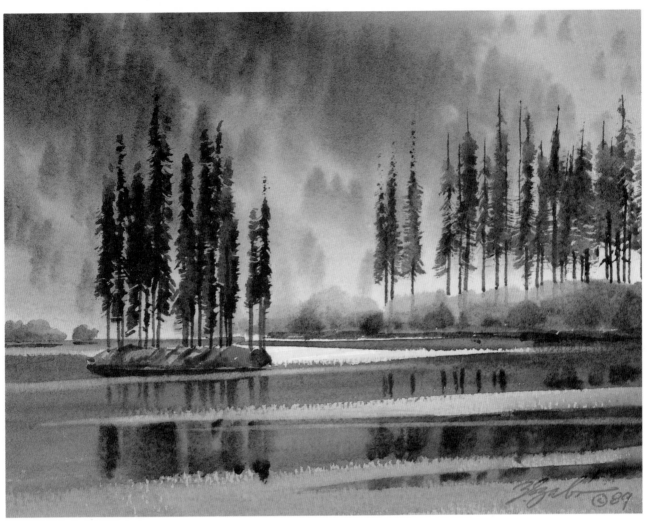

MIRROR GUARDS. 7½ × 10" (19.0 × 24.4 CM), 300-LB. D'ARCHES COLD-PRESSED PAPER.

PAINTING

I start with the sloping, tree- and mist-covered mountain in the background. I wet this portion of the paper and apply my shapes. For the first wash I use cobalt blue, a touch of burnt sienna, aureolin yellow, and a small amount of permanent rose. I work with a 2"-wide firm-bristle brush. I begin with very soft shapes. As the paper is drying, I develop more details suggesting trees on the mountain slope. I purposely deviate from the photograph and leave more pale colors on the lower parts of the mountain, giving a misty quality to the background.

Next, I paint several of the middle-ground shrubs in a yellow-green color. Directly after, I apply a

pale wash in the water to indicate the effect of the wind on the water. While the light wash in the foreground water is drying, with the help of a ¾" flat, soft brush, I mix burnt sienna, Antwerp blue, and a little bit of aureolin yellow into a rich, dark wash and apply it to the distant tall evergreens behind the shrubs. Then, onto the dry surface of the water, I paint the base of the island at left center with burnt sienna and cobalt blue in a damp, tacky consistancy. The paint is fairly thick. I texture it immediately with a palette knife to get the rocky effect. I use extremely heavy pressure on the widest part of the palette knife to scrape off the light shapes of the brittle rock surfaces.

I finish the water in the foreground, adding horizontal brushstrokes to the dark, reflecting surface. Before this wash dries, I paint into it with a dark combination of burnt sienna and Antwerp blue in a very thick consistency, using vertical brushstrokes to indicate the reflecting trees. The result is a dark blurred effect. After these colors dry, I put a little touch of yellow-green shrub to the left at the top edge of the water. I lift out a few linear horizontal shapes using a small, firm No. 5 oil-painting bristle brush loaded with lots of water. These touches add a little more character to the negative breeze pattern and completes the painting.

BLURRED REFLECTIONS

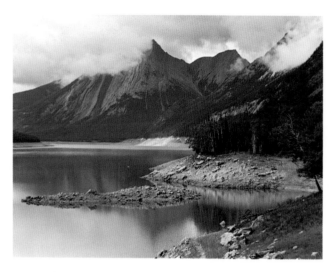
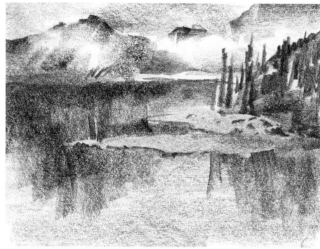

I start with a photograph. The mood is established but the composition is not quite right; the shapes are a little bit disorganized.

I make a very simple sketch using a 6B graphite stick, which establishes different values very quickly. I change what is in the photograph slightly. I raise the horizon somewhat to show more reflection in the water and add more clouds in front of the mountains to intensify the mood of the scene. The tall trees on the middle-ground slope become more emphasized in contrast to the misty background.

PALETTE

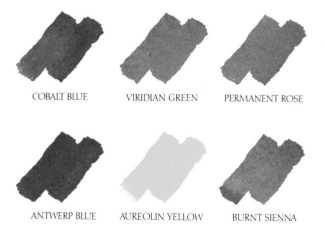

COBALT BLUE VIRIDIAN GREEN PERMANENT ROSE

ANTWERP BLUE AUREOLIN YELLOW BURNT SIENNA

Cobalt blue and viridian green are excellent atmospheric colors—even with some other colors added—as long as they dominate. I can even add permanent rose, which pushes the color somewhat toward a mauvish hue. In the water, I plan to keep the colors dominated by viridian green mixed with burnt sienna and a little Antwerp blue. Aureolin yellow is in there only to brighten up the foreground greens. Distant objects recede if they are cooler in color temperature and lighter in value. Forward objects usually advance better if they are warmer, colorful, and a little darker. In a panoramic composition such as this, I can take full advantage of this fact.

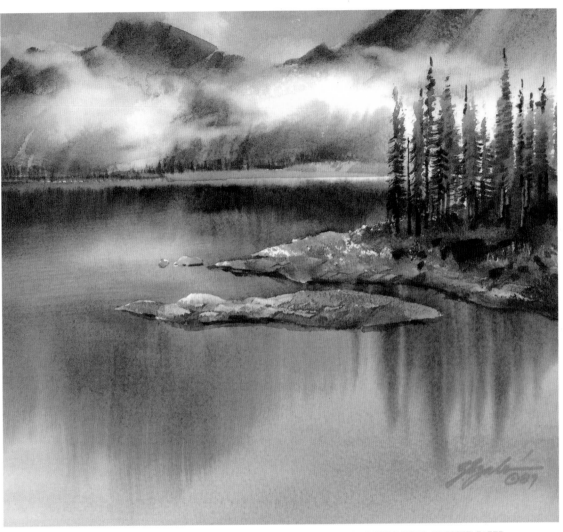

MIDDAY SHIMMER. 9½ × 10½" (24.1 × 26.7 CM), 300-LB. D'ARCHES COLD-PRESSED PAPER.

PAINTING

Working on dry paper and starting at the top using cobalt blue, viridian green, and burnt sienna, I begin to render the mountains and clouds, letting one or another of these three colors dominate with each brushstroke. I also add a touch of permanent rose to give the mountains a little more mood. Into the drying color, I add a few touches of clear water to give the clouds a clusterlike characteristic. As the basic washes dry, I deepen the value and add some modeling details to the clouds, mountains, and a few trees. After this wash dries, I strengthen the clouds by scrubbing out more color.

I mask out the little islands in the middle ground with liquid latex where my reflection needs to be flawlessly smooth. Next, I thoroughly wet the paper. Then, using a 2″ flat-bristle brush, I very firmly apply a combination of aureolin yellow, cobalt blue, and viridian green in horizontal strokes. I add Antwerp blue and burnt sienna to make the color much darker and richer. When the color is beginning to hold its value, I switch to Antwerp blue, French ultramarine, and permanent rose with a little bit of aureolin yellow. I estimate where the middle-ground trees will be and paint the reflection accordingly with burnt sienna, Antwerp blue, aureolin yellow, and a little cobalt blue.

After paper is dry, I peel off the liquid latex with masking tape. Then I use burnt sienna, a little aureolin yellow, and cobalt blue, and using a 2″ bristle brush held sideways, I tap texture onto the land area and to the little island. Then I use a palette knife to add rocky texture.

Next, using a 2″ flat-bristle brush richly loaded with pigment, I paint in the evergreens on the right side. These give me vertical contact between the middle ground and the background, similar to the vertical reflections in the water. This is done on a dry surface with a drybrush technique. With the tip of a brush handle, I scrape off fresh color to render the light tree trunks. I finish with a few dark trunks.

WATERFALLS

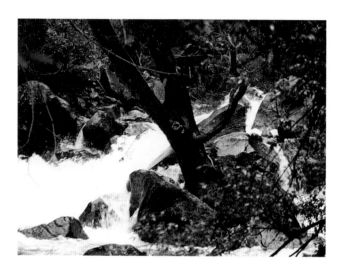

Waterfalls behave the way rapids do, but the amount of water in a waterfall seems much larger. The water is either moving in huge volumes or falling to a great depth, or both.

Very often the water is whipped into a steamlike vapor. The rainbows that occasionally accompany waterfalls are so delicate that on a painting, they end up looking trite. In general, it is best to avoid them. A waterfall is usually spectacular enough that it can stand alone.

Waterfalls can be divided into four structural components. Each will require different technical approaches. *Above the falls*: Where the water is calm and clear, reflections usually dominate. Therefore, paint this part of the waterfall as you would any still body of water. *Falling water*: Water in rapid motion is usually light in color. You can best convey its speed and shape with fast brushstrokes applied to wet paper. *The base of the falls*: Where the water lands it foams and splashes. These effects are best achieved with drybrush, spattering with a wet brush, or squirting water from a spray bottle into the damp wash to add the necessary texture. *The pool under the falls*: Here the foam dissolves into smooth, flowing water, and gradually breaks down to form a marblelike pattern. Pigment drybrushed and scuffed using semicircular movements with the side of a flat brush will establish most of the texture. After this dries, you can lift some color out to improve the design of the flowing pattern.

Waterfalls usually flow over jagged rocks and trapped debris with sharp edges. When you're painting rocks, use a palette knife to scrape off some pigment to depict their light, flat sides. Objects—rocks, logs, and branches—sticking out above the water's surface close enough to be splashed will appear dark because they are wet. Sepia, burnt umber, raw umber, Payne's gray, and Winsor blue are some of my favorite colors to indicate wet and dark images.

Rapidly moving water is subject to the same laws of reflection and local color that affect still water. The added challenge is in aiming to create the illusion of movement, which you can do by letting your brushstrokes follow the natural direction of the water's flow.

Moving water exhibits many different textures, each of which offers you an opportunity to create variations in your design. For instance, to depict swishing foam, try drybrush strokes; to depict the way water looks when it moves in a film from a high to a low point, apply paint in a linear manner with rapid, parallel strokes.

Surging streams are usually shallow, and their local colors are dominated by the color and value of the stream's bottom. Exaggerate the water's transparency by contrasting the darkest darks (the value of the wet bottom) with the lightest lights (caused by the reflecting sky).

Let's study the reference photograph for this painting. There is too much contrast. The values of the foreground and background are too close and the water lacks tones. I

need to establish clearer values. The tree is my center of interest but in the photograph it is too close to the center of the composition and needs to be moved. The rocks at the bottom of the photograph are broken up and need to be unified. The fine branches of the nearby shrubs are lost in front of the rocks. I need to place the shrubs to the left of the tree to contrast them against the white water. This improves my foreground composition.

The thumbnail sketch was done with a 6B graphite stick. It shows a new value relationship and an improved composition that is different from the photograph. The dark value in the foreground convinces me that I'm going in the correct direction. I must remember that I need to use warmer colors here than in the planes farther back.

PALETTE

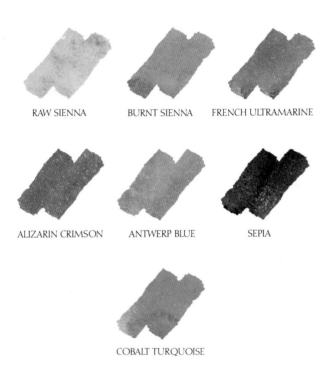

RAW SIENNA BURNT SIENNA FRENCH ULTRAMARINE

ALIZARIN CRIMSON ANTWERP BLUE SEPIA

COBALT TURQUOISE

Raw sienna is a mellow yellowish hue capable of contributing to subtle green mixes. Burnt sienna is a warm, transparent, rusty brown. I prefer it for mixing dull and dark greens as well as soft grays with French ultramarine, one of my blue colors. Alizarin crimson, a cool pinkish red, is one of my transparent dark mixers, one that I particularly like in combination with burnt sienna and Antwerp blue. It is also an ingredient in my greens, together with raw sienna. Sepia is my darkest color in this palette; heavy in consistency and on the opaque side, it is my warm neutral darkening agent. Because sepia has a tendency to go muddy, it needs to be strongly dominated by the most transparent colors whenever possible. Cobalt turquoise is a glowing, opaque blue. Its color is not far from the hue of Antwerp blue, but it's totally different in nature. It dries into a velvet-smooth tone that will not lift easily.

PAINTING

I begin on a dry paper surface. My first touches are the large, light brushstrokes of the falling water in the center. I use Antwerp blue and raw sienna. I shake a few drops of the same color into the midsection to indicate splashing water beads.

While this first light wash is drying, I proceed with the far shore at the top of the painting, with its rocks and neighboring forest. I add the blurry shapes first while the paint is damp so the edges won't become sharp. The better-defined calligraphic branches are painted after the base washes are completely dry. My next step is the midtone modeling of the white water's details. Negative and positive shapes are considered equally. These curving brushstrokes are painted rapidly. Those edges that needed softening are blended with a thirsty brush—one that is barely damp and capable of soaking up wet paint.

The foreground rocks are painted in dark values. Within each shape I encourage my brushstrokes of varied

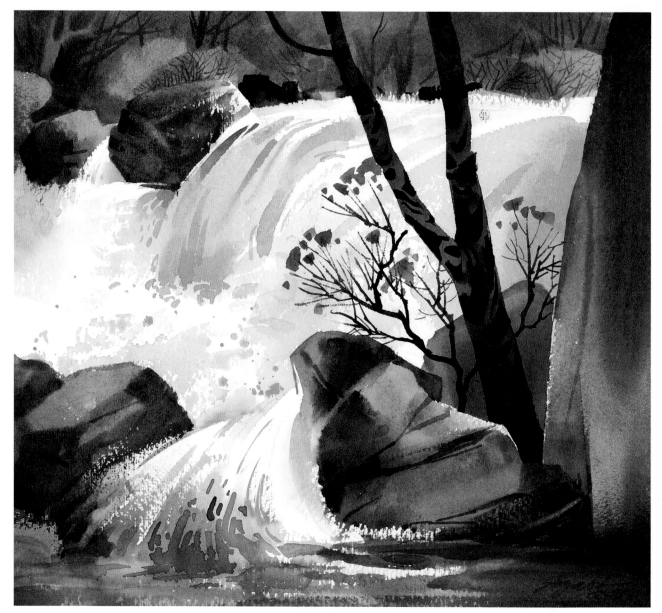

LITTLE FALLS. 10 × 11″ (25.4 × 27.9 CM), 140-LB. D'ARCHES COLD-PRESSED PAPER.

colors to blend into each other as they touch. These freely blended brush-strokes add excitement to the freshness of my darks. The outer edges of the rocks stay sharp, including the dry-brush accents that define the water's white foam.

The large tree is next. I use a com-bination of alizarin crimson, Antwerp blue, and a little burnt sienna. On top of this transparent dark, I paint the texture of the bark with exactly the same color combination as above. This second layer works as a glaze on top of the first wash, deepening the value. Next, I paint a few large leaves to add life to the twigs. To complete the painting, I darken the foreground wa-ter. With this dark tone, I seal off the bottom edge of the painting and at the same time give the water the same dark value as its neighboring shapes have in the foreground plane. My painting is now complete.

PUDDLES

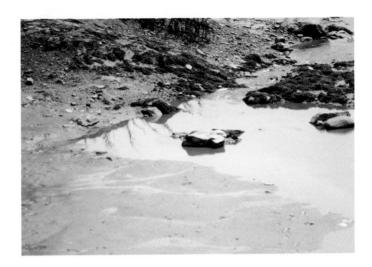

Small units of water can be used as still-life elements. The bottom of a shallow puddle or a little fountain will supply the transparent water's local color. Other still-life setups include liquid in glass containers. The resulting complex reflections may be glazed with layers of transparent washes. The simplicity or complexity of these subjects has to be determined by the artist. Generally speaking, complex reflections look great on the center of interest but are too much on complementing shapes. It is best to use simplified reflections on these secondary forms. Also keep in mind that colored liquid will cast a shadow dominated by that color.

This demonstration is painted from a photograph of a puddle of water that supplies me with as much information as nature would; thus, I will work directly from it, as if I were painting on location. The scene requires a very simple color combination. The only reflections of interest are the hints of some trees in one end of the puddle. I will exaggerate them and add the reflections of a few more trees. The trees, if shown, would be located in the visual path of the angle of reflection, so they reflect in the puddle. For the puddle, I will use a less structured-looking shape than what appears in the photograph.

PALETTE

NEW GAMBOGE BURNT SIENNA COBALT BLUE

PERMANENT ROSE SEPIA

New gamboge is a very transparent, slightly staining yellow. Sepia gives me the strength I need for the dark, wet rocks in the distance. Cobalt blue combined with burnt sienna will work as the local color of the shallow water under the rocks, and for the reflection of the trees at right.

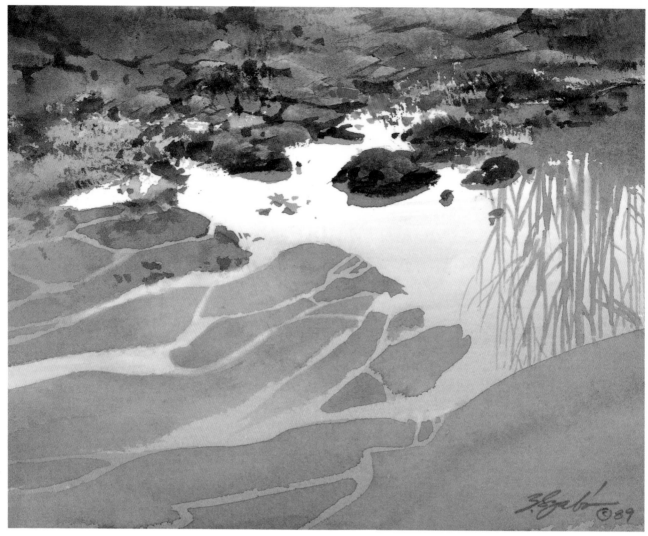

SHORE PATTERN. *7½ × 9½" (19.0 × 24.1 CM), D'ARCHES 300-LB. COLD-PRESSED PAPER.*

PAINTING

On a wet surface with a light combination of cobalt blue, burnt sienna, a touch of permanent rose, and an even smaller amount of sepia, I paint in the silhouette of the sand area with a 2"-wide flat, soft-haired brush. I accent the background with a 1½" bristle brush, using a lot of sepia, burnt sienna, and cobalt blue for the greenish rocks. I add some new gamboge to this combination to intensify the green. Before the color dries, I texture these cluttered rocks with a palette knife to make them look more brittle. I also touch up the distant rock's edges with pure sepia. The cooler influence of cobalt blue in the mix creates variety within the grays.

After this wash dries, I wet the bottom part of the painting and add a pale, blended gray tone to the area under the space I reserved for the reflective puddle. This gives a boost to my perspective and leads the viewer's eyes up toward the white contrasting area in the puddle. I allow this wash to dry.

As I paint the darker islets into the foreground sand, they echo some of the cool color from the sky. I use burnt sienna with some cobalt blue for this mix. I allow some light negative shapes to look like water seeping into the puddle. At this point, the paint texture is showing well because I am using a heavier combination of sedimentary colors, which show up proportionally larger on a small painting surface.

Next, I paint in the reflections of the cluster of trees to the right side of the puddle, using cooler colors near the top where the reflection is stronger and slightly warmer colors at the bottom where the reflection is weaker. Near the larger rocks, I place a few scattered autumn leaves, adding color and contrast to the white background. For the finishing touches, with a small No. 4 bristle brush, I lift out a few missing connections between the light rivulets of water in the sand.

Painting Ice

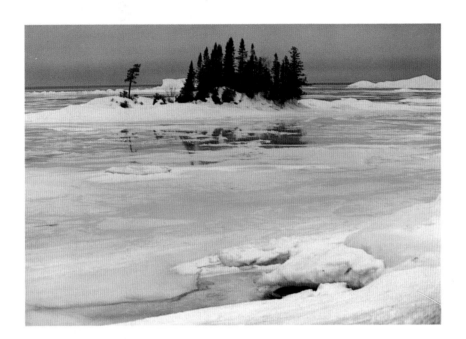

Because ice is translucent rather than transparent, its local color is lighter than that of water in the liquid state. This means the reflective quality of ice is very weak. It is observable only if the surface of the ice is wet or freshly frozen from still water, and when it does show reflections, they appear in very light values. On large expanses of ice, an occasional wet area showing good reflection helps to reinforce the illusion of three dimensions.

Ice sometimes touches open water. In these situations the ice is always lighter in value than the open water. The best way to achieve this transition is by combining sharp and blended edges.

When ice starts to form, it is paper thin, very transparent, and often exhibits fantastic patterns—the kinds of abstract shapes you see on frosty windowpanes. The application of salt or a spatter of clear water on a drying base color wash are two ways to re-create such effects in a painting; both methods leach pigment from the paper. Another way to indicate large, frosty abstractions is to press cellulose or plastic wrap into damp areas; leaving it in place until the paint has dried.

Minerals suspended in ice often tint it with their distinctive colors. Restraint is advisable when painting them; too much unrelated color can kill the luminosity of ice and make it look more like rocks. Cerulean blue, cobalt turquoise, manganese blue, and viridian green are cool, opaque colors that are useful when mixed with other colors. Mix them cautiously with raw sienna, Naples yellow, cobalt violet, burnt sienna, and new gamboge for pleasing results. Remember that ice is cold, so allow cool colors to dominate.

I would like to share with you a photograph of a very beautiful, severe winter scene. When large lakes, such as Lake Superior, freeze over, the ice gets very thick and heavy. During a thaw, a film of fine water melts on top of the ice. Such is the condition shown in my photograph. The composition has a few problems, chiefly that my center of interest, the clump of trees on the little island, is right smack in the middle of the picture. Of course I plan to change that,

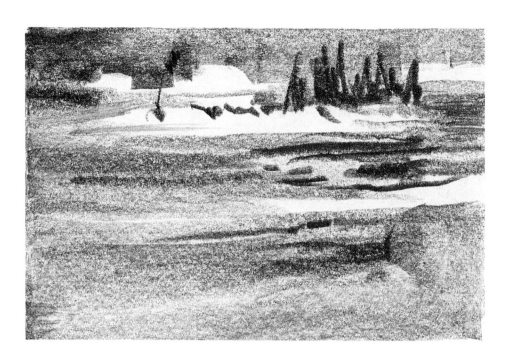

so, as usual, I make a pencil sketch, a little value study on paper with a 6B graphite stick. The first thing I do is move the tree-covered island to the right. I leave out the rutted ice that appears in the foreground of the photograph because it is such a powerful detail that it could compete with the island. I redistribute the floating ice more pleasingly in the background and move the tree-covered island off-center to the right. The completed value study shows me that my compositional changes will work. Now I can proceed with the painting.

PALETTE

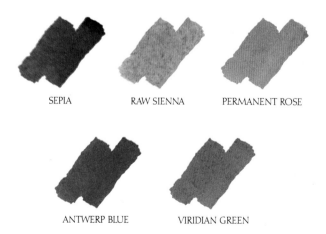

SEPIA RAW SIENNA PERMANENT ROSE

ANTWERP BLUE VIRIDIAN GREEN

I have chosen carefully to get maximum mileage out of a minimum number of colors. I mix Antwerp blue, raw sienna, and a little touch of permanent rose to become the color of the melting ice. Sepia is used mostly as a darkening agent for my trees on the island, and to some extent to make the blue-greens in the middle-ground darker. This will increase the drama of the icy island.

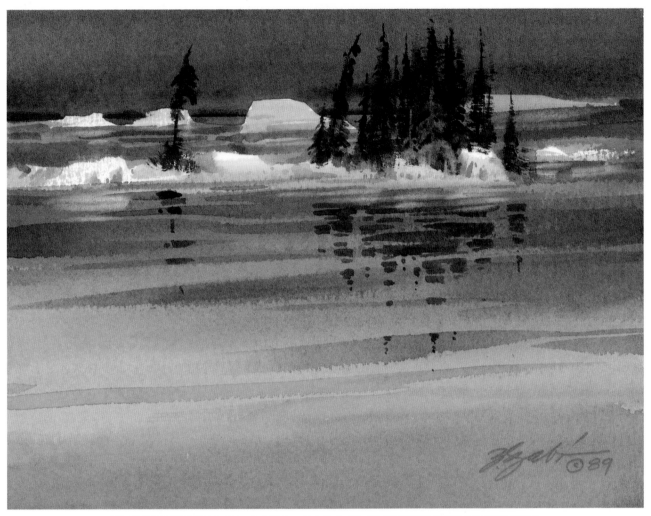

FROZEN FLOATS. 7½ × 10″ (19.0 × 25.4 CM), 400-LB. D'ARCHES COLD-PRESSED PAPER.

PAINTING

I start with the sky and establish the approximate value relationships using a warm medium tone that the dark and the light shapes will stand out against. While I paint the sky, I leave negative white shapes out for the floating icebergs. The repetition of the horizontal reflections allows me to carry some of the colors right down to the foreground. The rapid movement of my brush allows the colors to blend and go soft as I move from top to bottom. The brush doesn't stop on the painting's edges, it goes right past them on both sides and rapidly establishes the wash. I mix every brushful of paint separately, each time letting a different color dominate. All five of my palette colors are detectable, even a little sepia. When this first wash is almost dry, I put a heavily loaded brushful of darker value of the same color next to my intended center of interest. At this point, I let the paper dry.

With darker glazes—no sepia in this time—I render areas in the middle ground where the ice appears to be melting. Later, these horizontal shapes are hosts to the vertical reflections of the trees. I use a small 1″ slanted bristle brush loaded with a combination of Antwerp blue, raw sienna, and permanent rose mixed to a very rich consistency. Between the ice and the dark trees, there are warm touches of color reflected from the sky. For this I use raw sienna and permanent rose together. I paint the trees' reflection in the shiny surface of the water with Antwerp blue and sepia. After this is dry, I add a dark combination of Antwerp blue, raw sienna, and a little touch of sepia. The trees themselves have a little sepia in them.

At the end, I lift out some of the light values from the surface of the waves to indicate where the snow and ice are reflected in dark values. These repeating, narrow shapes carry the eyes up from the bottom toward the center of interest.

ASSIGNMENTS

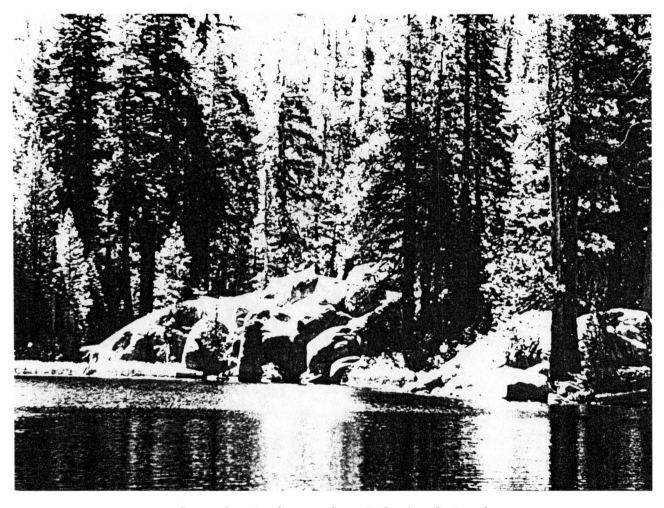

Reverse the ratio of water to forest. Define the reflection of
the tall trees without showing much of the trees themselves.

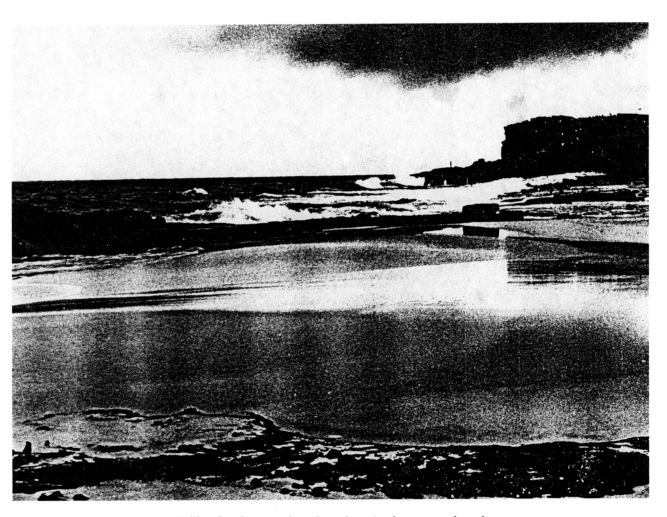

Add a few large rocks, place them in the wet sand, and reflect them.

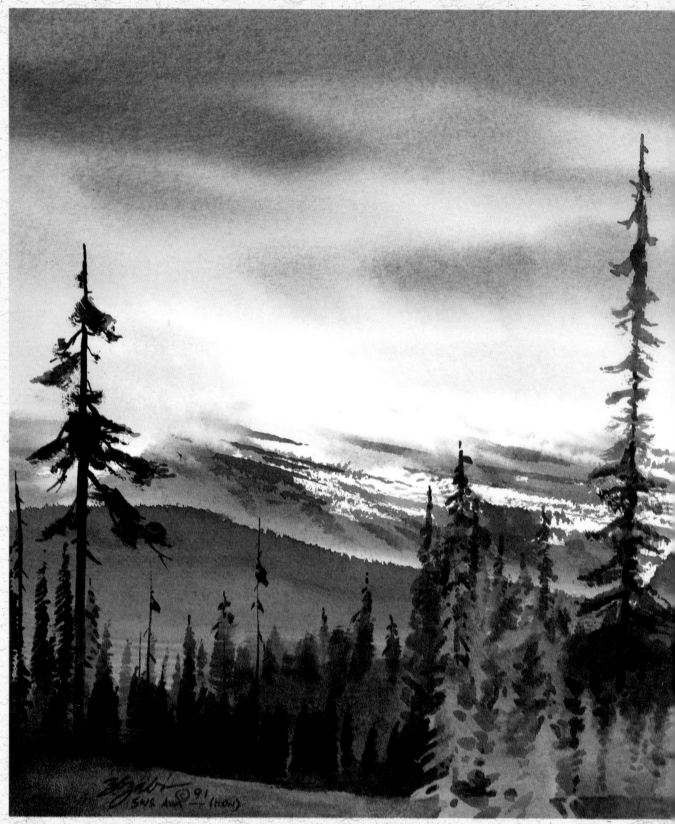

HIGH GRANDEUR. 11½ × 15" (29.2 × 38.1 CM), 300-LB. D'ARCHES COLD-PRESSED PAPER.

 # MOUNTAINS

Mountain landscapes require that you integrate several different elements. These are the dominance of vertical movement, the basic laws of perspective, and the environmental conditions characteristic of high elevations.

The composition always will be influenced to some degree by the dominance of vertical movement. Use perspective to indicate a very high mountain up close, and paint it cutting up through the painting's top edge. Do not allow snow at the top of high mountains to divide the painting between sky and ground. Leave passages to connect the two masses. Clouds and shadows are two excellent helpers that are always available for this purpose. In a panoramic setting, rolling mountains may occupy a large area of the support shape (painting surface). Don't paint them as repetitive forms; vary their sizes and shapes.

An important rule to remember is that distant objects appear paler, cooler, and less defined, while nearer images are darker, warmer, and more detailed. This is called atmospheric perspective. You should also be aware that environmental conditions vary according to changes in elevation, and that these conditions must be reflected in your painting. For example, at high elevations mountain streams are filled with silt from glaciers, giving them a milky color, while at lower elevations they are usually clear. Similarly, high mountain lakes are high in silt and mineral content, resulting in lighter and more opaque local color and somewhat lighter reflections, while mountain lakes at low elevations are clearer and more transparent, allowing light to penetrate their depths, resulting in darker local color and darker, more dramatic reflections.

Clouds often hide parts of mountains and behave as fog or mist. Generally, they appear light in value against a dark background and are soft around the edges, but in stormy weather may appear darker against a very light background.

Types of trees, their sizes, ground vegetation, weather conditions, and the color of the sky are just a few of the other elements you need to resolve in your composition. Whatever aspect of a mountain scene you choose as the focus for your painting, be consistent in your handling of the environmental conditions.

ROLLING MOUNTAINS

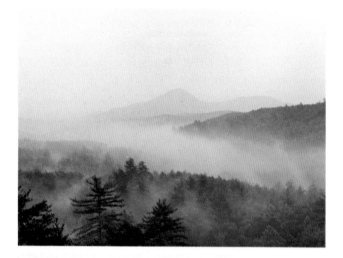

I start with two photographs of mountains in Virginia and in North Carolina. The Smokies are typical examples of rolling mountains. From a high enough vantage point, you can see miles of layers of mountains. The color is moody and soft, usually in grays and blues. They really look smoky. The foreground in the first photo (top) with the trees exposed against a soft mist is much more interesting than the foreground in the second photo (bottom). However, the blue mountain range in the background of the second photo is more exciting. I decide to use the pictures combined.

To start, I create a new composition in a pencil sketch with a 6B graphite stick. The resulting value study is a simplified rendering of the two elements I chose to use from the two photographs.

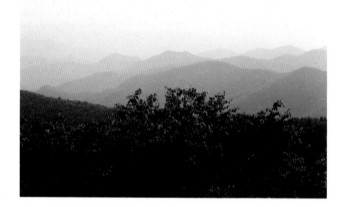

PALETTE

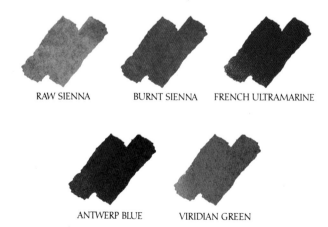

RAW SIENNA BURNT SIENNA FRENCH ULTRAMARINE

ANTWERP BLUE VIRIDIAN GREEN

The raw sienna and burnt sienna will give the foreground richer, warmer hues in combination with Antwerp blue. I use viridian green, and occasionally French ultramarine, to add to the foreground shapes. The cooler colors in the background are dominated mostly by French ultramarine, viridian green, and some Antwerp blue. In the middle range, a touch of burnt sienna is a strong influence. These colors are relatively muted when they are mixed. This subtle behavior is what I need for the misty value ranges of the rolling mountains.

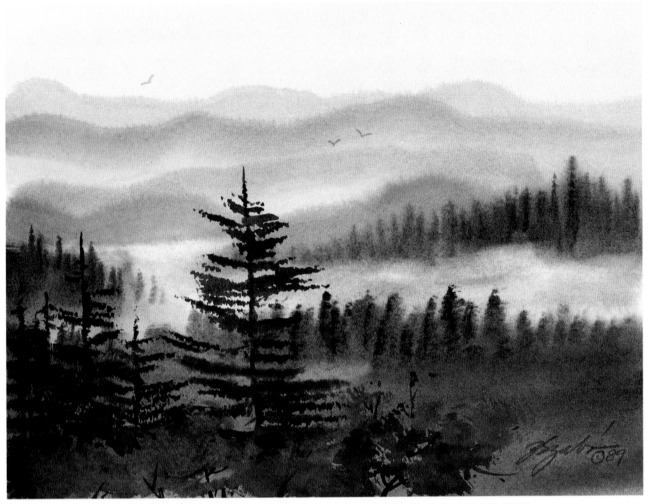

PLAYFUL MIST. 7½ × 10″ (19.0 × 25.4 CM), D'ARCHES 300-LB. COLD-PRESSED PAPER.

PAINTING

I begin by wetting the surface of the top two-thirds of my paper just once with a wide brush. I paint a very light wash of raw sienna, burnt sienna, and a tiny touch of French ultramarine at the top area to give the sky section a hint of warm light. I use a 2″-wide soft-haired synthetic brush, putting color only onto the top half of the brush and just water onto the bottom part. The edge of the applied shade blends as I paint the silhouette of the hills. I make the mountain shapes darker at the top and lighter in the valleys below. This way the distant mountains will appear soft and misty.

As I reach the middle ground, my colors get thicker and are dominated more by burnt sienna, as well as the addition of viridian green and Antwerp blue. The trees show as silhouetted, simplified shapes united with the nearby hillside. (By touching the damp paper repeatedly with the edge of my brush, these colors ooze soft.) The timing of the paint application has to be in harmony with the condition of the paper. As the paper dries, the edges of the wash get sharper, darker, and better defined. The softness has to be established earlier when the color is beginning to lose its shine.

For the nearest hillside, I use a 1½″ bristle brush that is very firm and can deliver rich amounts of pigment. These brushstrokes determine better texture, warmer color, and stronger values. As I advance toward the foreground, I use warmer and darker colors. I paint the forward range of trees on the nearby hillside a darker-looking value against the wet background because their color will dry lighter. Fortunately, burnt sienna with Antwerp blue, if applied dark enough, will stay nice and dark even after drying. Dark, warm-colored shapes in the foreground of the picture project forward and make the background appear to recede, enhancing the illusion of depth.

Before this wash is completely dry, and the shine is about to disappear, I paint the large trees in the foreground. They give me the darkest color. For the shrublike trees at the bottom edge, I add a little raw sienna by itself with the same 2″-wide bristle brush. To make sure the colors appear warmer, I sneak in a little burnt sienna darkened with a small amount of Antwerp blue. I add three pale birds over the distant mountains to finish the painting.

DESERT HILLS

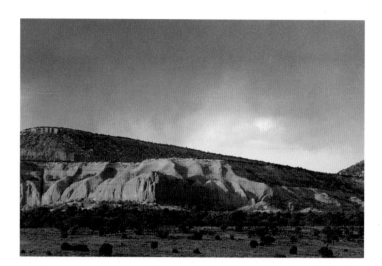

For this demonstration I paint directly from a photograph, without doing a pencil sketch. I feel that this subject is better suited to treatment as an on-location painting. I plan to unify the relationship between the sky and the mountains in the foreground; in the photograph they split the scene in half. The sunlight is a very important influence on the rolling hills. The vibrant colors are typical of desert mountains. Because there is little or no vegetation covering the mountains, more of the rock formations and soil are showing. We can really study the exposed shapes and forms of the rocks. The biggest change I plan to make from the photograph is to raise the horizon, meaning that I will raise the edge of the mountain, reduce the size of the sky, and increase the size of the foreground.

PALETTE

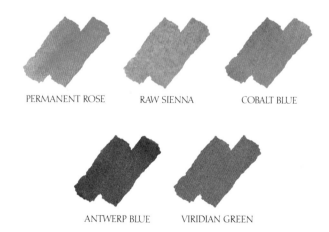

PERMANENT ROSE RAW SIENNA COBALT BLUE

ANTWERP BLUE VIRIDIAN GREEN

The most dominant colors of the hills and the exposed sandstone rocks come from permanent rose and raw sienna, with a little bit of Antwerp blue and permanent rose in the cast shadows. Raw sienna and permanent rose work well for the sunlit red rocks in the distance. Antwerp blue dominates the transparent shadows.

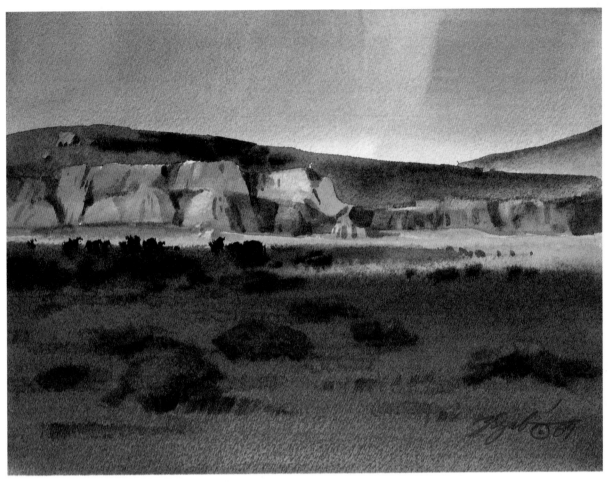

DESERT RUBIES. 7½ × 10″ (19.0 × 25.4 CM), 300-LB. D'ARCHES COLD-PRESSED PAPER.

PAINTING

I start working on dry paper. The color of the sky consists of Antwerp blue and permanent rose with a touch of cobalt blue and a little bit of viridian green. My reddish color differs somewhat from nature, but it creates a better overall color unity. I use a 2″-wide bristle brush and apply the paint fast enough for the colors to blend, using thirsty brushstrokes at the bottom edge of the sky to soak off excess pigment and water. As I move forward, I define the edge of the hill, and leave negative space for the mountain.

Next, I paint in the dark hill with a sharp edge at the top. The color is a combination of viridian green, permanent rose, and raw sienna, and where it is really dark, a little Antwerp blue. These colors look very dark while wet, but they dry considerably lighter. Immediately after, I paint in the sunlit,

rosy colors of the eroded rocky formations in the distance. Raw sienna yields a grainy texture that looks much coarser on this small surface than it would on a larger one. Some of the shades are done with cobalt blue, permanent rose, and Antwerp blue. I allow Antwerp blue to dominate wherever I use it in this painting.

After these shapes are dry, I model the surface of the rocks with strong contrasting shadows of Antwerp blue, permanent rose, and raw sienna. The modeling details of the middle-ground hills occupy my center of interest. The lightest area is in the middle section. I lift out the sunlight from the more distant formations on the right side where the red ended up a little too dark. For the sunlit area I apply raw sienna and viridian green very rapidly onto a dry surface with a

2″-wide firm-bristle brush in a very rich tone. For the shaded foreground, I add Antwerp blue with permanent rose, and for the shrubs that are scattered in the shaded foreground area, I mix Antwerp blue, raw sienna, viridian green, and a little bit of permanent rose to get a dark but transparent color. This color combination is dominated by Antwerp blue and viridian green. I keep the foreground as dramatically dark as I can. The raw sienna touch in the nearby shrubs is painted into the moist color with a firm-bristle brush. I move along in a repetitive way, lifting the dark color with a clean, damp, thirsty brush and applying raw sienna after the dark value has been removed. The raw sienna addition changes only the color; the values remain the same as other shadow tones. This makes the background really jump out.

WHITE PEAKS

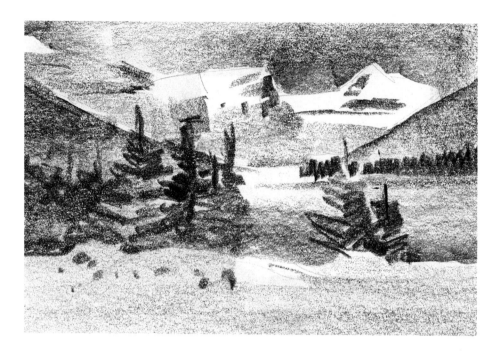

I do not have a photograph for this composition. I use mostly memory and a pencil sketch that I did in the Canadian Rockies. It depicts a spectacular white mountain with a little lake in front of it—a very common scene in the Rockies. I intend to play down the water in order to emphasize the mountains. My pencil sketch reveals my intentions

clearly. It is only a value study with young Douglas fir trees in the foreground, a bit of ground in front of them, and water. The middle ground consists only of two sloping hills, which I use as pointing shapes to attract the eye to the gap that leads to the distant mountains, which will serve as my center of interest.

PALETTE

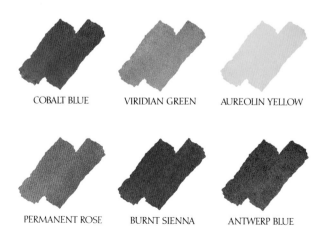

COBALT BLUE VIRIDIAN GREEN AUREOLIN YELLOW

PERMANENT ROSE BURNT SIENNA ANTWERP BLUE

Cobalt blue and viridian green give me the distant atmospheric colors at the shaded part of the mountains. With a combination of aureolin yellow and permanent rose, I warm up the rocky section. Burnt sienna and Antwerp blue are mostly used in the young fir trees. These colors make excellent shadow color on the trees—they are dark and rich, yet remain luminous. For the sunlit rim of the branches, I use aureolin yellow and viridian green with possibly a touch of burnt sienna. Permanent rose is an accent color. I plan to use it in combination with other colors. It is not used alone here, but its presence is noticeable, particularly in the sky and in the slopes of the middle-ground mountains.

44

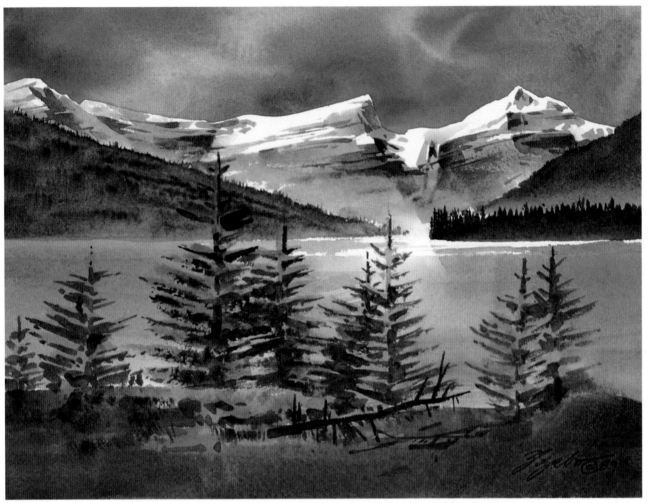

COOL POINTS. 7½ × 10″ (19.0 × 25.4 CM), 300-LB. WATERFORD COLD-PRESSED PAPER.

PAINTING

I paint the sky on dry paper with a 1½″ flat soft-haired brush using cobalt blue, a little Antwerp blue, and viridian green. As the sky's shape is established, I add a little richer combination of cobalt blue and a tiny bit of permanent rose next to where the white peaks will be. This wash must be blended quickly to look like a cloudy sky. On the small paper I am using this is not difficult at all.

I leave the white peaks out as negative shapes and establish the rocky sections of the mountains. For the lighter shapes I use a combination of aureolin yellow, permanent rose, and a bit of cobalt blue—just enough blue to mute the other colors and add the effect of distance. With a thirsty brush, I blend the bottom edge of this wash. For the darker value, I use the same

color combination but allow cobalt blue to dominate. I use the tip of a No. 14 sable-and-synthetic brush for the very fine details of the rocky shapes, rendering the crevices and cracks with cobalt blue and burnt sienna. Burnt sienna is introduced here only as a darkening agent. I model the exposed white snow with cobalt blue and viridian green to echo the sky colors.

Next, I add the dark, cool, middle-ground slopes. I use a 1″ bristle brush, which is firm and fast, and gives quick results. Before the water dries, I paint in the foreground's warm, brownish soil using burnt sienna, aureolin yellow, and a little touch of permanent rose. To darken it, I add a little cobalt blue. The color surrounding the water is still somewhat damp. With a 1″ flat-bristle brush, I add a rich tone of

viridian green and aureolin yellow to hint at the sun on branches of the larger trees. Where the tree crosses the sloping mountain at left, I move the brush back and forth to reduce the dark color behind the branch. As I apply the fresh, clean green, I simultaneously lift off some of the dark bluish color. This establishes the light accent and sunny colors on the young Douglas firs in a medium-light value.

Then, I add the dark green to this clump of young trees, which is mixed from viridian green, burnt sienna, and Antwerp blue. I use a ½″ flat synthetic brush to apply these shapes. Using a combination of burnt sienna, permanent rose, and Antwerp blue, I add in the rhythmical details in the trees and the pattern of clutter in the foreground to finish the painting.

MIST-COVERED MOUNTAINS

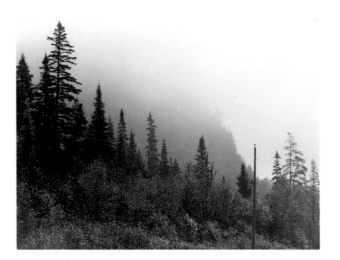

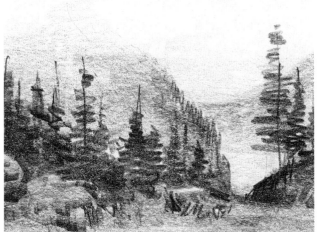

My photograph shows how fog behaves. The foreground is very detailed in reality, but simplified by dark value in the photograph. I make major changes in the composition, and break up the foreground with a horizontal cluster of shrubs in medium tones.

The pencil sketch gives a little better idea of the compositional changes. This preliminary study doesn't need to be detailed because I have a good photograph reference to work from. The illusion of depth comes from the misty values in the background. The colors I choose to use will be my key to the success of this painting. My value sketch is done with a 6B graphite stick that establishes values quickly.

PALETTE

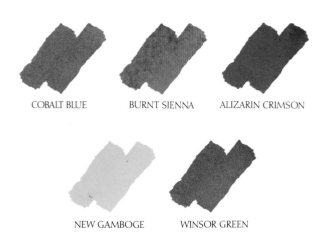

COBALT BLUE BURNT SIENNA ALIZARIN CRIMSON

NEW GAMBOGE WINSOR GREEN

Cobalt blue with the help of burnt sienna gives me a range of grays that can be teased into a little warmer hue with alizarin crimson and/or new gamboge. This gives me the misty colors based on the dominance of cobalt blue. In the foreground I need much darker, richer colors. I start with a gray, mixed with Winsor green and alizarin crimson, with a touch of burnt sienna. The variations of this combination, with the help of a little new gamboge, connect the foreground with the middle ground.

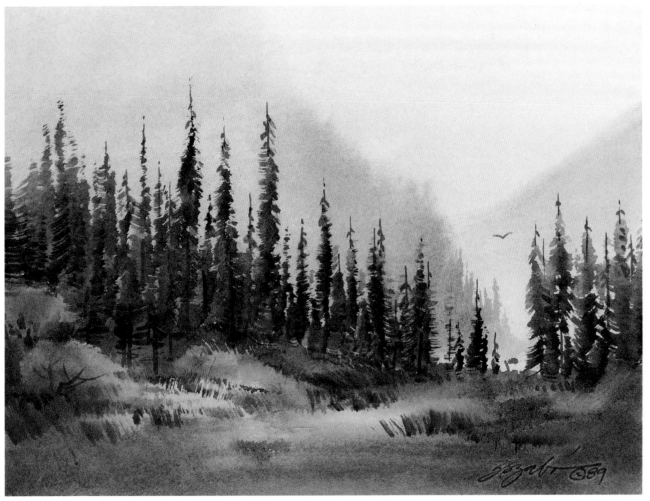

SOFT CURTAIN. 7½ × 10″ (19.0 × 25.4 CM), 300-LB. WATERFORD COLD-PRESSED PAPER.

PAINTING

I start by wetting the top four-fifths of the paper. I paint with a 2″-wide, soft, flat brush, using cobalt blue, burnt sienna, and a little touch of new gamboge. I advance from the bottom up, moving the brush rapidly from side to side, right past the edges without lifting up from the paper. The brush gradually loses color until it runs out and only white paper is left at the top. I repeat this to get the bottom color a little stronger, over-painting just a little to compensate for the weakening of the colors when they dry. While this wash is still relatively wet, I paint in the cloud-covered hills in the background. I apply a gentle gray at the tip of a 2″ flat-bristle brush and only water at the base. I need to judge the volume of the paint in my brush very sensitively to make sure that I use enough moisture to allow the color to blend smoothly

into the distance. I give the bottom edge of the hill on the left side a sharper edge near the base to indicate less mist.

I allow this color to dry because I want to paint the evergreens in the middle ground on a dry surface. Precious time is saved because a small painting surface dries much faster than a larger one. I can also maintain better mood consistency in the painting if I only have to stop for short intervals.

For the evergreens, I use a wide, firm-bristle brush loaded with Winsor green, cobalt blue, burnt sienna, and occasionally a little bit of alizarin crimson. I pull the edge of my brush sideways with short drybrush strokes to indicate the mass of branches on each tree, giving them a designed appearance that complements the repetitive rhythm of their shapes.

Up front, I have warmer, darker

colors rolling into a greenish foreground. The dark, tall spruce trees stand out in dramatic contrast. I break up the bottom edge of the row of trees with loosely painted light grass. This is the area where the trees are anchored to the ground, and the cool colors rapidly start to turn warmer. First, the color gets a little too bright, but as I add darker value, the colors become better related to the dark trees. I carry the design farther down toward the foreground with a 2″ flat-bristle brush. As the rich load of color touches the edge of the bottom part of the painting, the water tends to accumulate near the masking tape. I wipe off the excess water with a paper tissue to prevent it from forming ugly backruns. With the final details such as the treetops, branches, and so on, I complete the painting.

DRAMATIC CLIFFS IN A SIMPLIFIED DESIGN

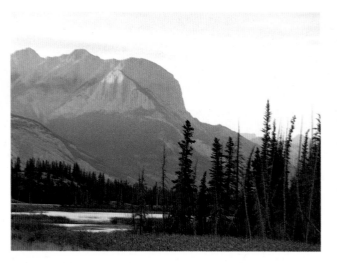

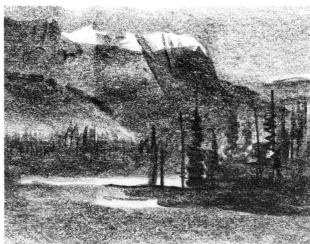

My photograph is from Yosemite National Park. It shows a simplified version of a moody subject. The contrasting light sky relates to the light value of the water. The composition in the photograph is not too bad, but the big tree on the right is poking at the edge of the large cliff (my center of interest). I plan to change that and make the foreground trees more playful.

I make a pencil sketch first. In this value study, I show very light sunlight on the top portion of the cliff. The contrast invites attention to it. The water at the bottom is only hinted at. I plan to unify the values in the middle ground and background to give a misty, distant appearance. These are simplified middle values. The sky itself is light. The values in front of the row of trees are dark. The sharp value contrast between the sunlit part and the much larger shaded section of the mountain is crucial to this painting and will succeed only if I can maintain freshness in my paint handling. Speed is essential; fortunately, though, the relatively small size of my painting makes the pace easy to control, preventing me from becoming tired or bored.

PALETTE

ANTWERP BLUE COBALT BLUE VIRIDIAN GREEN

AUREOLIN YELLOW PERMANENT ROSE SEPIA

Sepia is an opaque, dark color. The remaining five are transparent colors. I make sure that these transparent hues dominate my washes, rather than sepia, which can muddy the other colors. The nature of these colors is highly compatible with my intended mood of quiet drama.

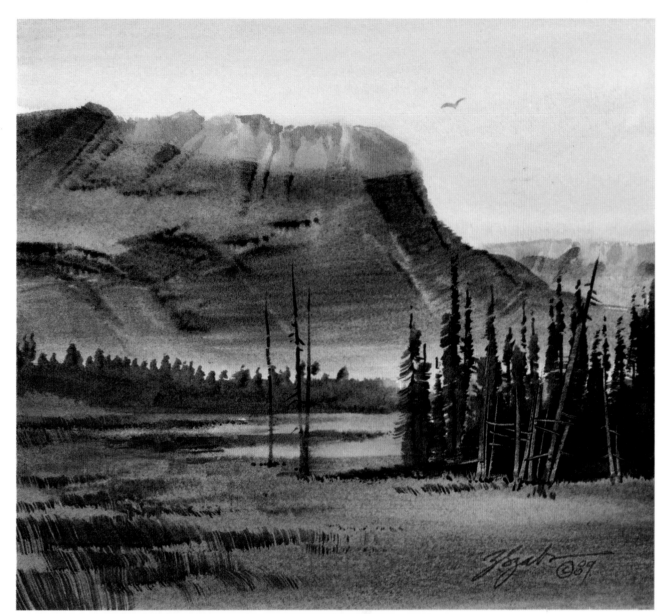

STILL BLUSHING. 9⅜ × 10¾″ (23.8 × 27.3 CM), 300-LB. WATERFORD COLD-PRESSED PAPER.

PAINTING

First, I paint the sky with a 2″-wide, flat soft-haired brush. I start with a dry surface. I apply the brushstrokes rapidly to allow them to blend just when they touch each other. I use cobalt blue, permanent rose, and a touch of aureolin yellow.

Next, I paint the mountain peak with a sunny, rosy color made up of aureolin yellow, permanent rose, and a touch of cobalt blue. I deviate a little from my value study by making the mountain a little darker than the sky to add solidity. I use a paler hue in the distant mountain on the right.

Before this color dries, I load a 2″ bristle brush with viridian green, cobalt blue, permanent rose, and a touch of aureolin yellow. I put the color at the tip of the brush, but not at the bottom edge, allowing the brushstrokes to blend from dark at the top to lighter at the base. I apply a few touches of simplified shadow details.

Next, I use a rich combination of Antwerp blue, sepia, viridian green, and a little bit of permanent rose, and with the edge of a barely damp, well-loaded 2″-wide bristle brush, I dry-brush the shape of the middle-ground

trees. I connect these shapes so they appear as one simple forest silhouette. While the paint is still tacky, with the chiseled tip of the plastic handle of my brush, I pull out a few light, negative shapes that look like bleached-out tree trunks. The simplified design adds a lot of contrast to the water, which at this point is white. I glaze a light coat of cobalt blue over the white area after everything is dry. By toning down the lake, I make sure that the most important area is the sunlit mountain. I finish by placing a lone bird in the sky to emphasize the mountain's grandeur.

ASSIGNMENTS

Add mist in the distance, and use it to improve the composition.

When you paint this subject, break up the horizontal monotony and
make the clouds appear more three-dimensional and translucent.

Paint this winter landscape using only three colors: raw sienna, cobalt blue, and alizarin crimson.

Invent a strong center of interest for this landscape.

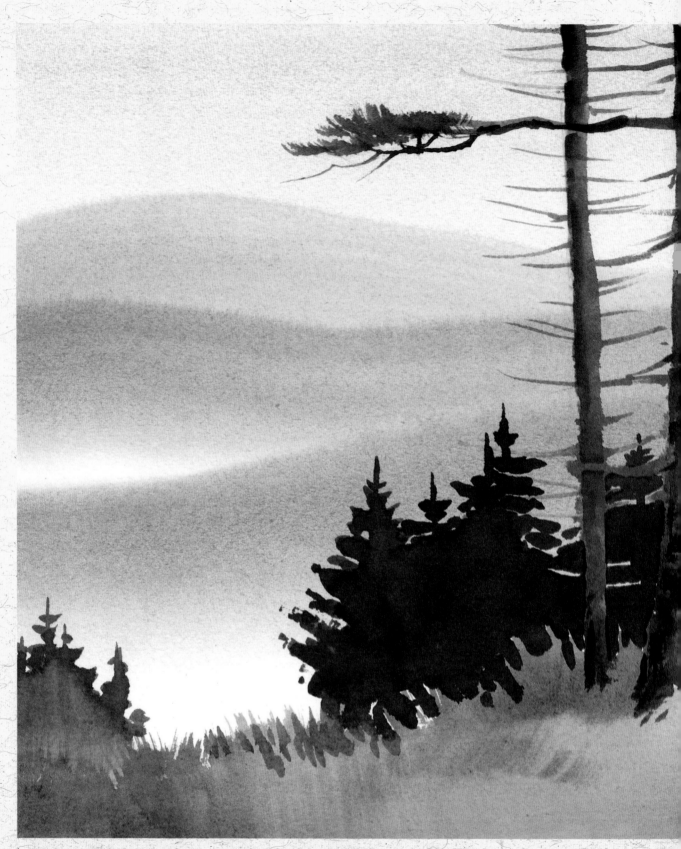

TOGETHERNESS. 11½ × 15″ (29.2 × 38.1 CM), 300-LB. D'ARCHES COLD-PRESSED PAPER.

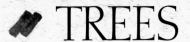 # TREES

Knowledge of the basic visual characteristics of trees is sufficient for painting them; you don't need to study botany or identify every species down to its last detail.

When I discuss trees in terms of painting, I divide them into four groups: deciduous trees, evergreens, tropical trees, and shrubs. Deciduous trees shed their foliage each year. This makes them good representatives for each of the four seasons. Evergreens or coniferous trees have needles instead of leaves and they keep them all year round, though the color changes subtly with the seasons. Tropical trees generally have heavier trunks with the leaves at the top. Shrubs are really small trees and should be treated the same as trees, unless they are part of your center of interest and thus assume a greater importance.

I would like you to think of trees in terms of how they will affect a small watercolor. Although they are covered with leaves in reality, trees look overworked in small paintings if the texture from the leaves dominates their shape. Using simplified washes to define a tree's silhouette and personality, further emphasized with good value control, is the right way to paint it. Too simple is better than too busy. When you paint a tree, keep your focus on the tree, not the leaves. When painting a distant forest, keep your focus on the forest, not the trees.

Some trees' trunks and branches are light in value. Sycamores, birches, and aspens are some of the most common examples. They may be painted effectively as negative shapes against a dark background. This means that the shapes of the light trunks and branches are preserved by either painting around them or masking them out while the background color is applied. They can also be lifted out with a palette knife immediately after the darker background color is applied. For best results, use nonstaining or lightly staining colors.

Trees in the forest need to be painted as free and naturally repeating groups of exciting shapes. If trees are painted too mechancially, they look monotonous. At the same time, abrupt interruption of their rhythm by a single leaning or fallen tree stands out and distracts because of the lone tree's isolated angle. Avoid isolated shapes by relating them to the rest of your composition.

When painting parts of trees, such as stumps or trees in deep snow, render them as if the whole tree were visible. They must relate to their environment in scale, value, color, and texture.

BIRCH TREES

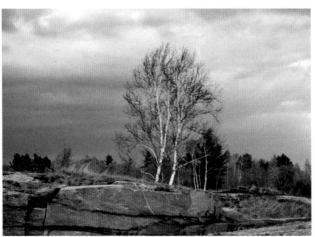

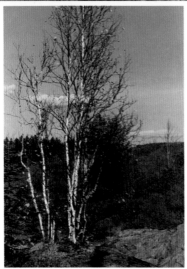

Two photographs are my starting references. Both are from the same general location. The photo I choose to work from has a few healthy-looking, young silver birch trees growing out of the soil between cracked granite rock formations. The tree clumps are located in the foreground. The background and the rocks next to it are of a medium-dark value. In contrast the tree trunks look white. I intend to make some changes to simplify the design. I plan to move the birch clumps farther to the right. To accommodate this move, I have to leave more middle-ground and background space at the left of them. This can be seen clearly in my value study although the space division is more simplified than I intend for the painting.

PALETTE

ALIZARIN CRIMSON **BURNT SIENNA** **FRENCH ULTRAMARINE**

ANTWERP BLUE **RAW SIENNA**

These colors relate very well to the mood of the subject. The ground is dominated by warm colors, as are the shrubs and trees. Because the sky is dominated by cool hues, I plan to echo cool colors in the warm dominated area and warm colors in the cool masses. Alizarin crimson, burnt sienna, and raw sienna provide the ground's color qualities. Antwerp blue is my base color for the sky with the help of French ultramarine and a touch of burnt sienna, to echo some of the warm ground colors in the sky.

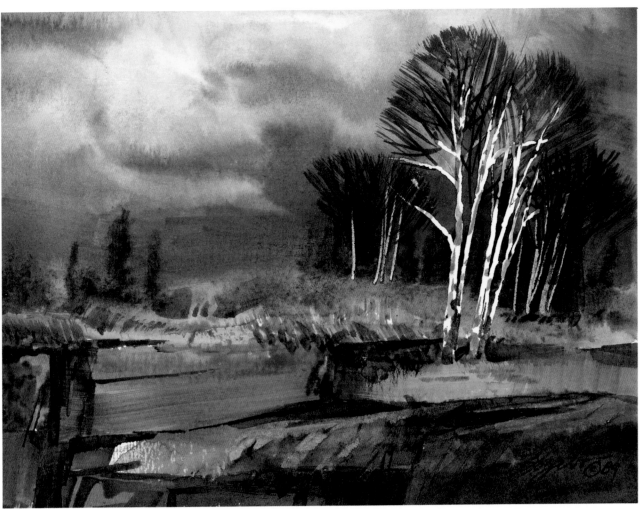

STRONG YOUTH. 9 × 6¾" (22.9 × 17.1 CM), 165-LB. OLD DUTCH AQUAREL HOT-PRESSED PAPER.

PAINTING

I start by masking out the larger birch tree trunks with liquid latex. Next, I paint the sky color onto wet paper using a combination of Antwerp blue, French ultramarine, and a touch of burnt sienna for this wash (Antwerp blue dominates). Immediately to the bottom edge of this color, before it dries, I paint in the distant evergreens with a 2″ flat firm-bristle brush. It's necessary to apply the color in rich consistency and blend it into the wet sky color. I use a dark combination of burnt sienna and Antwerp blue. Burnt Sienna, raw sienna, and alizarin crimson are my main ground colors, with

touches of French ultramarine. As I allow extra dark values to prevail behind the masked-out white trees, I am able to lift out the smaller, more distant light ones with the tip of a slanted plastic brush handle. Because the paper has sizing, it takes very little pressure to squeeze off the dark color and get the light contrast I want, which has a gentle greenish hint coming through.

Next, I paint the large angular rocks in front with snappy strokes of a ¾″ soft, flat brush using a lightly blended mix of raw sienna, burnt sienna, and alizarin crimson. The painting is done mostly with glazes. I lift out

a few light shapes from the middle section of the foreground rocks with a palette knife. The blue in the rock at the bottom right corner echoes the sky. The white drybrush sparkle on one of the rocks provides a repeat of the white birches.

After the color behind the trees is dry, I remove the latex by pressing masking tape onto it. The latex sticks to the tape's gummy surface and peels off like a film. I spot-touch the white birch trees with a burnt sienna, alizarin crimson, and French ultramarine combination to give them their natural texture. This finishes the painting.

SUNSET SILHOUETTE

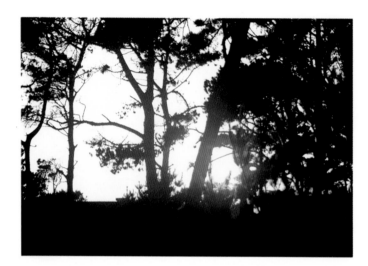

I start with an exciting photograph of trees silhouetted by intense sunlight. I feel the contrast is okay, but the dark details need improvement by using more medium values. The balance of the trees should create a stronger center of interest. I do not need to do a pencil sketch since I will not make major changes to the composition, but intend to alter the color values. Color strength is very important to this painting so I will need to use strong colors.

PALETTE

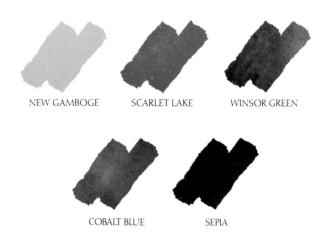

NEW GAMBOGE SCARLET LAKE WINSOR GREEN

COBALT BLUE SEPIA

The staining strength of scarlet lake, Winsor green, and new gamboge is essential to gain the deep, rich tones of a sunset condition. Cobalt blue is an accent color for the sky. Sepia adds very dark body to my shapes, which need to be represented with strong contrasts.

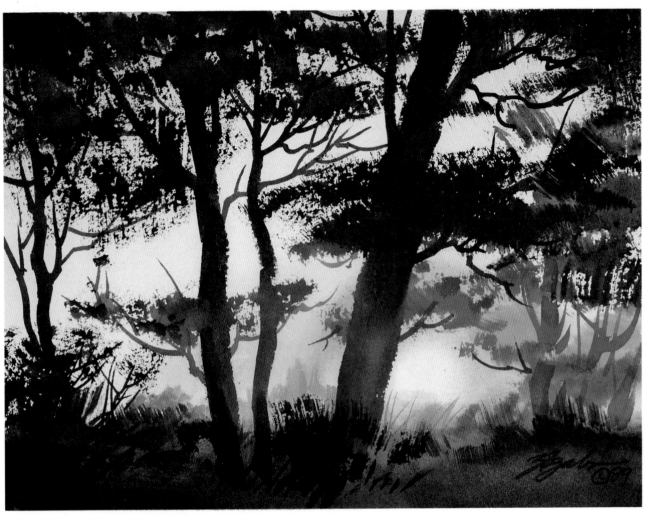

GOLD SEEKERS. 7½ × 10″ (19.0 × 25.4 CM), 300-LB. WATERFORD COLD-PRESSED PAPER.

PAINTING

I wet the paper and, with a 2″-wide flat brush, apply new gamboge and scarlet lake to the area where the sun is supposed to be setting. Cobalt blue and scarlet lake make up the soft mauve of the surrounding sky. The two washes are blended into each other rapidly before the paint has a chance to dry or get blotchy. I increase the strength of the yellow and red around the sun until it becomes fiery red. Although this color looks almost too dark when it is wet, about 30 to 40 percent of its intensity will be lost when it dries. While this top portion of the color is still quite wet, with an immaculately clean, 1″-wide firm-bristle brush, I lift out the circular shape of the sun by soaking

up the excess water and paint, cleaning the brush each time.

I apply the ground color in a very dark mauvish red hue. I know as long as scarlet lake dominates, it is going to dry lighter, so I allow the color to stay on the medium-dark side right next to the sunny area. I hook the brushstrokes together rapidly to achieve unified tones, mostly in the medium-value range, but darker at the edges.

Now the sky is dry, and I can paint a rich combination of sepia, scarlet lake, and Winsor green into the largest tree-trunk silhouette right next to the sun. In that same horizontal plane, scarlet lake dominates. All the other neighboring tree trunks and

branches get the same reddish dominance. The closer I am to the sun, the warmer I make the colors. I extend the tree trunks and limbs upward, letting Winsor green and sepia dominate for a cooler, darker appearance. The small size of my painting makes it easy to treat the shapes as a unified whole.

I paint the lacy foliage with a light tapping motion, using the side of a clean, dry brush heavily loaded with paint and hardly any water. After these shapes are dry, I paint in the smaller branches with the same color combination. I use a small No. 5 rigger to add cool, dark texture in the foreground, then insert some reddish brown tree trunks in the right middle ground.

EMPHASIZING THE FOREGROUND

The photograph feels quite good the way it is. I get lots of information from it. The light and the shadow on the tree is the most important, most dramatic part of it. I plan to exaggerate this relationship somewhat. I like the color unity between the water and the tree. There is a little too much clutter in the photograph. However, in all three planes, the objects relate well.

I follow with a value study. Again, I use a 6B graphite stick to establish my shapes quickly. I remove the distant shoreline and enlarge the tree to emphasize its strength and its close-up surface details. At the clutter of rocks at the base of the sketch, I make a little change. In the photograph, the pebbles are light and the water is dark. I reverse that and make the pebbles darker than the water.

PALETTE

COBALT BLUE AUREOLIN YELLOW BURNT SIENNA

PERMANENT ROSE WINSOR BLUE

I want to create a predominantly warm palette. Aureolin yellow, burnt sienna, and permanent rose offer this potential. I plan to use cobalt blue as a basic shadow color—in particular, on the big tree—and will charge this color with burnt sienna and aureolin yellow or even permanent rose as needed. For the darker accents, I plan to use various combinations of Winsor blue, burnt sienna, and permanent rose.

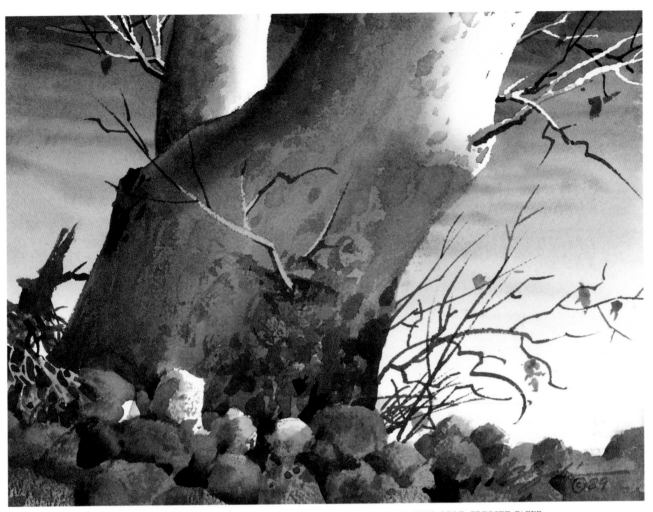

THE BOTTOM LINE. 8 × 11″ (20.3 × 27.9 CM), 300-LB. D'ARCHES COLD-PRESSED PAPER.

PAINTING

To start, I mask out the big tree with liquid latex so I can paint an uninterrupted wet wash behind its shape without having to worry about its edges.

After the latex has dried, I wet the paper completely with clean water. With fast, horizontal strokes, I apply a light value of cobalt blue, aureolin yellow, and a little burnt sienna. Moving from the top edge downward, I blend the color gradually into nothing. I repeat this several times until the top has become a rich medium value dominated by cobalt blue. I add a few dark, soft washes to indicate direction in the flowing water.

Next, I move to the foreground where I've left the paper dry, and paint in the rocks with loosely applied medium-value washes dominated by burnt sienna and cobalt blue. Then I drybrush in texture with the side of a ¾″ flat-bristle brush, using the tip to define the edge of the rounded rocks.

Once the paper has dried I peel off the liquid latex. With a 1½″ flat bristle brush, I apply the basic color of the sycamore tree with a combination of aureolin yellow, cobalt blue, permanent rose, and a touch of burnt sienna. The hues should mingle on their own, but the value should stay consistent. When this surface is just damp, not shiny, I define the light branches with the tip of my brush handle; pressing so hard that my stroke squeeze-dries its own path. Then, I add texture to the tree trunk with spot-glazing.

I paint in the shrubs and the stump with its exposed roots at left with a No. 5 rigger using a combination of Winsor blue, permanent rose, and burnt sienna. With quick, curving strokes I apply a lot of calligraphic, curving shapes. I paint a few dry leaves hanging onto the branches and a few fallen leaves in the foreground.

To the bases of the rocks I apply a dark glaze of burnt sienna and Winsor blue. After this dries, I paint a rich, wet glaze of Winsor blue, cobalt blue, and permanent rose with a touch of burnt sienna over the bottom rocks, except for a few bright, sunlit spots. This pulls the foreground pebbles into the same value range as the trees without losing all their texture. As a last touch, I add Winsor blue with aureolin yellow to darken the most distant portion of the water, bringing the eye forward.

TREES REFLECTED IN WATER

I start with a black-and-white Polaroid photograph of a flooded area. Very light, bleached-out trees reflect strongly in the water. The photograph is not of a very good quality, so I have to improve my composition. The water and the reflection look good in the photograph but the rest is not quite sufficient. The sky is too white and lifeless. However, I remember the elements that the photograph missed; the subject was very exciting.

I start with a value sketch. From a vertical format, I chose to move to a horizontal format. I raise the horizon. The water level, the hills, and the light trees move farther into the background, leaving more room for the reflections. I establish the shapes fast without any details. The tone value in the water is emphasized further. My pencil thumbnail is complete in no more than six or seven minutes. The middle ground is occupied by the dark values complemented with light accents. The medium values are in the water, and the lightest tones occupy the sky.

PALETTE

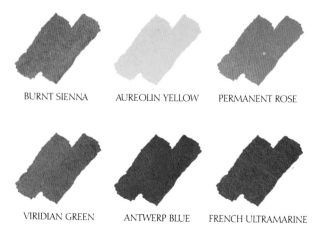

BURNT SIENNA AUREOLIN YELLOW PERMANENT ROSE

VIRIDIAN GREEN ANTWERP BLUE FRENCH ULTRAMARINE

Burnt sienna is the base color for my forest in the middle ground. These shapes have a yellowish influence, so I allow aureolin yellow to mingle as well as a little bit of viridian green, giving me a good range of medium-dark values. Where I need the trees to be darker, I add a touch of French ultramarine blue to this combination.

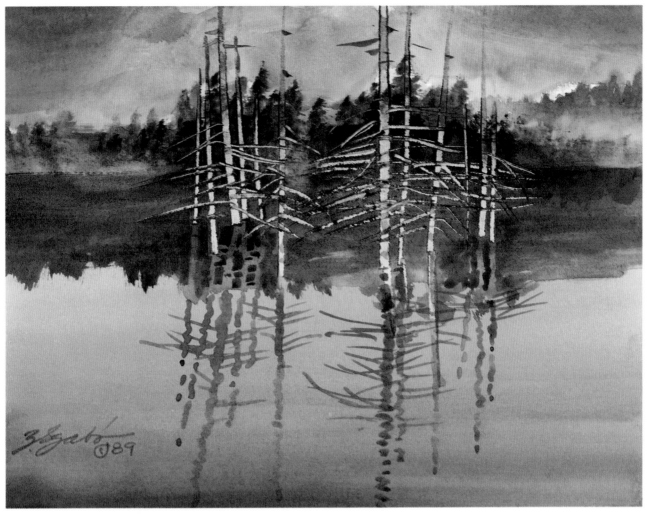

THE WHITE ONES. 7 × 9¼″ (17.8 × 23.5 CM), 140-LB. OLD DUTCH AQUARELE HOT-PRESSED PAPER.

PAINTING

I use permanent rose, Antwerp blue, French ultramarine, and a touch of burnt sienna in the sky. Where it is touching the trees, I sneak in a little aureolin yellow to give the horizon a glow of sunlight behind the clouds. I apply these colors fast enough to blend as one wash on the paper, and charge them by varying the color dominance. Next, I paint in the burnt sienna–dominated distant row of trees. Immediately after, I paint in the color of the water. I do not give the middle-ground trees a chance to dry. I paint a relatively wet wash from the bottom edge upward with a combination of Antwerp blue, a touch of French ultramarine, some viridian green, and a little burnt sienna. I start with darker value at the

bottom, and move upward, rapidly pulling by brushstrokes back and forth across the painting without lifting the brush. As I reach the bottom edge of the trees, the colors blend. The water's value is darker near the bottom with a few softly blended wavelike shapes. Into this wash, before it dries, I add the reflections of the distant trees with a combination of Antwerp blue, burnt sienna, viridian green, and a touch of French ultramarine. This time burnt sienna and Antwerp blue dominate the wash.

The middle-ground shapes are still moist enough for me to texture. I use the slanted tip of an Aquarele brush and squeeze off the white tree trunks and branches. They become the light-

est shapes on the painting. The Aquarele hot-pressed paper is remarkably responsive to lifting, and the small size of the painting surface allows me to finish quickly, before the colors dry so that they come off easily.

Next, I paint in the reflection of these trees with playful, somewhat wiggly brushstrokes to indicate movement in the water. The angles of the reflections correspond to the angles of the images over the water's surface; in this case the tree trunks. When the trunks lean to the left, their reflections also lean to the left. When they lean to the right, their reflections do as well. After a few touch-ups on the tree trunks that protrude against the sky, the painting is finished.

A LATE AUTUMN LANDSCAPE

I have a photograph that gives me a dim rendering of a simple but dramatic subject. The drama comes from its rich colors. The paper I picked is very smooth. Because of this I have to apply the color fast and look out for backruns. I plan to raise the horizon slightly and move the group of trees toward the right side. The field is covered with lush, warm-colored autumn weeds. Almost invisibly in the middle next to the trees, there are a few rocks hiding. They have the potential to become a separate center of interest, however, I want them to become part of the tree cluster as a unit. I do not need a pencil sketch because the information is all there in the photograph.

PALETTE

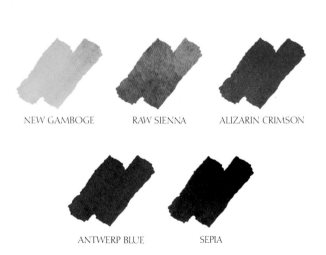

NEW GAMBOGE RAW SIENNA ALIZARIN CRIMSON

ANTWERP BLUE SEPIA

Raw sienna and alizarin crimson in combination will give me a color that will be very close to burnt sienna in its nature as well as in hue. If I want to brighten this further, new gamboge will do a beautiful job. The colorful autumn trees may also be achieved with this same combination. For the evergreen trees I need Antwerp blue, possibly a little raw sienna, and, because I need the darkness, I will use a very small amount of sepia; too much of it muds up the color. The jagged granitelike rock formations come from a combination of alizarin crimson, raw sienna, and some Antwerp blue. I need to be careful not to isolate the clouds in one color range and the foreground in another. In the photograph, the two planes try to divide the painting in color temperature. I need to unite them.

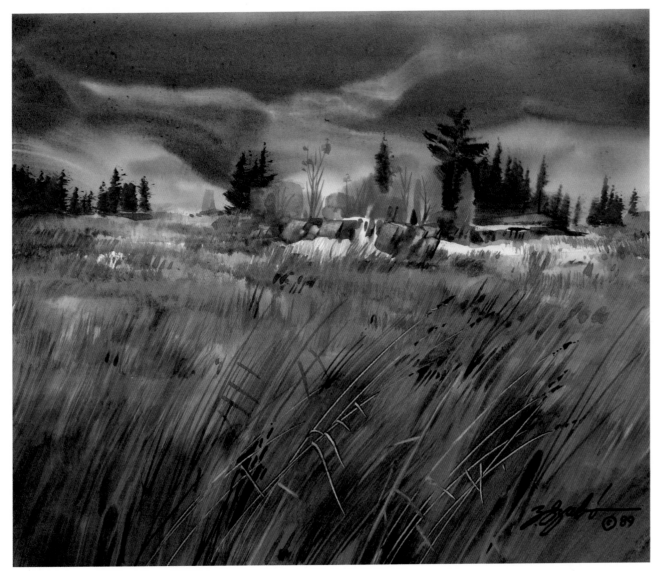

COUNTRY POWER. 9½ × 11″ (24.1 × 27.9 CM), STRATHMORE 300 3-PLY COLD-PRESSED PAPER.

PAINTING

To get texture on a relatively smooth surface, I assemble the painting with rapidly applied smaller sections like a mosaic. The small size assures me visual control over the whole surface.

I start with the sky. I wet the area first, and paint a varied gray mixed from alizarin crimson, raw sienna, and Antwerp blue. The behavior of this Strathmore paper is impossible to predict. I include a little Antwerp blue by itself to indicate blue sky. While this color is still damp, I paint the bright colors of the autumn trees using new gamboge, alizarin crimson, and raw sienna, and some Antwerp blue here and there for darker values. I use a ¾″

flat, soft square brush for this and the evergreens. The evergreens are painted with a very rich mixture of Antwerp blue, raw sienna, alizarin crimson, and some new gamboge. While this color is drying, the moisture retained from the first wet wash will result in soft edges. I paint in some of the rocks that are now part of my center of interest. I allow some white sparkle to stay next to them to hint of early snow and to add contrast. My background, the neutral sky, complements the bright colors and white accents.

In the foreground I use a 1½″ bristle brush for the weeds loaded with raw sienna, new gamboge, Antwerp

blue, and alizarin crimson. I paint clusters back and forth, alternating light and dark. As I come closer to the bottom of the painting, I indicate scale, making the weeds appear larger, more individualized. Because the wide bristle brush doesn't stay in one solid shape, it does a perfect job. When the foreground dark brown colors are applied, the paper is still wet. I use the tip of a palette knife and zip through the damp color, exposing very light, tall weed shapes. I lead the eye to the background contrast by gradually reducing the value of the weeds. I finish with some green accents in the weeds and sign the painting.

Evergreens in a Winter Setting

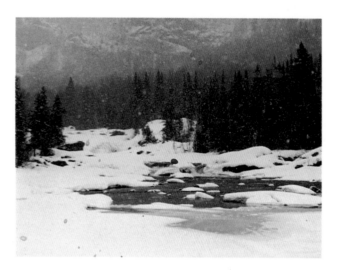

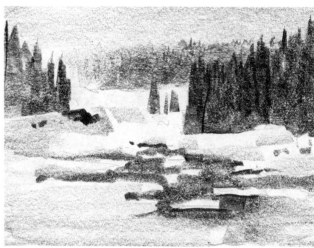

My photograph is of a subtle light condition. Everything is pale gray. The snow is falling. My subject is a heavy, frozen river. The trees are part of the background that disappear into the mountains. The atmospheric depth is not clear. I plan to change this by opening the background into a lighter sky area, virtually removing the mountain. While the center of interest is the pooling flat water with the snow humps in the foreground, the trees become a stronger com-plement by being identifiable. I want to give them a more prominent position than they have in the photograph.

My value study shows an increased contrast between the middle ground and the background. With this new tonal relationship, the evergreens in the middle ground gain strength. Although it doesn't show on this thumbnail sketch, I plan to emphasize the evergreens' strength further by using cooler colors on them than the rest of the painting.

PALETTE

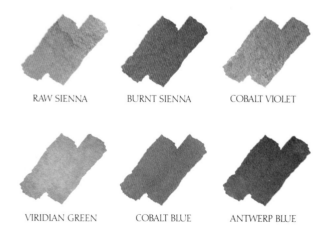

RAW SIENNA BURNT SIENNA COBALT VIOLET

VIRIDIAN GREEN COBALT BLUE ANTWERP BLUE

The combination of cobalt violet, viridian green, and co-balt blue gives me the atmospheric colors I need to give the painting lots of depth. Raw sienna and burnt sienna are modeling colors. I intend to give the sky a little bit of warmth, with raw sienna. Burnt sienna, with the combina-tion of viridian green and Antwerp blue, gives me a good deep color combination for the trees and the water.

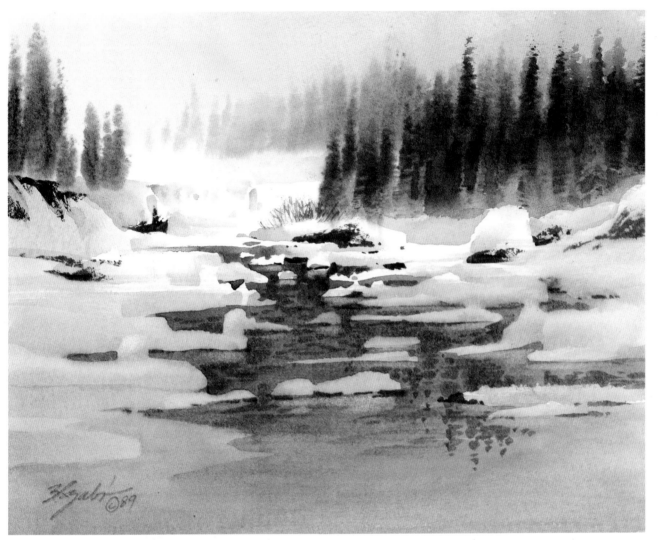

FREE FLOATERS. 8½ × 10½″ (21.6 × 26.7 CM), 300-LB. D'ARCHES COLD-PRESSED PAPER.

PAINTING

I wet the top half of the paper and establish the warm, light sky with raw sienna, starting at right and gradually going lighter in value as I move leftward. Immediately after I add cobalt blue from the far right again and blend it into the raw sienna. The result is a cool gray turning warm. Up to this point, I have used a 1½″ soft flat brush. Now I switch to a 2″-wide flat, thin-bristle brush, and with a rich load of cobalt blue and burnt sienna, I paint in the shapes that hint of a distant forest.

While the paper is still wet, I apply the left-hand clump of trees with cobalt blue, Antwerp blue, viridian green, and burnt sienna. For the larger mass of trees at right, I add a varied combination of burnt sienna and Antwerp blue, and a little cobalt blue. I go back several times with less and less water in my brush to indicate further details as the paper is drying. Cool blue-greens dominate. I hint of frozen rapids with very light colors. At left, I add a little cobalt violet to the snow under the evergreens to echo the warm color of the sky. I use a 1″ firm-bristle brush to indicate calligraphic shrubs in the background.

On the now dry paper, I paint the shape of the river with raw sienna, cobalt blue, viridian green, and Antwerp blue in varied combinations, adding a touch of burnt sienna to some of the darker areas. I leave the snow as negative shapes. The top of my paper is slanted about five to ten degrees toward me so that the wash can stay wet at the bottom edge and move downward at the same time. Here, speed is necessary, but the small paper makes my job easier. I let this wash dry.

Next, I model the snow with cobalt blue, cobalt violet, and burnt sienna, and paint a few rocks hidden underneath. I add some shimmer to the water with dark colors and lift out reflections of snow humps with a worn-out oil painting brush, pressing hard to scrub out the pigment. I paint a very light gray wash from the bottom over the whole dry area, uniting the foreground in value.

WORKING WITH BRIGHT AUTUMN COLORS

The photograph represents the time in midautumn when the maples are in full color. I want to focus on the trees with simplified forms and minimize the importance of the background area. I do not make a pencil sketch because the changes I intend to make involve adding contrasting color. When red dominates, another red will not add contrast. I need a color that is a little stronger, and more on the yellow side with a touch of fresh green to make it stand out.

PALETTE

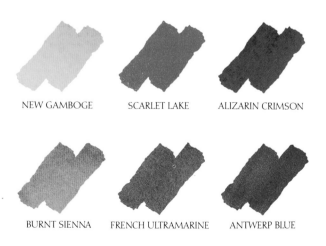

NEW GAMBOGE SCARLET LAKE ALIZARIN CRIMSON

BURNT SIENNA FRENCH ULTRAMARINE ANTWERP BLUE

The overwhelming dominance of the autumn trees will be achieved with the four warm colors—new gamboge, scarlet lake, alizarin crimson, and burnt sienna. These colors give me the glow that my painting requires. French ultramarine and Antwerp blue add potential blues and greens to the palette. They also darken the values, particularly if I use a French ultramarine and burnt sienna, or Antwerp blue and alizarin crimson combination. The colors become a little more important than usual because of the dominance of the autumn colors.

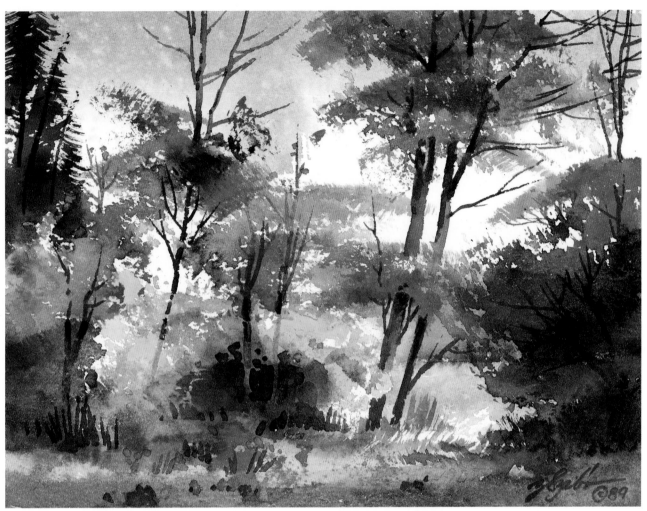

FALL COSTUMES. 6¾ × 9″ (17.1 × 22.7 CM), 165-LB. OLD DUTCH AQUARELLE ROUGH PAPER.

PAINTING

I start the painting on dry paper, using a 2″ flat, slanted, thin bristle brush. I paint the sky with a combination of Antwerp blue and French ultramarine in the tip of the brush, leaving the base of it clear of paint. This way I can blend the bottom edge of my brushstrokes. I paint the bluish hint of the sky and at the same time leave out some white negative area to suggest distance.

I drybrush the lacey shapes of the low shrubs, using new gamboge predominantly, with a touch of burnt sienna. This is an invented color because there isn't any yellow in the photograph. With a spray bottle, I squirt a few drops of water around these shapes to make the edges a little more feathery.

I continue with the red foliage against the sky. Each time the paper dries, I add more very brilliant foliage with a ¾″ brush, and then allow the color to dry. I design rhythmic curvilinear foliage shapes that will be accented by some angular static tree trunks to be painted later. Although the dominant shapes are curvilinear, I include enough static elements to make the painting balanced and exciting. I play with loose color blending as well as the lacy foliage. To be able to form these tricky shapes, I need to keep a vigilant eye on the evolving forms. The small painting surface allows me to observe the whole composition at once and control the balance.

I use Antwerp blue and alizarin

crimson on the tree at the right to set a darker, richer tone. I spread out a little grasslike foreground at the base. I paint into the wet wash with a French ultramarine, alizarin crimson, and burnt sienna combination to hint of a foreground shadow. After the color dries, the brilliant glow of these very luminous colors comes back to life. I glaze some dark contrast onto the ground and the undersides of the foliage.

At this point, I realize that the top left side is empty, leaving the composition without a challenge. I drybrush a dark green evergreen cluster. The green is also echoed in other areas of the foliage. After adding a few dark branches with my rigger brush, the painting is complete.

USING COLOR TO EMPHASIZE CENTER OF INTEREST

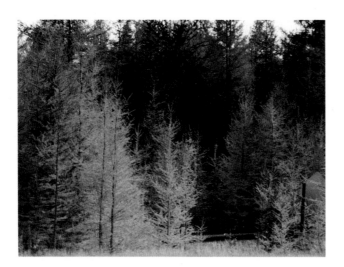

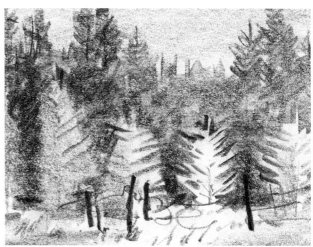

I work from a photograph that gives me a panoramic view of tamarack trees in the fall. Tamaracks are the only coniferous trees that lose their needles. They turn a brilliant yellow shortly after the deciduous trees drop their leaves. Northerners have an emotional attachment to tamaracks because they show the last touch of autumn color just before the snow falls. I intend to leave a little sprinkle of snow on the ground to hint at the time of year. My photograph shows an overcast, gray day and the colors are muted and gentle. I intend to intensify the colors of the young tamarack tree cluster, my center of interest, and add more muted hues in the area surrounding the trees.

I make a value study with a 6B graphite stick. The white touch in front of the trees intensifies the values. I add a broken-down fence with curling wires. The value study gives visual approval to an idea that started with the photograph. This idea has been improved on somewhat in the sketch, but the painting will require further refinements.

PALETTE

AUREOLIN YELLOW

RAW SIENNA

BURNT SIENNA

FRENCH ULTRAMARINE

ANTWERP BLUE

Aureolin yellow, raw sienna, and burnt sienna supply me with the necessary warm and bright, yellowish colors for the tamarack trees. To tone down and darken the background, I use a combination of French ultramarine and burnt sienna or French ultramarine and raw sienna. Where I want fresh green colors, which are part of the variety of those early changing colors on the tamaracks, I apply Antwerp blue mixed with either raw sienna or aureolin yellow. I intend to use aureolin yellow and raw sienna to achieve the reversed light washes in the dark background.

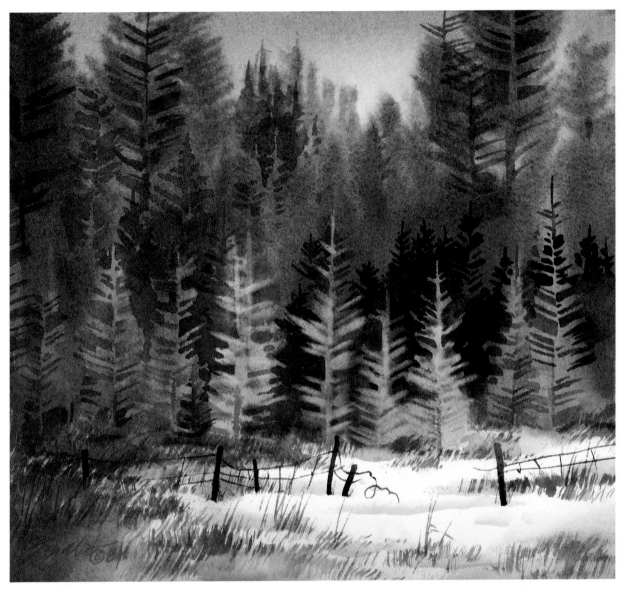

ENTER PLEASE. 9½ × 10½″ (24.1 × 26.7 CM), 300-LB. D'ARCHES COLD-PRESSED PAPER.

PAINTING

First, I wet the paper completely so the washes blend softly into each other. I paint a base color of gray with burnt sienna and French ultramarine to indicate the overcast sky. Hinting of distant trees in the background, I use the same combination of colors but add a little aureolin yellow and a touch of raw sienna in a medium value.

Next, with a 2″ flat-bristle brush, I paint the repetitive shapes of the branches and trees over two-thirds of my painting surface with varying combinations of raw sienna, burnt si-

enna, and French ultramarine. I leave a light negative background open for the brightly colored tamarack trees, which I paint in using aureolin yellow, raw sienna, burnt sienna, and some Antwerp blue. I reserve some white space in front of the trees to indicate snow. I wait for these colors to dry and follow with some silhouette shapes of deeper-shaded trees in the background, setting off the tamaracks in contrasting value. After this color dries, I go back with a small, a very wet oil painting brush, and softly lift out a few branches. At

this point, I texture the darker branches in some of the background trees. I paint in the grass at the front with tonal washes and drybrush accents.

Next, I paint a few deep dimples into the snow with a mixture of French ultramarine and burnt sienna. Finally, I place the broken-down fence against the white background, leaving an opening toward my center of interest. I use burnt sienna and French ultramarine in heavy consistency for the posts, diluting this color for the wires, which I indicate with a palette knife.

LUMINOUS FOLIAGE

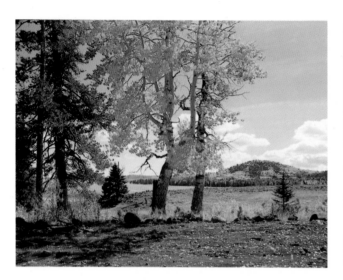

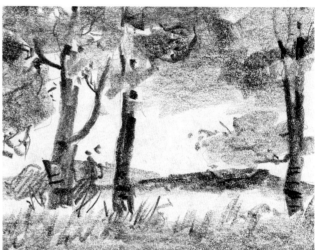

My subject is aspen trees in the fall with lots of brilliant color. The photograph depicts a high-elevation mountain landscape where the air is clear and the sun is behind the subject. Aspen trunks and branches are light in value. The severe backlit condition in this photograph causes the light values to become dark against the background sky. I plan to darken the top of the sky to help make the brilliant yellows of the leaves look glowingly bright in contrast.

I do a pencil value study with a 6B graphite stick to establish fast compositional changes. I rearrange the trees, lower the horizon, and keep the foreground very simple. The value study allows me to interpret the subject, my feelings, and the whole experience more objectively, and gives me an idea of how my changes will look.

PALETTE

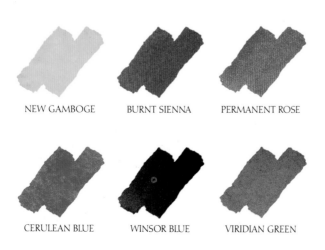

NEW GAMBOGE BURNT SIENNA PERMANENT ROSE

CERULEAN BLUE WINSOR BLUE VIRIDIAN GREEN

New gamboge, burnt sienna, and permanent rose blend into the brilliant colors that the yellow trees need to achieve the glowing, rich aspen foliage. Cerulean blue and Winsor blue supply the color for the sky and to some extent, the darker color ingredient wherever I need it. Burnt sienna and Winsor blue have a tendency to go muddy when used together in heavy consistency. For best results, make sure that one dominates. Viridian green is a gentle color. I use it here to supply some green accents. It is a luxury in this palette, but it adds a cool touch to the painting.

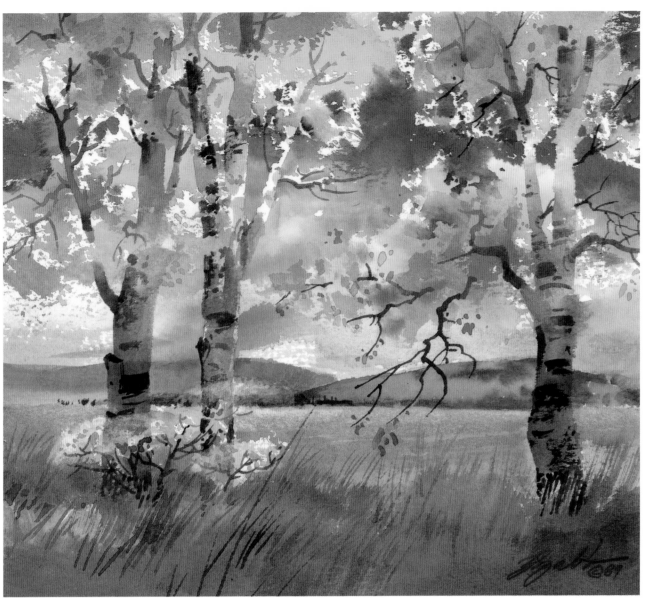

SUNNY LACE. 8½ × 9½″ (21.6 × 23.1 CM), D'ARCHES COLD-PRESSED PAPER.

PAINTING

I start on dry paper and establish the sky with a 2″ flat soft-bristle brush, leaving plenty of negative shapes for the foliage. Although I work with Winsor blue in a dark value near the top of the painting, I make sure that near the horizon it blends into a lighter, paler blue. At all times, I mix the transparent Winsor blue with a little cerulean blue, an opaque pigment, to keep it from going too dark.

Before the sky wash is dry, I go into an equally aggressive drybrush technique with the same 2″ brush, painting leaves into the white shapes

with new gamboge and little touches of permanent rose, burnt sienna, and cerulean blue. I leave plenty of white sparkle around the foliage.

For the background hills I use varied combinations of permanent rose, cerulean blue, new gamboge, and Winsor blue. The mauve-dominated hill looks more distant, and the green-dominated one a little closer. By this time, the background is more or less dry, so I paint in the bases of the aspens, moving up from the foreground.

I fill in the middle ground and foreground area with muted, warm

colors—new gamboge, burnt sienna, and a little touch of cerulean blue. I use a nearly dry 2″ firm, flat-bristle brush to paint in the linear weed clusters. I paint the wash lighter toward the distance, giving my field a feeling of perspective. I extend the tree branches behind and in between the foliage. I add the texture of the tree trunks, the structure of the foreground grass, and the bright yellow shrubs under the two trees using drybrush and spot-glazing with a ¾″ soft, flat brush. For the smallest branches and the little touches of tiny details, I use a No. 5 rigger.

DELICATE ASPEN TREES

This painting is done on location. I do not do a value study because I am too excited about the subject, and I want to start painting. I need to work quickly to capture the sunlight as it highlights the bright foliage in the background. The scene is in the Arizona White Mountains at a high elevation on a relatively cold day. I am also anxious to get the painting done before the temperature changes drastically, as is typical of high mountain elevations.

PALETTE

ANTWERP BLUE ALIZARIN CRIMSON NEW GAMBOGE

BURNT SIENNA RAW SIENNA SEPIA

New gamboge, alizarin crimson, burnt sienna, and raw sienna are a very bright combination of luminous autumn foliage colors. Antwerp blue adds its cool but dark value to the greens. Sepia is a very dark accent color. I use it sparingly as always.

PAINTING

I start by wetting the paper. I use a large, flat, soft synthetic brush as I paint the sky with a rich load of Antwerp blue, and spot-blend it with a touch of alizarin crimson to add variation. I leave out the white clouds as negative shapes. Immediately following this, I paint the trees on the left background forest with a similar color combination, darker in value, with a touch of new gamboge. Alizarin crimson and Antwerp blue dominate this wash that extends to the right side. New gamboge indicates some greens in the color combination. On the right side of this, I add some raw sienna and Antwerp blue touches to give the light on the background hill a little warmer color. At the bottom edge of the dark forest, I leave out a few small negative shapes for my brightly lit aspen trees. I cover these with a rich glaze of new gamboge. To model these colorful trees, I use a touch of burnt sienna and raw sienna between the larger trees.

I wet the bottom two-thirds of the paper for my warm grayish neutral colors in the middle ground and foreground. I paint a mix of burnt sienna, a little sepia, and a touch of new gamboge, with a 2"-wide flat-bristle brush and very rapid brushstrokes. Before this color dries, I define the shapes of a few leafless aspen trees in the foreground. They become my center of interest. With the tip of a slanted brush

72

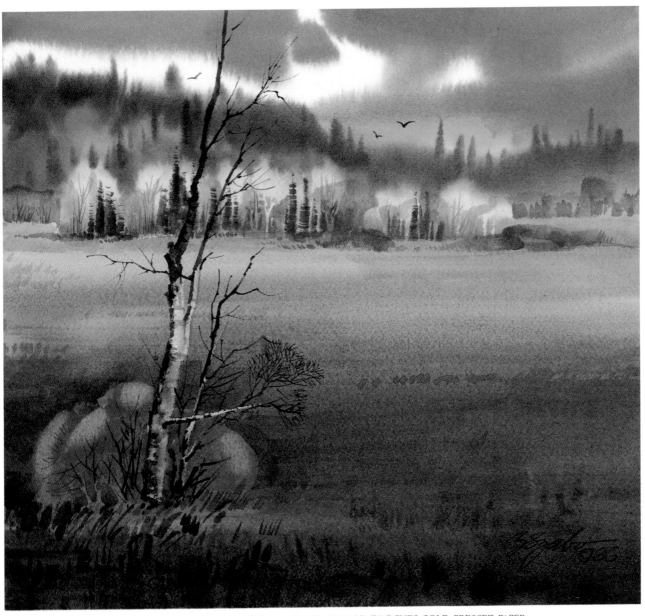

THE REVUE. 10½ × 9½" (26.7 × 23.1 CM), 140-LB. D'ARCHES COLD-PRESSED PAPER.

handle I rapidly squeeze off the color of the light tree trunks. Then I paint in the details of the sketchy evergreens and add some glazes of raw sienna for the aspen trees in the distant tree patch. For the little evergreens, I use Antwerp blue, new gamboge, and a touch of sepia. Alizarin crimson and new gamboge and/or burnt sienna supply the warm color touches.

Next, I return to my center of interest, the young aspen trees. I dry-brush the shaded side of the trees using sepia and burnt sienna with a tiny bit of Antwerp blue here and there. I extend these trees right through the painting's top edge with a mixture of sepia and burnt sienna. I add tiny details to the branches giving them calligraphic effects. At the bottom, where the dark sepia-dominated color accumulates, I scrub out the dark color, exposing light shrub shapes with a small, very wet No. 5 firm-bristle brush. The shrubs look too white, so I tint them yellow with new gamboge. This shrublike impression adds a soft complement to the highly contrasting maze of distant yellow trees and strengthens the relationship between the background and the foreground. For final texture, I paint in some dark, calligraphic brushstrokes to indicate twigs and clumps of grass in the foreground. A few crows added in the distance hint of wildlife.

HANDLING STRONG LIGHT AND SHADOW

This is painted on location in Essex Park, Colorado. The subject is a strongly lit tree, heavily shaded by its own foliage. I do not do a pencil study but go directly into my painting. The small size of a painting of this nature is a distinct advantage because the condition I want to paint lasts such a short time. The sun moves rapidly and the location of sunlight and shadow constantly change. To capture this light condition, I must work rapidly.

PALETTE

BURNT SIENNA NEW GAMBOGE ANTWERP BLUE

FRENCH ULTRAMARINE SEPIA

This color combination is partly determined by the condition of the subject. The tree's trunk and larger limbs are brightly sunlit, yet textured. To assure the survival of the texture in the sunlight and in the shade as well, I plan to use sepia, a strong staining color. It will not come off completely, even if I scrub it with a wet brush. I use Antwerp blue and French ultramarine for my sky colors. While both colors are transparent, Antwerp blue is capable of going very dark while retaining its luminosity. French ultramarine is not quite as good for dark values. New gamboge and burnt sienna are my sunlight colors. I allow these colors to stand on their own where the sunlight hits the tree trunks.

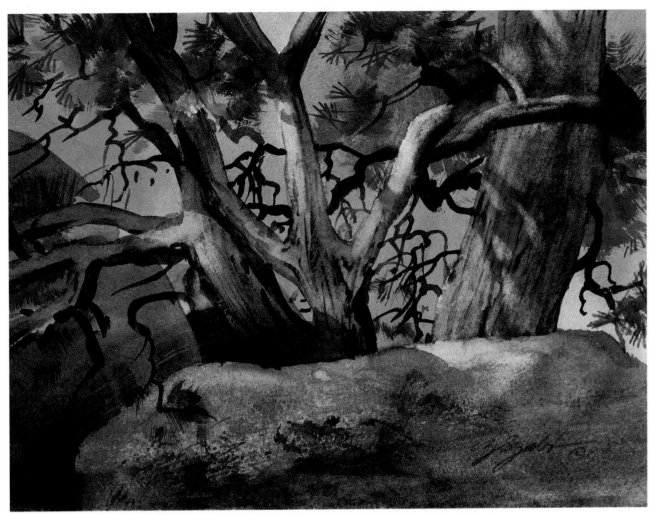

TANNING. 7½ × 10" (19.0 × 25.4 CM), 300-LB. D'ARCHES COLD-PRESSED PAPER.

PAINTING

I start on dry paper and use a drybrush textured pattern of sepia to indicate the bark details on the tree trunks and the large limbs. After this texture dries, I apply a heavy load of burnt sienna and new gamboge on top without disturbing the sepia texture. I establish the largest tree trunks with very rich pigment, using a ¾" flat, soft-bristle brush. I apply the same combination onto the rock beside the heaviest tree trunk as well. New gamboge dominates this color.

After these washes dry, I paint in the sky with French ultramarine and Antwerp blue applied in a medium value with a very liquid consistency.

When this wash dries as well, I paint the dark foliage using Antwerp blue, a touch of burnt sienna, and a little sepia. I use a ¾" flat brush. Where the needles hint of their nature on the pine branches, I use a rhythmical pattern of calligraphic touches. In the foliage where the branches appear closer, I use some new gamboge to obtain a warmer green to add the illusion of depth. I paint the dark branches as calligraphic elements with sepia and a little Antwerp blue. After allowing the paint to dry, I wash the shadow color all over the tree and the rocks, using a French ultramarine and burnt sienna combination. Burnt sienna–domi-

nated dark color occupies the area at the very bottom of the split tree's trunk. At the edge of the rock, French ultramarine dominates. I add a little touch of Antwerp blue where the rock is shaded.

Next, I lift out the sunlight on the tree and the rock with a very wet No. 5 firm-bristle brush, scrubbing out the excess shadow color to allow the new gamboge and burnt sienna to look sunlit. I lift out the sun patches as independent little islands of light, exposing warm color. The color looks sunny because only the value has changed. The hue remains because of the staining nature of the pigments.

WINDBLOWN TREES

I work from a black-and-white Polaroid photograph that is vastly underexposed with very dark values, giving me an impression of a scene I experienced. The Spanish moss and the big oak trees form a blended unit. I add the weather condition of a heavy wind-blown subject. Because I make drastic changes from the photograph, I need to clarify my thinking visually.

I proceed with a value sketch. I increase the size of the tree to make a powerful foreground. I place a Southern-style building in the distance and paint wind-blown palm trees and other images into the middle ground. The foreground tree is covered with Spanish moss, leaning into the wind. The trees in the back are also leaning. I plan to express more graphic activity with my paint.

PALETTE

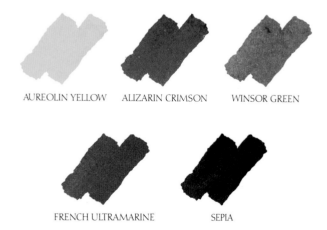

AUREOLIN YELLOW ALIZARIN CRIMSON WINSOR GREEN

FRENCH ULTRAMARINE SEPIA

Aureolin yellow and Winsor green give me a fresh greenish hue, muted into a more distant color with French ultramarine. Alizarin crimson and Winsor green give me a neutral gray that is very close to the natural color of Spanish moss. More importantly, it suggests the right color for the sky and for the foreground. These are dark and luminous at the same time. Sepia is to be used sparingly because it is an opaque staining color, and can dirty up these otherwise clean hues. I don't intend to use it in heavy consistency unless I need real dark shades.

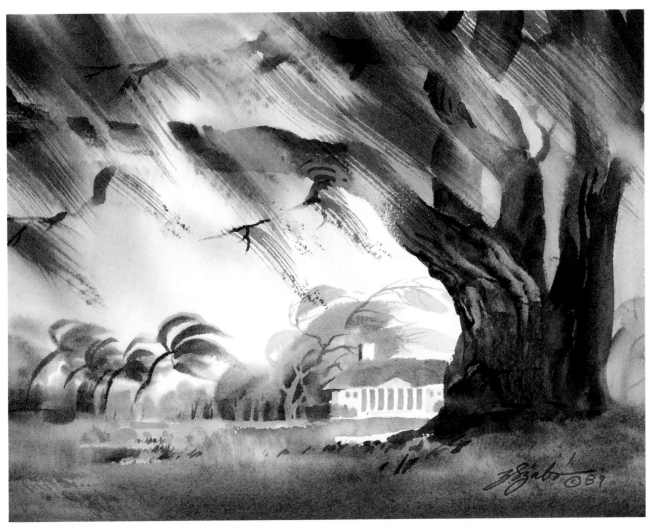

SOUTH WIND. 8 × 10½" (20.3 × 26.7 CM), 300-LB. D'ARCHES HOT-PRESSED PAPER.

PAINTING

I wet the paper and briskly brush in some of the Spanish moss shapes with a 2" flat-bristle brush. I use the shapes of the Spanish moss to give me the repetitive movement I need to establish wind direction. I use a very strange combination of alizarin crimson and Winsor green as a basic mix. These colors, by nature, separate on wet paper. After the color dries, they show independent identity. I move to the lower portion, and with swiftly moving brushstrokes, I paint in the blurry, distant shrubs and trees, the palms, and an old oak tree behind the building. The house is left out as a negative shape. When this color is almost dry, I paint in and around the branches and tree trunks, creating negative as well as positive shapes. I add a few simple details to the white building.

I paint the dark tree in the foreground with a rich combination of aureolin yellow, alizarin crimson, sepia, and French ultramarine with the warm colors dominating. I also extend the large limbs between the softly washed Spanish moss blowing in the wind. I darken the foreground to coincide with the dark value of the tree and drybrush the same color combination of alizarin crimson and Winsor green with French ultramarine on top of the Spanish moss glaze. While the wind-blown moss is drying, I carefully apply a very gentle tone of French ultramarine, sepia, and aureolin yellow around the painting's edges to preserve the purest white next to the large tree for contrast.

CAPTURING TREES IN MOTION

I begin this painting from memory. The stormy condition, such as what I am about to paint, is not very conducive to painting or sketching because the wind is just too ferocious and objects are flying all over the place.

I make a value study with a 6B graphite stick, which can establish shapes rapidly. The palm trees are bent. I indicate a simple cluster of trees with some branches already on the ground. There is a distant point on the shore with wind-blasted trees trying to hold up against the wind. The values are basically dark and light. However, on the right side of the painting, I shade the paper to a light-medium value to indicate the light direction from the left side. I add a few rocks in the front, and my value study is established well enough for me to begin painting.

PALETTE

RAW SIENNA BURNT SIENNA ANTWERP BLUE

FRENCH ULTRAMARINE ALIZARIN CRIMSON WINSOR GREEN

A combination of raw sienna, Antwerp blue, French ultramarine, and Winsor green becomes the wind, water, and vaporized splashes. For my dark grays, I plan to use alizarin crimson and Winsor green or French ultramarine and burnt sienna. I can add a little Antwerp blue to either one of them if I want a lighter value. Antwerp blue and burnt sienna when mixed are a little on the greenish side. Winsor green and alizarin crimson give me a good neutral, almost black deep tone wherever I need it.

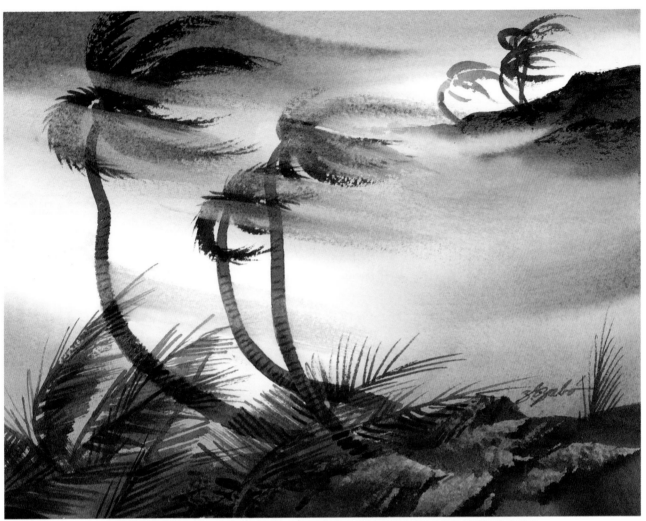

WIND DANCERS. 8 × 10¾" (20.3 × 27.3 CM), 400-LB. D'ARCHES COLD-PRESSED PAPER.

PAINTING

I wet the paper thoroughly and keep the surface shiny wet to help the illusion of a moving, splashing, roaring water and wind combination. I establish the sea with rolling, moving brushstrokes in a very soft, blurry manner, with an ample amount of paint. I use both blues and Winsor green with a little burnt sienna without blending them into one solid unit. I achieve a stronger tone value on the right side, but leave more white on the left to contrast against the trees. Immediately after, I paint the color of the sky using a small ¾" soft brush loaded with a thick mix of burnt sienna and French ultramarine. I paint the surface on the right edge to indicate distant dark formations. These edges do blur a

little. I use a hair dryer to dry the surface completely.

Next, I paint the large, fast moving palm branches leaning into the wind directly against the white background. I paint their shapes with very fast-moving drybrush strokes. I use a No. 12 round sable brush with an excellent point to make sure that the shapes of the branches end up looking wide near the trunk and tapered toward their tips. I paint repetitive, leaflike texture on each one of these branches to depict living palm branches.

In the background, where the rocky shoreline is located, I paint the windblown trees in medium-dark values. I texture the surface of the rocks

with scuffled drybrush strokes. For all these dark shades, I use Winsor green, burnt sienna, and alizarin crimson in varied combinations.

I paint in the dark, warm-dominated foreground of rocks and debris with burnt sienna, raw sienna, a little alizarin crimson, and some Winsor green. On the right center at the bottom part of the painting, I use a palette knife to texture the rocks while the color is still damp. I leave the dark, cracked edges as the knife forms them. As a last touch, I spot-wet the tree branches and forcefully wipe off the color with a bunched up tissue, enhancing the illusion of wind action. I repeat this a few times for overall consistency in the finished painting.

ASSIGNMENTS

Paint this misty forest with only three colors: Winsor blue,
burnt sienna, and sepia. Work fast and avoid muddy colors.

Paint these trees in warm, bright sunlight, with cool, dark
but open shadows.

Use very bright, contrasting autumn colors and create a
definite center of interest.

DESCENDING CRYSTALS. 11½ × 15″ (29.2 × 38.1 CM), 300-LB. D'ARCHES COLD-PRESSED PAPER.

SNOW

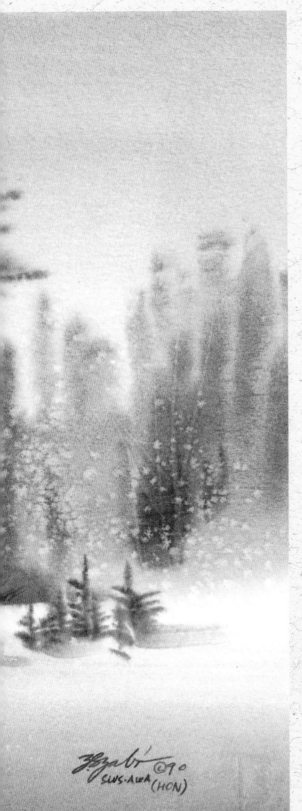

Snow and watercolor are well-suited to each other because the white of the paper already suggests the purity of snow. However, snow is not just white but is shaded by gentle tones of color. To render snow effectively, you must capture those subtle tones in a way that will express volume. This is called modeling. The value of snow is determined by its relationship to neighboring shapes. The color of snow shadows always relates to the color of the sky and any other strong colors close enough to reflect into it.

Objects covered with snow will not show any of their natural sharp or jagged features. The snow rounds and softens them. The best way to paint snow is to leave the white shapes unpainted and work around them. Define snowdrifts by painting the darker objects around them. Then you can add the shading and modeling.

When you paint snow on the ground, consider the tilt of the uneven surface. Because the light source (the sun or the sky) is usually above the top of the snow, the top must be the lightest in value. However, if the sun is low, the side of the snow shapes facing the sun will be the lightest, not the top. The surface that turns away from the light source turns darker gradually. Low sun also creates longer shadows that eliminate white snow.

Accumulated snow most often is the lightest on top and a little darker on the side. One good way to model large humps of snow is to alternate blended and sharp edges. When blending your edges, you must use an immaculately clean brush and crystal-clear water and clean out your brush after each stroke to protect the purity of the next application.

When a winter sky is stormy in the distance, the snow on the ground may be much lighter than the sky. When you paint gently shaded snow with an overcast sky above, mix the color of the shading on the snow to be a little warmer rather than cool. It makes the painting more pleasant to view because warm colors are more pleasing to the eye.

SNOW CONTRASTING AGAINST BOLD SHAPES

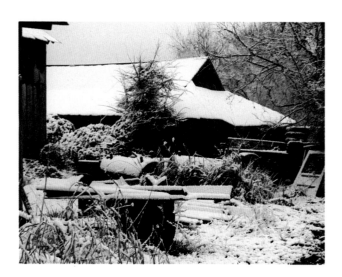

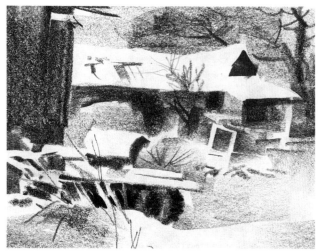

My reference is a very good photograph of an overcast weather condition. The most exciting potential for this painting is in the harmonious balance of the light shapes. The photograph minimizes the color and gives a black-and-white impression. I feel this is an advantage because I can choose the colors instead of relying on nature's suggestions. Overcast winter days have a tendency to minimize color, particularly when most objects are covered with snow. The way the photograph shows the subject, it is cluttered with too many small shapes competing for attention. I have to reorganize them and simplify their influence on the painting. The composition is based on high contrasting shapes. I intend to concentrate on this important feature.

On the value study, I use a 6B graphite stick again to show bold, high contrast and simple shapes. I like the shape of the door, but not its location in the photograph. At the foreground, I simplify the shapes, leaving more white space in the form of modeled snow.

PALETTE

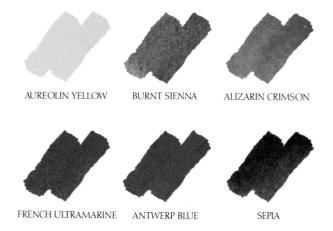

AUREOLIN YELLOW BURNT SIENNA ALIZARIN CRIMSON

FRENCH ULTRAMARINE ANTWERP BLUE SEPIA

Burnt sienna and aureolin yellow warm up my grays. French ultramarine and burnt sienna offer the best neutral gray that can be pushed warm or cool, depending on which color dominates. Antwerp blue combined with alizarin crimson gives me dark, deep, luminous color with the help of a little sepia. Sepia is an opaque color I use to influence my transparent colors and darken them a little.

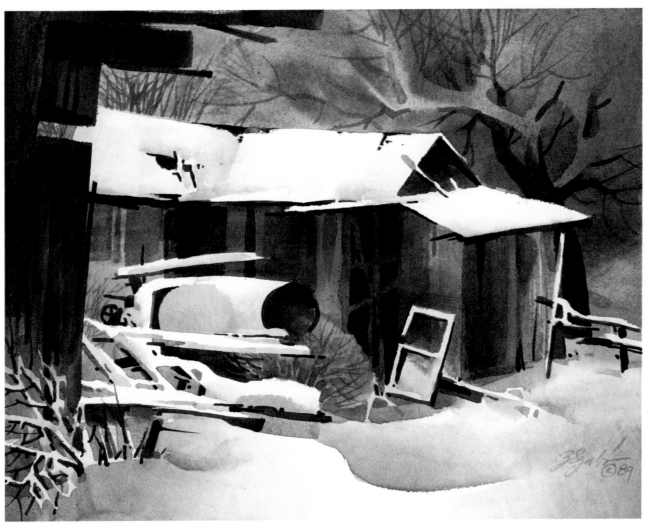

CLEAN UP TIME. 8 × 10½″ (20.3 × 26.7 CM), 140-LB. WATERFORD PAPER.

PAINTING

I start on dry paper with the sky. As I establish a soft blue-gray wash above the snow-covered roof, I leave the snow exposed as pure white shapes. While the wash is still wet, I add a little aureolin yellow, burnt sienna, and French ultramarine combination to the right top edge, hinting of branches. As the color dries, I glaze the side of the shed, varying the colors from warm to cool. For the shrubs, I use aureolin yellow, burnt sienna, and a touch of French ultramarine. I paint negative as well as positive branches by painting a second wash of the same color, leaving out the light (negative) branches. I paint these islands of color with a ¾″ soft flat brush. I treat the large tree at top right similarly.

Advancing further, I roughly mask out the edge for the dark foreground shed with masking tape to protect the existing shapes in the back. I paint the boards by applying very quick brushstrokes with a 1″ firm-bristle brush loaded with a combination of burnt sienna, alizarin crimson, Antwerp blue, and French ultramarine. This dark, luminous shape frames the painting on the left side. As a finishing touch, I spot-paint the darkest accents with the help of Antwerp blue and sepia.

FINE SNOW-COVERED TWIGS

The photograph may be a bit of a puzzle to you. It is a bleached-out, nothing-looking subject with one of the worst errors you can possibly have in a composition. There is one isolated white pointing object in the area of highest contrast. It is always more challenging to make a good painting out of an uninteresting subject. Because the snow is broken into negative patterns, I have an excellent opportunity to demonstrate how to approach large forms textured with small shapes. The challenge in this painting is to allow my feelings to take over the most important part of the painting, its soft and inviting mood. I want to deepen the values and make the foreground more exciting. The cedars form a dark background. I intend to be pretty bold with them and play with the foreground. I don't do a pencil sketch; so much depends on the painted details that a pencil sketch is relatively unimportant in this case.

PALETTE

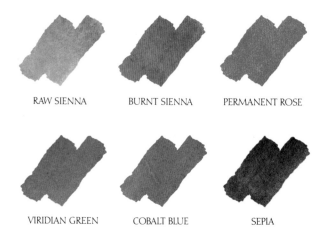

RAW SIENNA BURNT SIENNA PERMANENT ROSE

VIRIDIAN GREEN COBALT BLUE SEPIA

Raw sienna, burnt sienna, and permanent rose warm up the grays and add fresher colors to the snow-covered weeds and twigs in the foreground. I need to use warm colors, to make the neutral snow feel warmer and more pleasing. The transition of tone between the cluttered branches is subtle and soft. The dark values must include sepia, because cobalt blue does not go dark. I intend to use sepia with great discretion, diluted with water and overwhelmingly dominated by transparent hues. My color selection is designed for subtle values and soft hues.

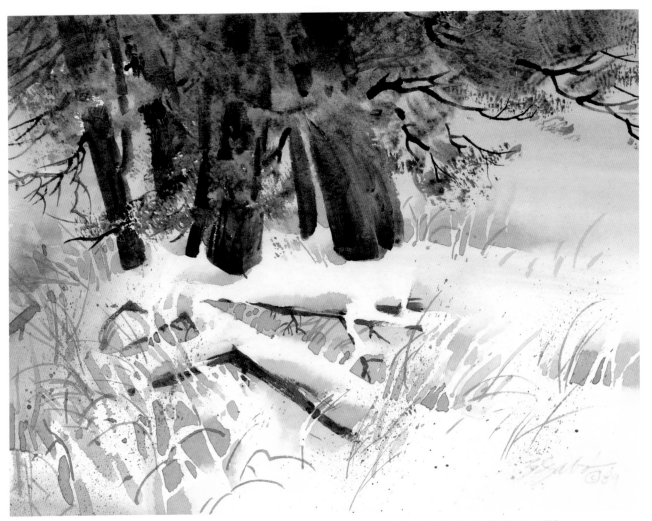

WINTER LACE. 8 × 10½″ (20.3 × 26.7 CM), 260-LB. STRATHMORE ARTISTS COLD-PRESSED PAPER.

PAINTING

I start on dry paper. I load a 2″ firm, flat-bristle brush with rich paint at the far tip and clear water at the bottom edge, and apply a tone of cool gray to the top right side of the paper mixed from cobalt blue and burnt sienna. On the left side with the same brush, I paint in warmer tones dominated by burnt sienna. As this color dries, I paint in the foliage of the trees. I combine viridian green, cobalt blue, and burnt sienna, and with the side of my brush I apply the color with a gentle tapping motion. Before this color is dry, I paint in the shapes that represent the tree trunks using a little sepia, permanent rose, raw sienna, burnt sienna, and cobalt blue. I apply these brush-strokes very rapidly, blending them

into the foliage. On the small surface, it is easy to time the right moment to apply my brushstrokes.

As the tree trunks are drying, I blend their dark, luminous shapes with viridian green and burnt sienna to appear as if they were behind the green foliage. I use a palette knife to add in the support branches wherever they are exposed against the light background with sepia, burnt sienna, and viridian green. The paint needs to be in a liquid consistency to allow the color to flow off the tip of the palette knife.

When the paper is dry, I complete the foreground, starting with the lightest tones of cobalt blue, a little burnt sienna, raw sienna, and a touch of sepia. The clutter is not repetitive; it

has interesting little passages of light shapes squeezing through medium tones complemented by a few dark accents. The darks have sepia, burnt sienna, and cobalt blue in them. These dark branches under the snow are pointing to the center of interest, the heavy clump of trees. They serve as little directional signals. With a small rigger brush, I also paint a few touches of raw sienna and burnt sienna weeds to add warmth to the foreground. Where the background is continuous and the white is dominant, I leave the shapes sharp all around. Where the background needs to disappear into the soft snow, I blend the edges. I finish the painting with a few spatters of seedlike texture over the weeds.

SNOW-COVERED PEBBLES IN A CREEK

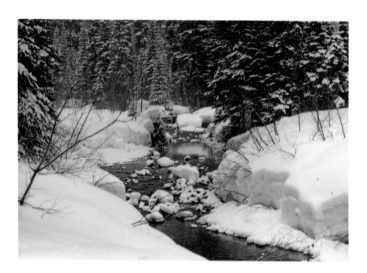

This photograph is one of those mysterious subjects that shows up once in a while. It is located at a very high elevation, deep inside mountain country. When a subject like this avails itself in a very gloomy, overcast weather condition, a lot of questions come to mind. What is it about it that moves me? The enormity of the snow country, the quiet hush, the subtlety of a little creek as it tries to compete with the massiveness of the mountain, the size of the trees, and the deep snow. This kind of emotional response to the subject usually means a potentially exciting painting. As with many photographs, this is one where the composition is not quite right for a painting. I intend to zoom in a little closer and establish the shapes with a lot more vigor. This means adding a little more color, as well as increasing the volume of white. My immediate response to a subject like this is usually enthusiastic; the complexity of the problems sets in later. My advice to you when painting subjects similar to this is to simplify the graphic delivery. By simplifying the subject, you ensure that your initial excitement prevails through the whole painting experience.

PALETTE

BURNT SIENNA PERMANENT ROSE FRENCH ULTRAMARINE

ANTWERP BLUE SEPIA

I want my grays to be lively mixed colors with unique personality. To achieve this, I intend to use burnt sienna, French ultramarine, permanent rose, and Antwerp blue in varied dominances. I use sepia only as a dark accenting influence dominated by Antwerp blue or burnt sienna.

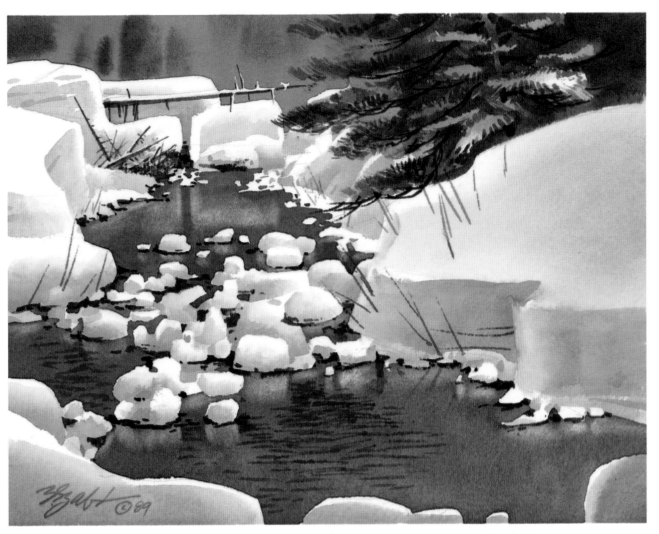

SUGAR FLOATS. 8 × 10½" (20.3 × 26.7 CM), 400-LB. D'ARCHES COLD-PRESSED PAPER.

PAINTING

I start on dry paper imagining a colorful shaded slope in the background. Permanent rose, Antwerp blue, French ultramarine, and burnt sienna in varied combination mingle to hint of this distant shape. This is established as a wet-on-dry wash with a ¾" flat brush. My color stops at the top of where the snow drifts, as well as where the lone snow-covered fallen tree will be. While this wash is still wet, I paint in the big evergreen on the right side with a bold silhouettelike greenish tone using Antwerp blue and burnt sienna as the base of my color. I add the darker details with French ultramarine and sepia. I glaze in some shaded gray tones representing the deep, heavy mounds of snow with a cool gray color. French ultramarine, burnt sienna, and permanent rose are my hues in varied domination. Later on, I accent this with another light glaze of Antwerp blue.

After allowing the paper to dry, I elevate the back of my painting surface, forcing the paper to tilt toward me. I paint in the medium-dark, warm color of the water with a combination of burnt sienna, French ultramarine, and a touch of permanent rose. I leave out negative shapes for the snow-covered pebbles as well as for the edge of the creek bed. Gravity assists me by keeping the beading water at the bottom as I slowly extend the intricate shape downward. To avoid possible backruns, I do not touch this wash until it is completely dry. After the water dries, I select a small No. 5 bristle brush and lift out the reflections of the snowy rocks and snowbanks.

I add the darkest accents under the snow piles: the fallen tree, the clutter at the back, and the big long pine log hanging over the white snowdrifts. I similarly darken the shimmer in the water and the young twigs coming up through the snow in the foreground, using a combination of sepia, burnt sienna, and a little permanent rose to finish the painting.

CAST SHADOWS ON SNOW

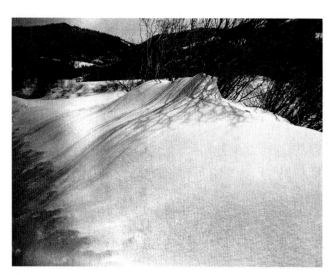

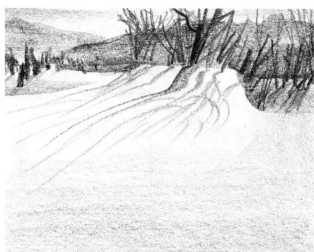

I am painting from an old black-and-white Polaroid photograph of a very dramatic, simple subject with a deciduous forest in the background. Huge snowdrifts and a few shrubs cast very intricate shadows on the rolling surface of the snow. The subject is dramatically backlit. My intention is to lift out the sunlight and leave the shadows intact. I use a technique that I call recovered luminosity. For this, I need to apply colors that can be lifted out almost completely. The removable color quality is absolutely essential in this technique even if the colors are used in rich consistency.

To clarify my composition, I do a pencil value study. I rearrange the background values that are too dark in the photograph. I intend to vary the values of my shadows to show more detail.

PALETTE

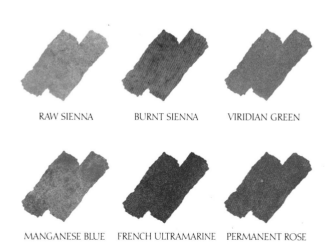

RAW SIENNA BURNT SIENNA VIRIDIAN GREEN

MANGANESE BLUE FRENCH ULTRAMARINE PERMANENT ROSE

These colors give me a very rich, wintry combination of hues. I plan to use viridian green in the sky for a more dramatic color effect. I will also echo it in the foreground shadows on the snow. Manganese blue is the key to the success of the shadows. This is a color that can come off without a trace after it dries. I simply need to wet the surface with a brush, loosen the pigment, and blot it off. For this technique, the paper and the paint on it must be dry. Manganese blue by itself is a little too raw. I plan to add other colors in minute quantities. French ultramarine, viridian green, and a little burnt sienna will probably suffice. For the trees, I plan to use some burnt sienna, French ultramarine, and a little permanent rose to give them a more dramatic color effect than there is in the photograph.

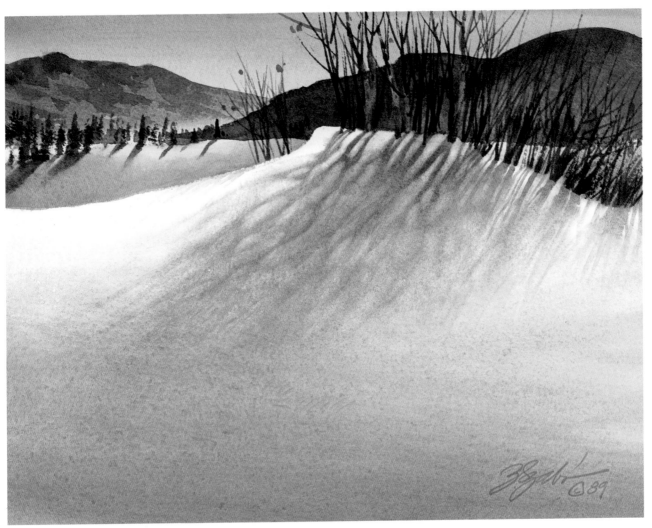

BLUE SPARKLE. 8 × 10½" (20.3 × 26.7 CM), 300-LB. D'ARCHES COLD-PRESSED PAPER.

PAINTING

I start on dry paper with the background shapes established in layered washes. First the sky, then the distant mountains, and then the closer mountains with little hints of snow in the valley between. For the sky, I use viridian green, French ultramarine, and a touch of burnt sienna. For the mountains, I combine French ultramarine, burnt sienna, a touch of permanent rose, and an even lesser amount of manganese blue. The middle-ground, snow-covered white hill with a number of backlit evergreen trees provides an opportunity to cast some shadows on the snow. The trees are painted with viridian green, burnt sienna, and French ultramarine. Manganese blue, French ultramarine, and some raw sienna make up the mix for the snow. The color of the snow needs to relate to

the color of the sky each time I apply shadows. Raw sienna and burnt sienna provide the common denominator.

The next step is done on wet paper. I paint in a very bold combination of manganese blue with a little viridian green, raw sienna, and French ultramarine all over the area of the foreground snowdrift that I intend to occupy with cast shadows. Manganese blue prevents the other colors from staining and makes it possible to lift them out later. While this color is drying, I paint in the shrubs and young trees in the back, where the lighter birch trees are. I need to lift out the dark colors from the background first so I can get the light, warm, reddish colors nice and clean. I use permanent rose, burnt sienna, raw sienna, and a touch of French ultramarine. For the

dark shrubs, I work with a rich load of burnt sienna and French ultramarine using a small rigger brush. I paint them from the bottom up so that the brushstrokes taper away from the trunk to indicate light branches.

With a well-lubricated, small No. 4 firm oil brush, I lift out negative white or very light shapes between the shadows. The shadows are left intact on the paper. It is much faster and easier to handle small units on a small area than on a large one. The wet brushstrokes need much less scrubbing and the whites end up cleaner and more sparkling. I leave the edges of the cast shadows sharp where the trees touch the snow and make them blurry as they stretch farther from that point. A few scattered reddish leaves on the fine twigs finish the painting.

OVERCAST SKY REFLECTED IN SNOW

I chose the subject in my photograph because it has a very high dramatic angle. The shapes protrude against the sky. The round, soft abstraction of the snow in the foreground is contrasting against the bold, sharp, jagged, and somewhat calligraphic shapes in the back. It is unusual that a photograph captures the sun momentarily breaking through the clouds in overcast weather. The color of the snow has a greenish gray quality, reflected from the overcast sky.

I draw a pencil sketch with shapes somewhat more simplified than they appear in the photograph. I emphasize a higher horizon and give the foreground a more lush appearance. The deep snow gives me the opportunity to bring attention to the top of the snowy hill next to the snow-covered branches and building. The most important change in the composition is that I leave out the mechanical structures on the left side and replace them with a shrub.

PALETTE

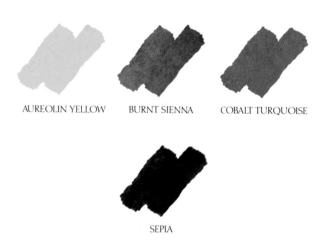

AUREOLIN YELLOW BURNT SIENNA COBALT TURQUOISE

SEPIA

Cobalt turquoise and sepia are the most important ingredients in my snow shadows. Burnt sienna affects them here and there by warming up the color. I also use burnt sienna in the sky to keep the sky color and the color of the snow shadows related. Because cobalt turquoise and sepia are extremely opaque in heavy consistency, I intend to dilute these colors severely and use only a light tint of their combination. Their color is important to me, but I also need to keep them luminous and glowing. The only way I can do that is to dilute them.

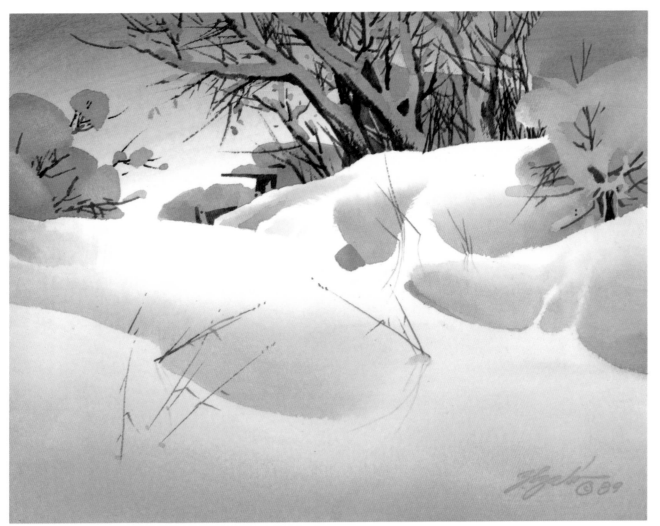

SOFT MOOD. 8 × 10½″ (20.3 × 26.7 CM), 300-LB. D'ARCHES COLD-PRESSED PAPER.

PAINTING

I start the painting on dry paper using a 2″-wide bristle brush richly loaded with cobalt turquoise and burnt sienna at its far tip and only water at its base. The half-loaded brush blends its own edge. This method establishes a sky darker at the top and lighter near the center of the painting. Holding the brush upside down, I paint heavy drifts of ground snow with the darker color on the bottom tip of the brush. I also paint in the heavy clumps of snow on the trees and houses behind the strongly lit white snow mounds. After these colors are dry, I paint another

glaze on top of the bottom one-third of the painting with the same brush technique but with lighter color. Moving the brush steadily up toward the light, I blend it off into the white paper. This wash reduces the contrast in the foreground and exaggerates it near the top edge of the hill benefiting my center of interest. Similarly, I tone down the two sides as well.

With a simple combination of sepia and burnt sienna, I paint the calligraphic branch structure, the trees, and the gently exposed part of the house in the back. I use a small rigger

brush for this, as well as for the snow-covered shrubs. I also paint a few scattered weeds in the foreground to lead toward the distance where the lightest light and the darkest dark are next to each other. I add cast shadows to the weeds where they are exposed to sunlight in the white area of the foreground. I use the same color combination as I used before—cobalt turquoise and burnt sienna. As a finishing touch, I place a few scattered bright leaves of aureolin yellow and burnt sienna on a dry old tree at the top of the hill.

DRAMATIC SUNLIGHT ON SNOW

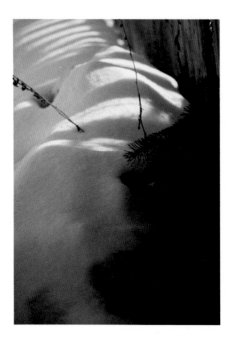

I start with a small photograph of a very dramatic late afternoon winter scene. A wooden fence is placed almost vertically, and the sun is hitting the snow between the fence blades from the right side. I need to establish a composition based on the natural behavior of some colors that can be lifted out after they dry. I widen the composition into a horizontal format because I want to take advantage of the beauty of this rich shadow pattern over the strong foreground. On the sunlit snow, there are a few dry weeds. I intend to paint them even more luminous than they are in the photograph. They could become my center of interest; however the little tree and the shaded fence provide the drama I am after. I do not use a pencil study for this work because its success is dependent on the lifted-out, rhythmical colors. Most of the painting needs to be simplified. D'Arches paper has a lot of sizing in it. This should make it easier for me to lift out the colors even though I intend to select hues that lift well on any paper.

PALETTE

MANGANESE BLUE COBALT VIOLET FRENCH ULTRAMARINE

BURNT SIENNA ANTWERP BLUE SEPIA

Manganese blue and cobalt violet are capable of coming off the paper completely after they dry by simply scrubbing the pigment with a wet brush and blotting off the loosened paint. If I want any warm residue to be left, I can add a touch of burnt sienna. To add value, I use French ultramarine. To mix a gray, I use French ultramarine and burnt sienna. Antwerp blue is a non-granulating, transparent non-sedimentary color. Its nature is opposite to cobalt violet and manganese blue, which are sedimentary and non-staining pigments. Antwerp blue is a weak color, but it is capable of going dark. I use it in combination with other hues. Sepia will add dark value to the shaded young evergreen.

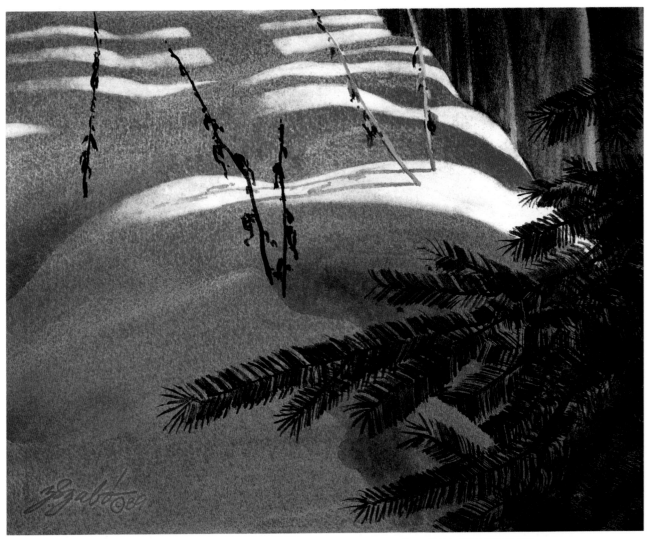

LIGHT WAVES. 8½ × 10½″ (21.6 × 26.7 CM), 300-LB. D'ARCHES COLD-PRESSED PAPER.

PAINTING

I wet the paper thoroughly. This 300-lb. paper holds the moisture for quite a long time. I mix a rich combination of manganese blue, cobalt violet, a little Antwerp blue, French ultramarine, and a touch of burnt sienna and paint rapid brushstrokes with a 2″ soft, flat brush where the snow is shaded. The granulating sedimentary qualities of manganese blue and cobalt violet become very evident right away and show off their ability to sparkle. This is further helped by the small scale of my painting surface, which exaggerates the scale of the appearing images.

When this color is almost dry, I paint in reddish brown fence boards with a French ultramarine and burnt sienna combination, with burnt sienna

dominating the wash. After everything is dry, with a small firm-bristle brush, I wet, scrub, and blot off the shapes of the sunlit snow patches. The color comes off quite well because of the overwhelming dominance of cobalt violet and manganese blue allowing me to recover pure white paper. I keep the edges sharp near the fence and soften them as the shadow moves farther away. When an image is close to the surface where its shadow is cast, the edge of the shadow is sharp. Where the portion of the image is far from the surface, the edges are blurrier. Once the light patches and the shadows are established, I lift out the narrow edges of the fence boards that also receive warm light from the setting sun.

Burnt sienna stains the paper and after scrubbing, it shows through in a lighter value.

I suggest sunlight on them with a little burnt sienna. I paint a couple of weeds in the shadow in the nearby foreground with sepia and burnt sienna. They cross right over the pattern of sunlight and shadows in a very dark color. Sun does not reach these weeds. I paint the branches of a nearby evergreen tree in the shade with a very dry, flat, firm-bristle brush loaded with sepia and Antwerp blue. This color is so dark that the texture is obvious and easy to read. It is intended to set off the brilliant light in the back. After this, I add my signature and the painting is complete.

FALLING SNOW

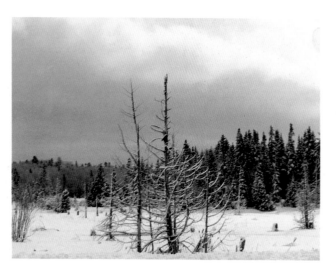

My subject is falling snow. I start from a photograph that depicts a time when the snow is about to fall. The sky is darker than the snow, and the evergreen trees are exposed, as well as the dry, stripped branches of the foreground trees. Since I am changing the condition to when the snow actually starts to fall, I must consider the falling snow as a filter. It drastically filters out the values in the background. I plan to make my forest much paler than it is in the photograph. Much of the success of this painting depends on how speedily I can achieve the results, and how carefully I can time the application of water and paint, so I plan to soften and simplify the subject considerably. My memory of the conditions shortly after I took the photograph helps me to recall the fresh and silent mood.

I start with a pencil sketch. I only need to do a value study because my photograph provides enough detail. I think of the sky as the darkest value mass. The clouds are dark and foreboding. The snow-covered trees in the back are filtered with the falling snow, and the foreground is white from the freshly landed snow.

PALETTE

AUREOLIN YELLOW

BURNT SIENNA

ANTWERP BLUE

FRENCH ULTRAMARINE

The grays are important to depict the filtering nature of falling snow. I try to vary and excite the grays as much as I can using French ultramarine, burnt sienna, and a little Antwerp blue together. Aureolin yellow is used only for accenting the foreground shapes.

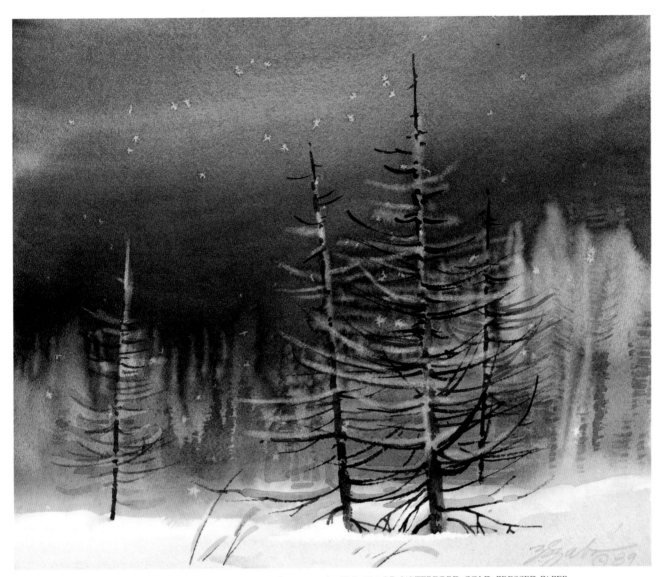

DESCENDING STARS. 9 × 10½″ (22.9 × 26.7 CM), 300-LB. WATERFORD COLD-PRESSED PAPER.

97

PAINTING

I begin by thoroughly wetting the paper. The nature of Waterford paper is different from other papers in that it has a lot of sizing in it. I know I will have to apply colors fast and evenly. I paint the sky first with burnt sienna and French ultramarine in very rich consistency using a 2″-wide firm-bristle brush. Immediately after, using the same brush, I add a little bit of Antwerp blue and a lot more water into my brush and paint the distant forest. Just as the color loses its shine, I quickly add watermarks with my rigger brush indicating the individualized frosty branches of the foreground trees. These little backruns show defi-

nite shapes with soft edges. Immediately after, I sprinkle a few crystals of salt into the drying paint to absorb the color, resulting in spots that look like snowflakes. The timing of these few precious seconds is quite easy on the small paper.

After these colors are quite dry, I apply calligraphic images of the scrawny foreground trees, using burnt sienna, aureolin yellow, and Antwerp blue. Next, I paint in the edges of the little drifts under the trees and give a layered effect to the snow in the foreground. In the middle ground where the frosted trees are indicated with just a soft wash, I paint a hint of texture

with my 2″-wide bristle brush loaded with very light color dominated by Antwerp blue.

With a small No. 5 bristle brush, I scrub out some of the snow-covered branches on the foreground trees because they need to be more definite. I do this in addition to the backrun caused by the initial clear water brushstrokes. Using my small rigger brush, I also add a few lower calligraphic branches tucked into the snow, as well as some weeds sticking out of the deep snow. The background is dry and the salt has now done its job. I brush off the dry salt particles and the white, snowflakelike shapes are exposed.

SNOW

DRIFTING SNOW

The photograph I work from is faint because of the filtration of the active snow. It is only a reminder to trigger my memory of the scene where the soft blowing snow filters out dark shapes and makes them appear like there is movement in front of them. The activity in the sky is not visible. The composition is not right as it is. It is somewhat divided. I intend to move in a little closer and make the buildings better defined and the shapes a little more active. The stronger the shapes are, the more chance I have to indicate the blowing snow and its activity. This is what the painting is all about. The behavior of the paint needs to be timed and controlled on wet paper to depict the feeling of unpredictable movement. I don't bother doing a pencil sketch, but dive into the painting itself right away.

PALETTE

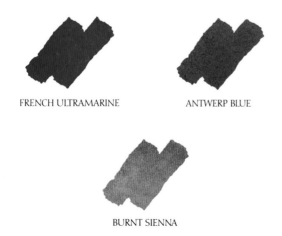

FRENCH ULTRAMARINE ANTWERP BLUE

BURNT SIENNA

I use a very simple palette of only three colors. With this small palette, I can get a good variety of grays. Burnt sienna has a warm influence and has enough yellow in it to give me a greenish touch when mixed with Antwerp blue. With French ultramarine, burnt sienna mixes a good gray. I can cool it or warm it depending on which color is dominating the combination. While the individual colors may be subdued, they are designed to give the grays variety.

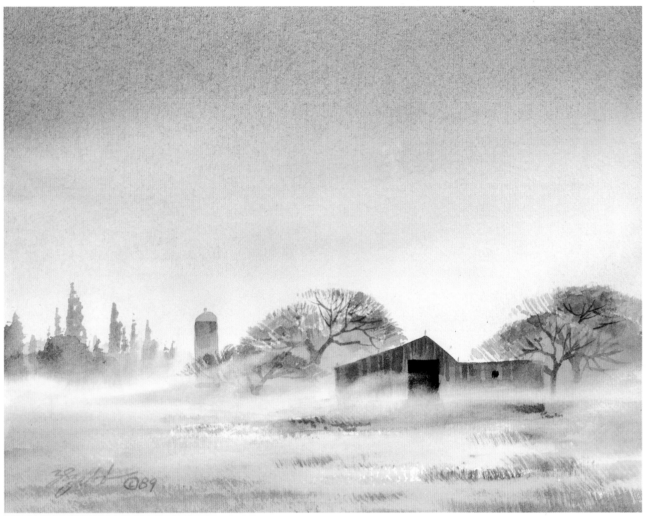

CHILLED DAY. 8 × 10½″ (20.3 × 26.7 CM), 300-LB. D'ARCHES COLD-PRESSED PAPER.

PAINTING

I wet the paper and with a soft 2″-wide brush, I apply French ultramarine and burnt sienna near the top of the paper and allow it to blend downward. I tilt my wet board somewhat toward me to make sure that the color does not run back into itself. I also introduce a touch of Antwerp blue near the bottom of the sky to hint of a thin layer of clouds with some blue sky behind it. I let this color dry completely.

When the paper is dry, I paint the middle-ground images. The gray color is rich from a variation of brownish, bluish, and greenish hues. I need to deal with some static forms with straight edges: the building and the distant silo. The trees and the wind-blown snow are curvilinear shapes.

Some of the distant tall trees are also on the static side. The tone of the ground is darker than the blowing snow. By contrast, the snow looks lighter when it is blowing than when it is sitting on the ground. I paint the building, the silo, and the trees with a mix of burnt sienna and Antwerp blue, making the shapes solid first on dry paper. I leave them sharp and dark at the top edges where they are contrasting against the sky, but blend the bottom edges until they disappear. I do this to all the shapes involved with drifting snow. Much of the blowing snow is established with blended shapes. My small paper is easy to observe, and the result is a convincing illusion of moving snow.

I add some drybrush clutter of grasslike impressions to the foreground and a little touch of burnt sienna by itself over the main part of the building. I also apply a real dark combination of burnt sienna and French ultramarine to the dark door and the window of the building. After everything has dried, I scrub out a little more activity and movement in the blowing snow. I use a small No. 4 firm brush saturated with water. I scrub hard to lift out as much of the background as I can and expose little tails of blowing snow such as the one in front of the dark door. This is the most important section, which shows high contrast and lots of rhythmical activity. The painting is now complete.

SNOW-COVERED FOREST
INTERIOR

I start with a black-and-white Polaroid photograph. It gives me an excellent impression of a scene just as I experienced it on a very bright day when the heavy shadows of the trees contrasted with the bright snow. I intend to carry this high contrast into the painting. The clutter in the photograph is not quite right. I intend to make changes by simplifying the clutter and shadows, and making sure that the

composition reflects the way I feel about the experience.

In my pencil sketch, I make the medium-value shadows lighter than they are in the photograph. This gives me a better range between the light, dark, and medium tones to add a few variations from location to location. My sketch is very rough, but it gives me a good indication of where to begin.

PALETTE

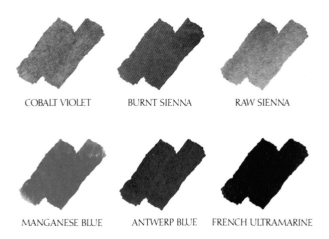

COBALT VIOLET BURNT SIENNA RAW SIENNA

MANGANESE BLUE ANTWERP BLUE FRENCH ULTRAMARINE

The nature of cobalt violet and manganese blue is similar even though their colors are vastly different. Both colors are capable of coming off the surface of the paper after they are dried by simply scrubbing them with a moist brush and blotting off the loose pigment. This way I can recover pure white paper. Even if I add French ultramarine and a little burnt sienna to these colors, I can still lift the hue as long as cobalt violet or manganese blue totally dominates. I intend to paint the shaded space in a way that allows hinted forms to show independent identities. My palette is divided into two categories: warm and cool colors. Some of the colors are not staining while a few of them are lightly staining.

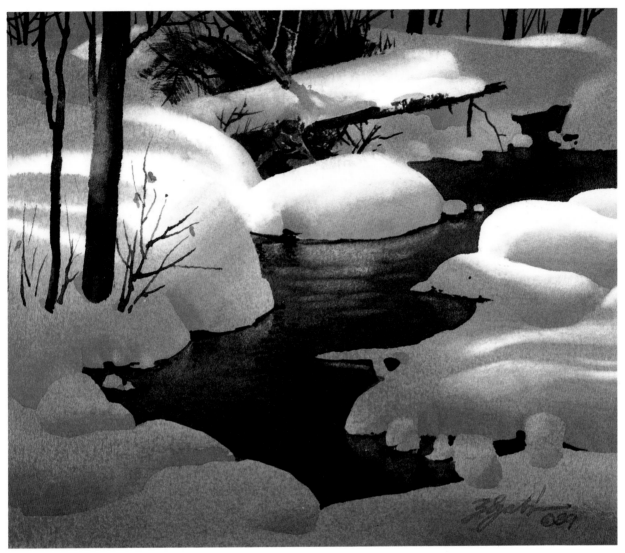

BATHING SUN. 8½ × 10″ (21.6 × 25.4 CM), 300-LB. D'ARCHES COLD-PRESSED PAPER.

PAINTING

I dampen the paper surface, and then load a 2″ flat brush with a little water and lots of paint—an equal amount of manganese blue and cobalt violet—for my medium-value washes. I add French ultramarine and some burnt sienna to the shadows in the foreground and suggest some details with a thickly applied darker value of the same colors. After this step, I allow the paper to dry.

Next, I paint in the dark trees with a color mixed from burnt sienna, French ultramarine, and some Antwerp blue. To indicate a patch of sunlight on the largest tree's trunk, I use only burnt sienna blended into the

shaded dark color. I follow with the distant cluster of branches next to the snow-covered fallen log using a small round brush. I use a palette knife to squeeze out a few light branches. The snow on the log is left out as a negative shape. I carefully paint one branch protruding through the snow with its shadow on the horizontal log.

Next, I raise the top of the board that supports my paper. I begin my wash for the creek at top right with a rich, wet mix of burnt sienna, French ultramarine, and Antwerp blue, extending the color to the bottom edge.

From the dry surface, using a wet

No. 4 oil painting brush, I lift out the reflections of the snow shapes next to the water's surface. I also paint in the small, dark ripples on the water, as well as the dark edges of the rocks and clutter under the snow puffs. With a rigger brush, I paint in the small shrubs and spot a few scattered leaves on them with pure burnt sienna. To finish, I lift out touches of white light on the snow from the shadows. The sparkle of the shaded snow appears fresh and inviting because the large grain of the sedimentary manganese blue pigment is exaggerated in proportion to the small painting.

Deep Drifts and Shadows

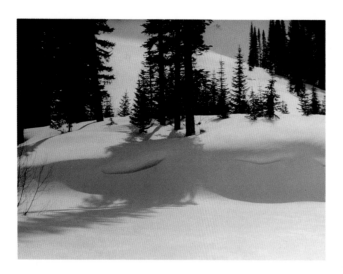

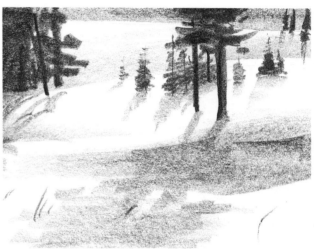

I start with a photograph of a subject at an elevation of about 12,000 feet. Large fir trees are standing in hugh drifts occupying several planes. They cast beautiful shadows. The snow is immaculately clean although somewhat greenish-looking. The brilliant warm light of the sun demands not only high contrast, but color unity dominated by warm colors. I love this condition because the warm light makes the cold snow appear warmer and psychologically more pleasant to look at. The way the subject presents itself is only a trigger to a creative mind. It is the way you interpret it that makes the painting exciting. I love snow because its purity is

already evoked by my crisp white paper. The challenge lies in the way I shape it. The drama in this subject is the sunlit condition; the shadows carry the design. I need to make changes to reduce the symmetrical formality of the subject.

To clarify my plans, I decide to do a value study with my favorite 6B graphite stick. I open up the snowy plains somewhat and move the center of interest farther to the right. I change the angle of the shadows to lead the eye into the composition. While my pencil rough is not the last word, nevertheless it confirms visually that giving the snow more emphasis is the right direction for my painting.

PALETTE

RAW SIENNA PERMANENT ROSE VIRIDIAN GREEN

ANTWERP BLUE SEPIA

Raw sienna, viridian green, and permanent rose combine into a beautiful gray that may be dominated by any of the three colors. These pigments are not strong stainers and are easy to lift. Antwerp blue helps me get good luminous darks. Raw sienna and permanent rose together look and behave like burnt sienna, but the hue is a little cleaner. I use sepia only in the most dramatic dark colors. I plan to keep it out of my shadow hues because it is an opaque color that could go muddy on me. I prefer to mix the shadows out of the first three pigments.

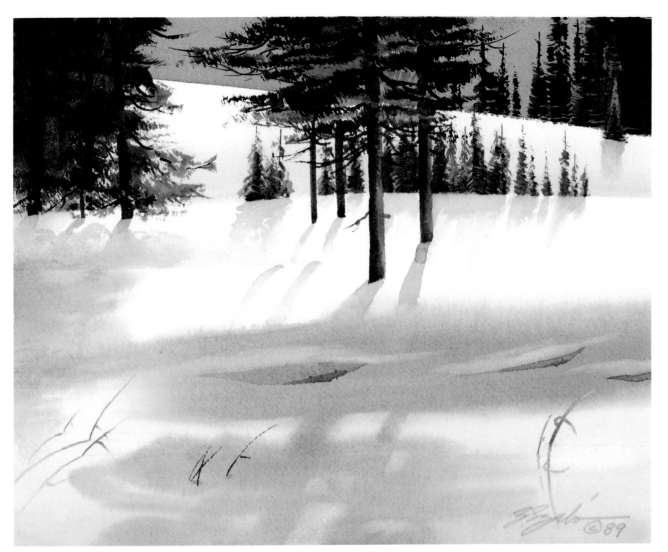

SHADOW DANCE. 8 × 10″ (20.3 × 25.4 CM), 300-LB. D'ARCHES COLD-PRESSED PAPER.

PAINTING

I begin on dry paper and paint in the most distant shaded plain at the top of the painting with a neutral combination of raw sienna, permanent rose, and viridian green. To create the illusion of the middle-ground snowfield curving toward me, I use the same color and paint the bottom edge of the snowfield with a single broad horizontal brushstroke. I blend the top edge of the wet paint with a barely damp, clean brush. To keep the foreground shadows' edges soft, I wet this portion of my paper. Then, I shade the bottom a little and blend the color the same way as in the middle ground. While this wash is still shiny wet, I paint the large drift and the trees' cast shadow, letting the edges dry soft and blurry.

With a rich load of viridian green, Antwerp blue, and sepia, I paint in the most distant trees against the gray shape at the right corner. I use a 2″ thin, flat-bristle brush held upright. My brushstrokes consist of short horizontal touches of drybrush. I work similarly on the next plane, but with different colors. I start with raw sienna to indicate the sunlit outer rim of the branches. I paint in the dark foliage with sepia and Antwerp blue. I carefully leave the rim exposed to look like backlit foliage.

Now I am ready to paint my center of interest, the large tree, and the dark trees at the top left corner. I follow a similar procedure as above. Because these shapes are larger, I pay more at-

tention to their details. The function of the trees in the corner is to block the corner and prevent the viewers' eyes from leaving the composition. My color is mixed from viridian green, permanent rose, and Antwerp blue. This luminous gray is detailed with sepia and Antwerp blue as I paint in a few tree trunks and branches.

Next, I connect the sharper portions of the cast shadows to the softer parts. The ability to see the whole small surface makes this easy and improves the overall unity of the composition. I use the same colors as on the earlier shadows. Last, I paint a few weeds in the foreground with their sharp cast shadows and the painting is complete.

RISING SUN AND SNOW

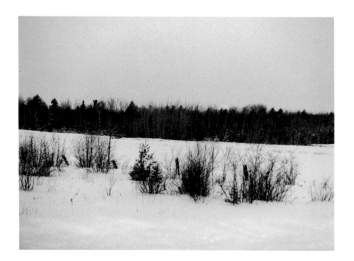

I start with a photograph of a deep winter sunrise. The whole subject swims in a glow of pinks, blues, and soft mauves. The pink disk of the sun is peeking through the morning haze. The composition is divided by the undis-turbed straight edge of the distant forest. I intend to make the trees look more exciting and varied in my painting. I do not need to do a preliminary sketch. The success of this work depends on color, timing, and application.

PALETTE

| AUREOLIN YELLOW | BURNT SIENNA | PERMANENT ROSE |

| FRENCH ULTRAMARINE | CERULEAN BLUE | WINSOR GREEN |

Permanent rose will provide the color of the dominating sunrise. Aureolin yellow, French ultramarine, and cerulean blue combined with permanent rose will give me rich pinks, blues, and mauves for the sky. I use burnt sienna and Winsor green for the vegetation with cerulean blue added when I want cool, dark tones.

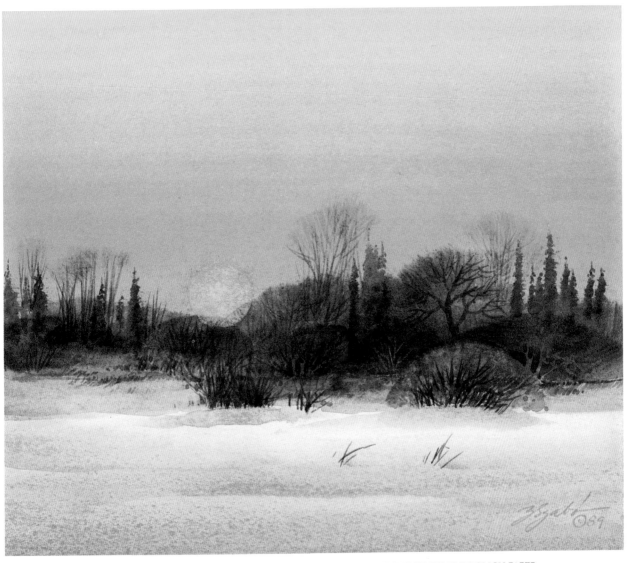

MORNING HUES. 8½ × 10″ (21.6 × 25.4 CM), 300-LB. STRATHMORE GEMINI ROUGH PAPER.

PAINTING

I begin by wetting the paper. I load my 1½″-wide soft-haired brush with permanent rose and some aureolin yellow, and starting at the horizon, I apply my color with rapid horizontal brushstrokes. I do not lift my brush, but spread the color toward the top until I run out of paint. Next, I load my brush with the same colors, but now the yellow is dominant. This time I spread the colors from the top down. While the paper is still wet, I add a little cerulean blue to the mix and paint a light coat of this pinkish hue on the lower part of the painting as well. To add mist to the horizon, I glaze a rich wash of cerulean blue and French ultra-marine on top of the sky color and blend it upward.

After all these colors are dry, I draw a circle around a quarter on contact paper and cut out the shape. I place the stencil where I want the sun to be located and gently scrub off the exposed disk shape. For the scrubbing, I use a very wet No. 4 oil painting brush. I lift off the stencil and quickly tint the white shape with a mix of permanent rose and aureolin yellow.

After this, I paint the lacy shrubs and trees with a 1½″ flat-bristle brush. I blend these gentle forms as I go. I use a varied combination of burnt sienna, cerulean blue, and Winsor green mixed warmer for the closer foliage and cooler for the more distant objects. The top edge of the distant tall trees is painted with a soft gray. The tall evergreens supply the composition with vertical static complements and bluish accents.

I follow with the middle-ground details. I paint in the calligraphic branches of the trees and shrubs; I paint in some of the branches and leave others as negative spaces. I also accent the foreground with a few lone weeds. I finish shading the foreground snow using a darker value of cerulean blue, French ultramarine, and permanent rose.

ASSIGNMENTS

Find and recover the middle-tone snow shadows. You may darken some of the white area, lighten some of the dark shapes, or both.

Improve this composition by changing the shape and position of the creek.

Paint this sunny snow scene using viridian green and cobalt blue in the sky and snow shadows.

Improve the feeling of three dimensions by shading the snow everywhere except for a few strongly contrasting white patches. You may leave out the sunlit spots as negative shapes or lift them off from a dark background.

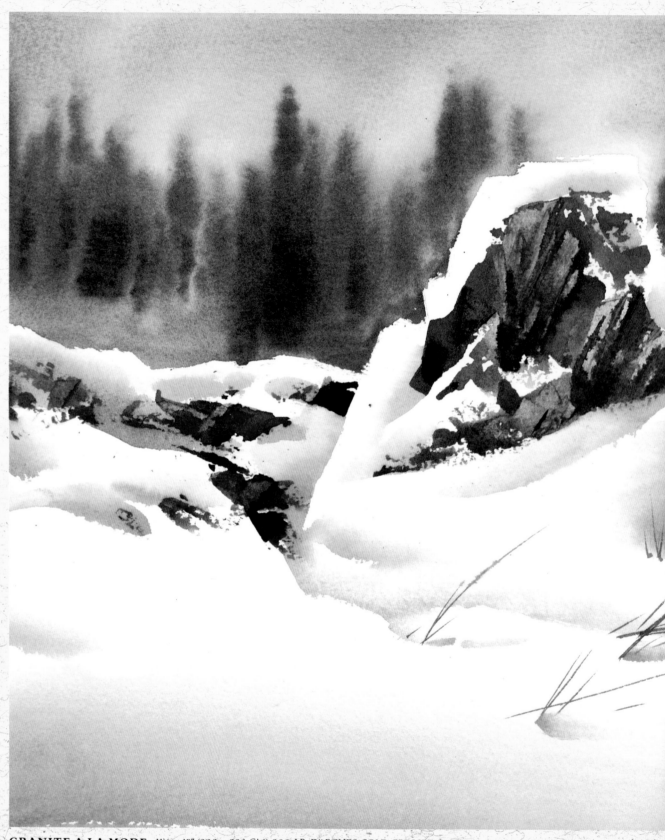

GRANITE A LA MODE. 11½ × 15" (29.2 × 38.1 CM), 300-LB. D'ARCHES COLD-PRESSED PAPER.

ROCKS

Rocks are probably the oldest features in our landscapes. Their composition varies as much as the environment that surrounds them. As an artist you do not need a degree in geology to paint them well, but knowing the physical characteristics of rocks may help you to interpret them correctly.

Glacial rocks are characteristically rounded on the surface and their type and composition vary infinitely. These rocks are usually rounded and weatherbeaten by the eroding power of rain, wind, and snow. The texture becomes more pitted, and patches of growing algae, moss, and other living matter add color and variety to it. I usually paint the shapes of glacial rocks by first using a wash to define the light and dark values, then I add some drybrush modeling and some texturing with a palette knife to remove the lighter top side of the rock. I use spatter or a sponge to add the texture of growing algae or moss.

Angular rocks, like blasted rocks at a roadside or in quarries, usually consist of granite, quartz, and coal. The sharp straight edge of the palette knife naturally lends itself to modeling angular shapes; I use extreme pressure on the knife to lift out the sharp, light sides of the stone.

Sandstone rocks like those in desert areas are relatively soft and the wind and sand blast them into rounded shapes. Sandstones appear in almost any color. The Painted Desert region of Arizona is an excellent example of colorful sandstones. Consider the color of rocks as an element that affects color unity in a painting. Strong color influences from the sky, bright vegetation, and so on, in turn reflect in the rocks' color. Colorful buttes can be painted with horizontal strokes to indicate their sedimentary layers.

Rocks usually look darker under water than they do when dry. When part of a stone protrudes from the water, its dry section above the water is light while the submerged portion is much darker.

Scale can make rock shapes look like pebbles, medium-sized boulders, or cliffs. Locate them correctly in the foreground, middle ground, or background next to objects that indicate their scale. Rocks are repetitive objects. Vary their sizes and shapes, allowing them to create exciting rhythms.

HIGH DESERT BUTTES

In my photograph, I have a very humble desert terrain. The sun is brightly lighting up the distant rock formations. I am facing a powerful contrast that defies the normal law of atmospheric perspective, which says that warm colors advance and cool colors recede. Desert rocks are often bleached by the sun and do not show much detail when sunlit. The rocks in this case are shaded in the foreground. I have a good opportunity to play up the shadow details. I also intend to take full advantage of the strength of my large

foreground and to add vertical elements contrasting against the light background.

To test my theories before I start painting, I try them out in a value sketch. With a 6B graphite stick, I change the values of the background shapes. The buttes look better if they are lighter than the sky. I establish the large dark tree in the middle ground. My idea is confirmed visually; the vertical shape improves the composition's balance, and enriches the desert feeling.

PALETTE

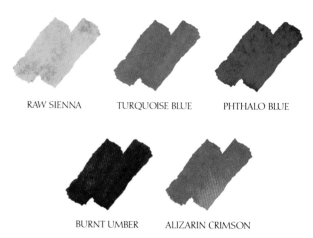

RAW SIENNA TURQUOISE BLUE PHTHALO BLUE

BURNT UMBER ALIZARIN CRIMSON

There are many quality transparent watercolor pigments on the market. For this next painting, I am using an excellent American-made watercolor brand called Permalba. All of these colors are nontoxic. They mix well not only with each other, but with other brands as well. The nature of these colors differs somewhat from other brands such as Winsor & Newton. The raw sienna is a little warmer, but it is a delightfully luminous color. Turquoise blue is definitely an opaque pigment. I plan to use it well diluted to calm the ferocious power of phthalo blue. Burnt umber in this case is more transparent than most other brands. I want to use it with alizarin crimson for warm effects in the shadows.

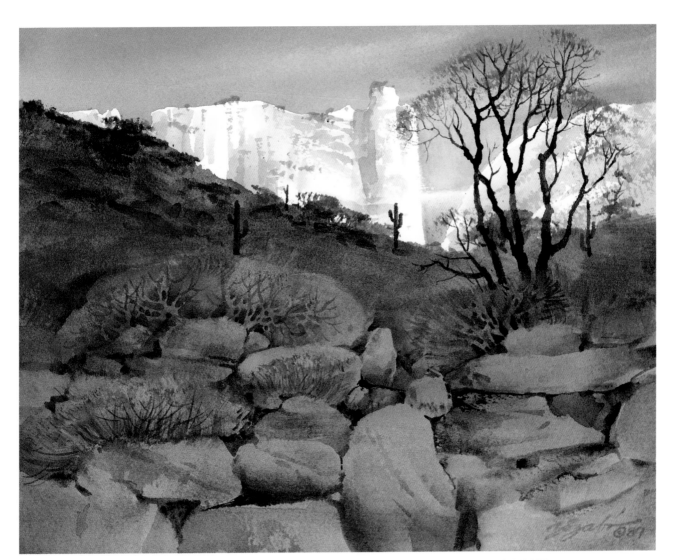

DESERT GEMS. 8½ × 10" (21.6 × 25.4 CM), 300-LB. WATERFORD COLD-PRESSED PAPER.

PAINTING

I start on dry paper using a flat, soft 1½"-wide brush. First, I paint the shape of the sky with a rich wash of a turquoise blue and phthalo blue combination. I carefully go around the space I reserved for the butte and distant hill. I add a little raw sienna to make the sky relate better to the color of the sunlit rocks. Next, I paint the details on the sunlit butte and the distant hill. I use a soft brush with raw sienna and alizarin crimson for the rock's color. Then I indicate a few scattered trees with turquoise blue. I keep the values of all these colors light to make them feel distant.

I use a 1½" firm-bristle brush to add the basic color of the large shaded

section because it lets me apply dark color fast. My wash is dominated by phthalo blue and influenced by raw sienna, burnt umber, and alizarin crimson. As this large shape spreads, I make sure that the upper edge is darker to show up well against the light, sunny color. The dark, staining phthalo blue has a tendency to soak into the paper and lose too much value. On the small paper I keep an eye on it and make certain that my color is strong enough to compensate for this phenomenon. At the same time, I break up the sharp edge with some dark, distant trees. I follow this bold approach with the definition of the rocks and shrubs in the foreground. I use raw sienna and

alizarin crimson for the shrubs and burnt umber for shading the rocks. Then I glaze light touches of alizarin crimson to further warm the color of the boulders.

Next, I define the forms of the shrubs with negative and positive calligraphy. My brush is a No. 5 rigger. I paint the large clump of desert trees next. I establish their crooked trunks by applying my dark but liquid color with a small palette knife. I continue with the smaller branches using the rigger brush. On top of the tree, I apply drybrush strokes with gentle tapping touches. After I place a few dark saguaro cactus in the middle ground, I consider the painting finished.

USING FOLIAGE TO COMPLEMENT ROCKS

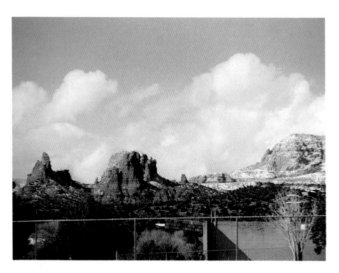

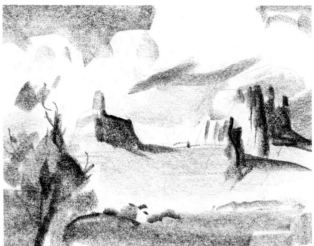

The photograph I work from depicts a scene from one of the most spectacular locations in the United States, Sedona, Arizona. The view shows off a beautifully sculptured group of red buttes. The color of the buttes varies from pale cream to deep terra-cotta red. Junipers and pinyons create a scattered pattern on them. While the photograph doesn't have an acceptable composition, it does supply me with a lot of information. My composition needs improvement and simplification.

A thumbnail sketch is my way of testing some of these changes. I try bold contrast and zoom in for larger images. Because color is such an important part of this painting, I leave the details to the paint and brush. I shade the foreground as a united shape and keep the background lighter.

PALETTE

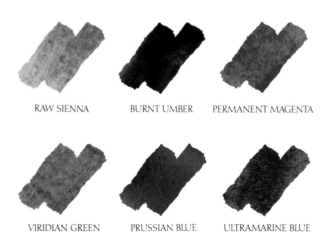

RAW SIENNA BURNT UMBER PERMANENT MAGENTA

VIRIDIAN GREEN PRUSSIAN BLUE ULTRAMARINE BLUE

I am using Permalba Artists Watercolor again, as I did in the previous painting. The sunny color of the buttes may be mixed from raw sienna, permanent magenta, and burnt umber. I plan to paint the shadows with a combination of permanent magenta, Prussian blue, and ultramarine blue. The blue portion of the sky needs to be dominated by Prussian blue but influenced by ultramarine blue. The scrawny foreground shrubs' color includes Prussian blue, viridian green, burnt umber, and raw sienna.

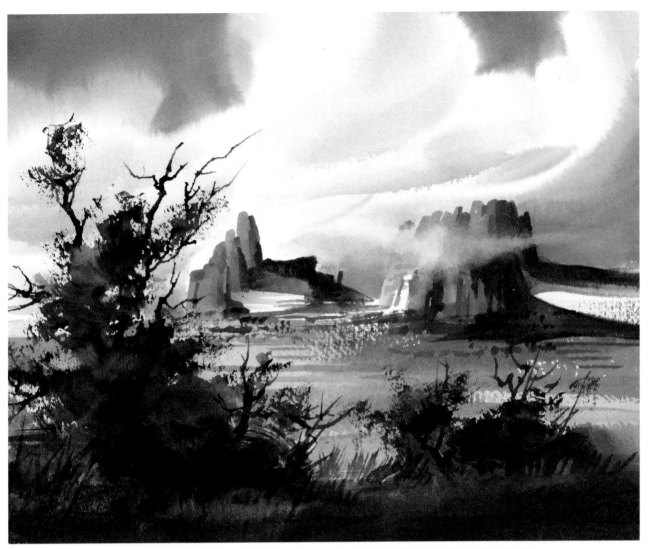

PROUD BUTTES. 8 × 10″ (20.3 × 25.4 CM), 300-LB. D'ARCHES COLD-PRESSED PAPER.

PAINTING

I dampen the top half of my paper to establish soft edges that hold their shapes. Using a 2″-wide firm-bristle brush, I apply the blue portions of the sky, reserving the shapes of the white clouds. I use Prussian blue and ultramarine blue in my mix. The application of these washes takes only seconds. Immediately after, I paint on the pale grays to shade the white clouds. The gray comes from two different combinations that I use together to add variety. One is permanent magenta and viridian green; the other is burnt umber and ultramarine blue.

By now the paper is dry, and I proceed with the warm, sunlit buttes. I begin by glazing raw sienna, permanent magenta, and a touch of burnt umber to the left side of the rock formations. I model and darken these shapes as needed. For the shaded side, I use a combination of Prussian blue, permanent magenta, and ultramarine blue. These colors are similar to the color of the sky and relate well in the shadows. Where a snowfield was left white originally, the shadow color looks bluer. I decide to paint a soft cloud in front of the right peak. To achieve this, I blend the glazed colors as they reach this area. When the butte is completed, I further soften the cloud by wetting and scrubbing its shape until it becomes uniformly soft. The red color on the buttes loses strength downward. I add horizontal drybrush strokes to the bases of the hills to indi-cate their natural sedimentary character. I decorate this area with a few rows of distant trees using Prussian blue and raw sienna.

In the foreground, I need very dark values. My colors are dominated by Prussian blue in addition to viridian green, burnt umber, and ultramarine blue. I start with the rich, drybrush foliage of a large juniper on the left side and rapidly extend the shape down to the base of the painting. The color's variation in hue dominance, as well as in value, is detectable in the finished painting. After these colors are dry, I paint in the exposed branches and twigs with a palette knife, using Prussian blue and burnt umber in a very rich consistency.

SUBMERGED ROCKS

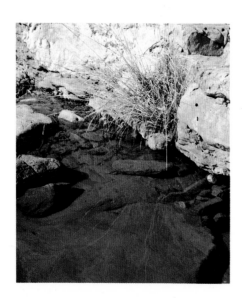

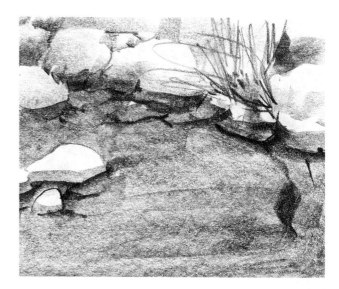

My reference photograph is a somewhat exaggerated reproduction of a humble corner of nature. Some of the rocks are submerged and some are dry. To get a good underwater definition, my camera's automatic light meter bleached out the light, dry shore colors. My memory has to make up the difference. The quiet solitude of this innocent subject is my emotional reason for selecting it. I intend to express this feeling graphically.

In my pencil study, I make a few changes. I change my compositional format from vertical to horizontal. To ensure that I don't divide the painting, I break up the large dark water area with some lighter protruding rocks. These negative shapes not only prevent potential monotony, but help the perspective as well.

PALETTE

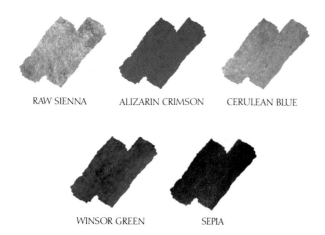

RAW SIENNA ALIZARIN CRIMSON CERULEAN BLUE

WINSOR GREEN SEPIA

Raw sienna, alizarin crimson, and cerulean blue are the primary color influences in this palette. Cerulean blue is a light, sedimentary opaque color. Its soft nature is very useful for painting dull textures such as what I need for the dry rocks. For my greens, I plan to use Winsor green mixed with cerulean blue and/or raw sienna. All of these selected colors are useful for the rocks' dry-textured surfaces. The details of the submerged stones are to be done with sepia, a rich, staining color. For the dark color of the water, I intend to use alizarin crimson, Winsor green, and raw sienna.

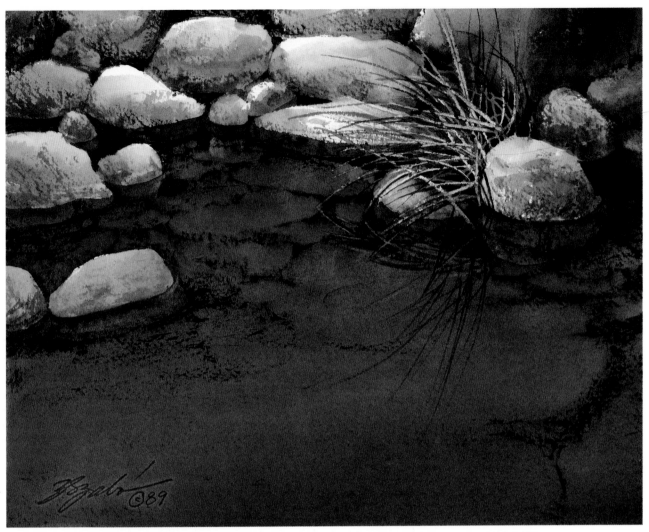

TURTLE DECOYS. 8 × 10″ (20.3 × 25.4 CM), 300-LB. D'ARCHES COLD-PRESSED PAPER.

PAINTING

On the dry surface of the paper, using a soft No. 6 round brush, I drybrush the outer edges of the submerged stones, as well as all the surface rocks, with sepia. I turn the brush on its side and scuffle the texture to avoid sharp edges. For consistency, I use a little sepia on the dry surface as well, but soften the color with a little cerulean blue and raw sienna. I glaze the base value washes onto the surface of the dry rock shapes. I blend these washes with a ¾″ soft brush, making sure that the shapes end up lighter at the top and darker at the base.

Where the clump of grass protrudes from the surface, I paint a solid wash of raw sienna, Winsor green, and

a touch of sepia and immediately pull out a few light grass blades with the tip of my palette knife. Because Winsor green is a strong stainer, the light lines look green, not white. After this area is completely dry, I add some more dark as well as light negative grass blades with a small rigger brush. My colors are Winsor green, sepia, and raw sienna. Next, I complete the texture on all the rocks with several glazes of drybrush. I vary the color combinations until the cool and warm colors are well balanced and the texture is rich.

In anticipation of painting the dark shape of the water, I elevate the top of my paper about two inches higher than the bottom. I mix a large

pool of wet color. I use a generous amount of alizarin crimson, Winsor green, and raw sienna with lots of water. Alizarin crimson is the dominant hue. I carry this wash slowly, starting at the top and carefully covering the portions of the rocks up to the water level. Because the area is relatively small, I am able to keep my wash under control with a single pass and do not smear the sepia texture. The value of this wash stays strong and its color stays even. After this wash dries, I indicate the reflections of the overhanging grass blades. I lift out the color where light grass blades reflect and paint the dark ones with a small rigger brush. This completes the painting.

TEXTURED ROCKS

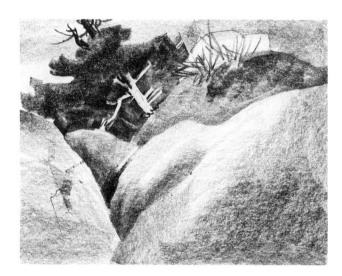

This time I work from a black-and-white Polaroid photograph. It reveals a close view of a glacier-carved cluster of round rock formations. The textured surface of the otherwise smooth boulders leads to an evergreen tree struggling to survive. The rocks' surfaces are covered with colorful lichens. Even though the rich color of these surface patches is not visible on this black-and-white picture, I remember them very well. The colorful texture was what attracted me to the scene. The composition needs some help as well.

I reach for my 6B graphite stick and draw a small value study. I switch from a vertical to a horizontal format. The rocks are indicated with shapes and blended values. The texture can wait for the brush and paint. The increased width provides better visual lead-in to the painting and a larger surface for the exciting rock texture. My approach seems right, and the sketch is done.

PALETTE

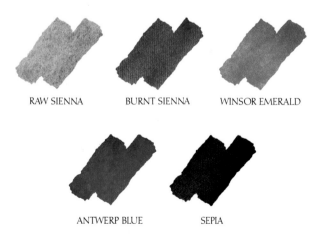

RAW SIENNA BURNT SIENNA WINSOR EMERALD

ANTWERP BLUE SEPIA

Winsor emerald is an unusual color. I need it for this painting because of its opaque but gentle and cooperative nature. I intend to use a little of this color not only in my sky, but as a general unifying hue for the whole painting. These five pigments will provide a good variety of greens ranging from cool to warm depending on the mix. Sepia is a neutral dark color. It can dirty up other colors, but I want to use it in small quantity as a darkening agent.

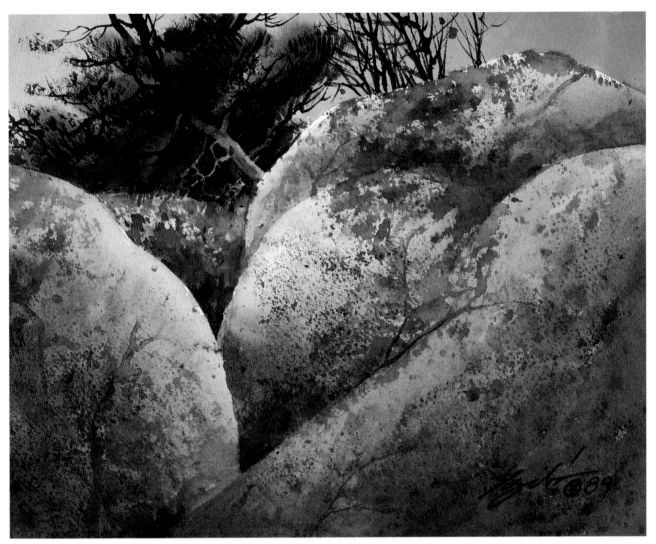

ANCIENT SPONGES. 8 × 10″ (20.3 × 25.4 CM), 300-LB. D'ARCHES COLD-PRESSED PAPER.

PAINTING

I start on dry paper and mask out the top edges of the rocks with narrow strips of masking tape. The narrower the tape, the easier it will bend to the contours of the rocks' curving edges. I apply the sky color rapidly with a 2″-wide firm-bristle brush. My colors are Winsor emerald, raw sienna, and Antwerp blue. Raw sienna is more dominant on the left side, Antwerp blue on the right. I blend these colors until the sky looks like the light is coming from the left side.

After I carefully remove the masking tape, I establish the tone of the large boulders. I use a gray derived from burnt sienna, Antwerp blue, and sepia. With the same 2″ brush, I softly

blend the color to look lighter at the top and darker at the bottom of the shapes. A feeling of roundness is the result. I do each rock separately, dividing the foreground into sections. As soon as one area is shaded, and still damp, I spatter some droplets of raw sienna, burnt sienna, and Antwerp blue separately into the drying color. I repeat this with every section until I have a colorful, softly textured surface. The spattered surface texture looks convincingly like moss or algae. The relative size of these small color spots appears large on the small surface because the rock shapes look enormous in scale on the small paper.

Next, I remoisten the left half of

the sky area. I apply a soft dark wash of sepia, Antwerp blue, and burnt sienna to start the shape of the big evergreen. This wash dries quickly and I drybrush the same colors in a heavier consistency to render the textured foliage of the tree. While I am working with this second glaze, I paint around the negative shapes of the tree trunk and its light branches. Then I tint them with burnt sienna to add warmth and lessen the contrast. I follow with the dark branches of the tree using a small rigger brush loaded with sepia and Antwerp blue. I treat the shrubs' exposed branches on the right of the dark tree the same way. As a finishing touch, I add in a few burnt sienna leaves.

FLAT ROCK MOUNTAIN

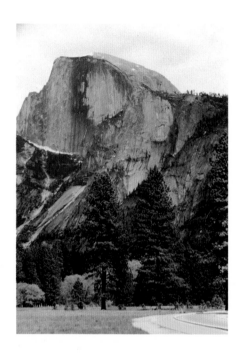

I plan to work from a photograph taken at Yosemite National Park. The mountain is intimidating to say the least. The cliff is a sharp, flat shape soaring up several hundred feet. The lighting in the photograph is too flat and loses the feeling of depth. I plan to increase the drama by exaggerating the contrast in the foreground.

My visual planning is done on a thumbnail sketch with a 6B graphite stick. I change my composition to a horizontal format. I rearrange the shapes and increase the value of the tall trees in front while I lighten the value of the foreground. The large mountain dominates the sketch because it is completely surrounded by contrasting light values.

PALETTE

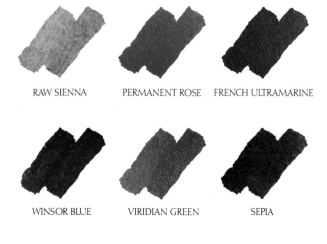

RAW SIENNA PERMANENT ROSE FRENCH ULTRAMARINE

WINSOR BLUE VIRIDIAN GREEN SEPIA

With permanent rose, raw sienna, and viridian green I can mix interesting grays that allow individual hues to shine through. Winsor blue and sepia are the darkest colors on the palette. I intend to take advantage of them in the foreground where I plan to darken the trees. Viridian green has a quiet nature. It is ideally suited for the subtle greens I need.

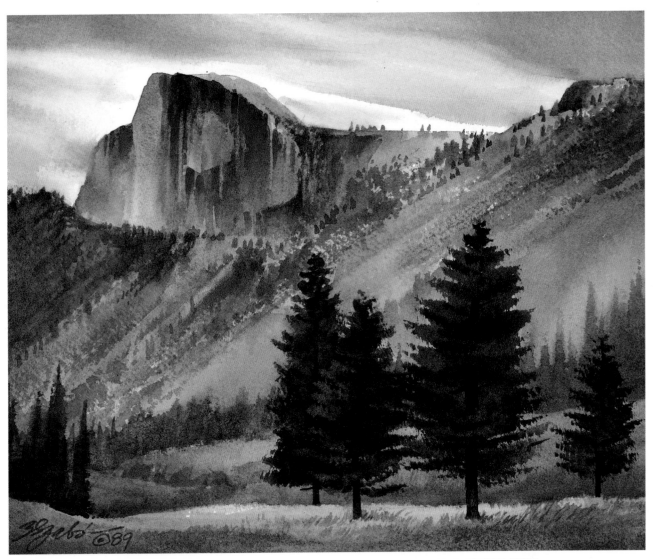

HIS MAJESTY. 8¼ × 10¼″ (20.9 × 26.0 CM), 300-LB. D'ARCHES COLD-PRESSED PAPER.

PAINTING

I start by painting the silhouette of the cliff and the mountainside with a pale gray wash. The ingredient colors of permanent rose, viridian green, French ultramarine, and raw sienna are blended loosely on the paper and show their individual hues. I glaze several luminous layers of these colors to indicate the watermarks on the vertical rock's surface. Next, I paint the sloping mountainside with layered drybrush strokes. My colors are Winsor blue, viridian green, and permanent rose. I increase the illusion of rows of trees by spotting a few individual trees

in strategic points. I add the trees in the middle ground with the same colors in middle value. I define the edge of the grassy field at the same time. I apply the dark foreground evergreens with a 1½″ firm-bristle brush. The rhythm of the trees demands repetitive touches with the edge of a heavily loaded brush. The color is a mixture of Winsor blue, sepia, viridian green, and some raw sienna. First I apply the heavy foliage, and then add the trunks and branches after the shapes of the foliage look satisfactory. I darken part of the grassy foreground as well.

Next, I mix raw sienna, permanent rose, and viridian green to get a subtle gray for the sky. Using a ¾″ soft, flat brush, I wet-wash the slanted brushstrokes into each other quickly and in light value, allowing them to blend naturally. I make sure that the lightest values are next to the domelike mountain for good contrast. They end up looking like wind-swept clouds. I also paint a few blended touches of Winsor blue to make the clouds appear thin where the blue sky peeks through. This hint of blue also echoes the cool influence from the ground.

GLACIAL ROCKS

My approach to this painting begins with a photograph of a contrasting subject in the high Sierras. It is a formation of glacier-carved white granite rocks partially covered by the rolling shadows of a large tree and some shrubs. To create an overwhelming dominant role for the rocks, I plan to simplify the composition by painting less clutter around them. In the photograph, the sky is an isolated shape and color. I intend to change that by allowing more sky color to show through the foliage of the trees and by increasing the blue in my shadows, echoing the color of the sky.

PALETTE

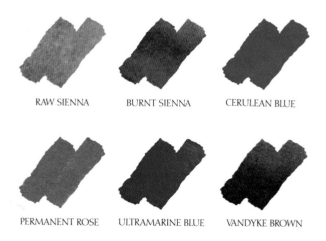

RAW SIENNA BURNT SIENNA CERULEAN BLUE

PERMANENT ROSE ULTRAMARINE BLUE VANDYKE BROWN

This time I use Schmincke Horadam brand artist's-quality transparent watercolors. The unquestionable transparency of these pigments is truly wonderful. If you wish to try Schmincke watercolors, be prepared for glowing, luminous colors.

My first surprise in this limited palette is cerulean blue. It is absolutely transparent, contrary to the traditionally opaque cerulean blues of most brands. I plan to mix cerulean blue and ultramarine blue for the sky and the shadows. Permanent rose and the two siennas provide me with the warming influences. Vandyke brown is a permanent dark brown in this brand. I plan to use it sparingly wherever I need very dark accents.

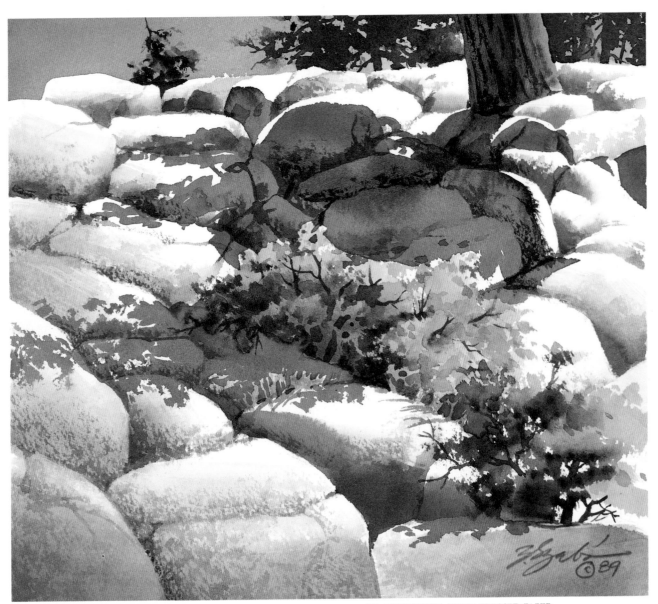

SIERRA SHADOWS. 9 × 12″ (22.7 × 30.4 CM), 300-LB. WATERFORD COLD-PRESSED PAPER.

PAINTING

I start directly on dry paper with the shape of the sky. My colors are cerulean blue, ultramarine blue, and a tiny amount of burnt sienna. I blend these colors well into a smooth wash and apply it quickly with a 1″ flat soft-haired brush. Next, I paint the wash of the shadow of the big tree. The color is the same combination as the sky, but I charge the blue with burnt sienna while the color is still wet for warmer color hints.

I define the rocks with a warm gray drybrush glaze. I take care that the top of each boulder is left sharp and white. I paint the shadow's edges as if they were rolling over the top of the yet invisible rocks. In this small painting I have an easy job controlling my shadow shapes without disturbing the dark drybrush underneath. I follow by painting the base of the sunlit redwood. I use burnt sienna and permanent rose on the sunny side, and cerulean blue and permanent rose on the shadow side. For the texture of the bark, I drybrush some Vandyke brown. My sky wash is now dry, and I paint the silhouette of the distant trees above the top rim of the white rocks using cerulean blue and Vandyke brown.

I move to the foreground and paint the shrubs next. My colors are raw sienna, burnt sienna, cerulean blue, and ultramarine blue. I do the modeling with three separate glazes. The first one is a light value of raw sienna. After the paper dries, I add a medium-value shading with burnt sienna and cerulean blue. I follow with the darkest value and leave out some negative shapes for the interior branches. I also paint the thin branches. I add a cast shadow of the lacy shrubs over the neighboring rocks the same way I did the tree's shadow and the painting is complete.

JAGGED ROCKS

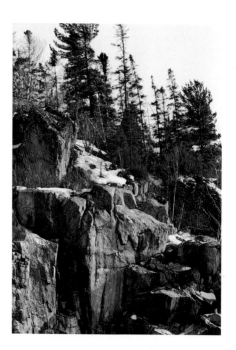

The photograph I work from shows an old granite quarry. The quarry is much deeper; the photograph only shows the top. The drama of the deep excavation appeals to me. I need to recall the missing elements from memory. The leaning angle of the trees is caused by the strong prevailing wind. I plan to change my composition to a horizontal format to accommodate the rocks' massive volume. A value study will not be necessary for this painting.

PALETTE

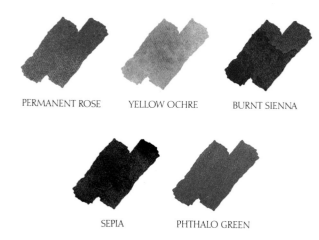

PERMANENT ROSE YELLOW OCHRE BURNT SIENNA

SEPIA PHTHALO GREEN

Again I choose to use Schmincke Horadam brand artist's quality transparent watercolors exclusively for this painting. I need the extremely transparent nature of these pigments to gain glowing luminosity for my intended darks. Yellow ochre is usually opaque in most other brands. In this brand it is not only fairly transparent but a more pure yellow as well. I can achieve good warm greens with it in combination with just a touch of phthalo green. The rich, glowing colors of permanent rose, burnt sienna, and phthalo green are ideally suited for palette-knife texturing. Sepia is in my palette this time for quick dark accents.

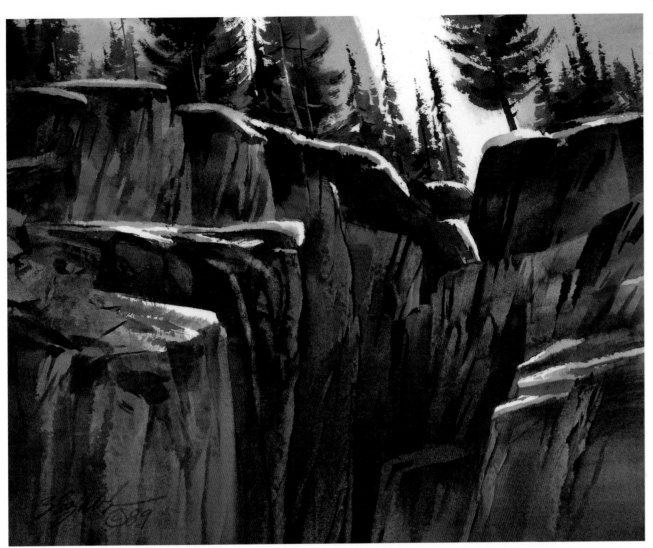

GRANITE SHRINE. 8½ × 10½″ (21.6 × 26.7 CM), 300-LB. WATERFORD COLD-PRESSED PAPER.

PAINTING

On a dry surface at the top, I paint two very pale, simple gray shapes. They could serve as a misty mountain or just sky. I mix this color from burnt sienna and permanent rose with a little phthalo green. I leave out a pure white shape to serve as a background for my highest contrast later. I apply my wash fast with a 2″ flat-bristle brush.

Next, I work on the dark rocks starting at the top. I double-load the same 2″ brush with a tacky consistency of burnt sienna and permanent rose and add phthalo green to the tip of it. I paint the rocks by sections, stopping where snow clings to the rim. While the color is fresh and moist, I texture the rocks with my palette knife. I press the knife hard so that the pressure not

only squeezes the color off but dries the knife's path, preventing the color from oozing back. Where I press hard with the knife, the dominant hue shows through in light value. Where the knifestroke stops, it leaves the accumulated dark color looking like cracks in the rocks. I repeat this procedure for all the sections, but vary the color dominance slightly each time. The cracks and crevices are created with a relatively small palette knife. The knifestrokes appear as texture on the huge rocks because the shapes are scaled to complement my small paper size. These knifemarks need to be applied before the wash of the rocks dries. On the small paper it is easy to keep each section in the right condition

for knife-texturing.

I continue with the leaning trees at the top. I use the same 2″ brush loaded with yellow ochre, burnt sienna, and phthalo green in medium value and drybrush the trees' rugged shapes. I continue by adding darker values and more texture to the trees. The dark detailing is done with phthalo green and sepia. While this paint is still damp, I scrape off a couple of tree trunks with the slanted tip of my plastic brush handle. I use a ¾″ soft, flat brush to correct some of the imperfections. I clean up the top edges of the snow patches and clarify the character of the trees. Last, I drop in a few dark edges over the distant rocks. Finally, the painting is finished.

ASSIGNMENTS

Improve the composition of this rocky subject. The light snow on top of the rocks is swimming in warm late-afternoon sunlight. Correct the value and shape relationship.

Paint the rocks with a drybrush technique. Texture the
surface with richly colored moss and lichen.

Change the composition of this desert mountain to a verti-
cal format and create a strong center of interest.

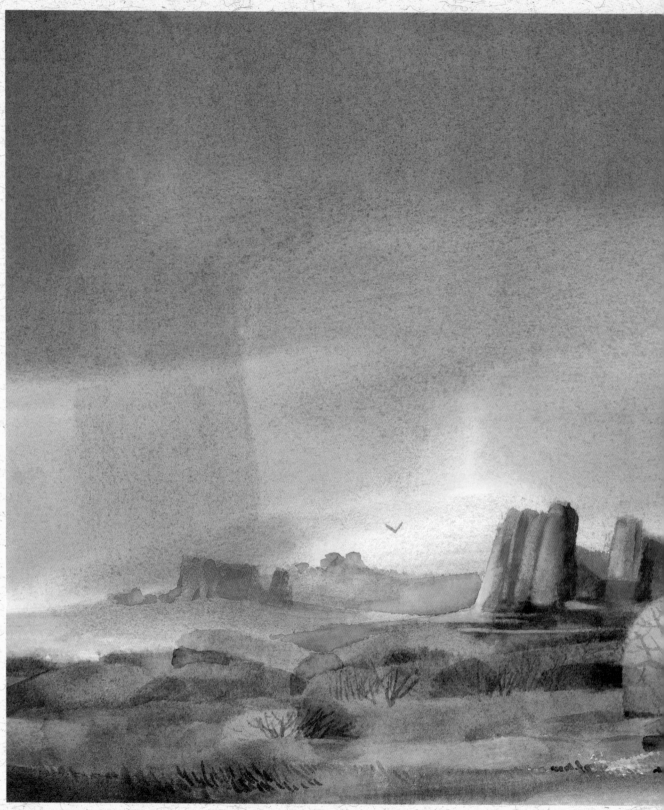

ROCK MUSIC. 11½ × 15" (29.2 × 38.1 CM), 300-LB. D'ARCHES COLD-PRESSED PAPER.

SKIES AND CLOUDS

A sky that occupies a large portion of a composition can be quite intimidating to the landscape painter. The sky itself very seldom makes a good center of interest, but it can be a powerful complement when used to dramatize other forms silhouetted against it.

The larger the sky is in your painting, the more exciting it needs to be. It is also important for the sky not to appear isolated. In any landscape painting, the sky's color must relate well to the whole composition. The closer it is to the dominant ground color, the better it is for your overall color unity. The neutral color of the clouds will pick up the ground colors as reflected light. In a cloudless sky, echo the ground colors in the sky itself and repeat the color of the sky on the ground to prevent a harsh division between these massive shapes. Lacy ground elements such as trees can soften or break up the meeting edge between the sky and ground as well.

The color of the sky may be, but is not always, blue. A blue sky should never be just one flat blue but a combination of several freely mingled hues. Do not blend three blues into a fourth flat color on your palette. Blend them on the paper while they are wet, and allow each one to show its own identity. Large brushes used for this purpose create faster and fresher results. The sky looks better when it is full of movement caused by the rhythm of softly blended shapes.

Whenever your ground subject is very exciting, try to neutralize the color of the sky somewhat. A grayish sky color serves better as a complement than a pure, bright hue. However, if your intended center of interest is located in the sky area, you can afford stronger color dominance in your sky color.

White stands out as a strong color against most backgrounds and needs some blending to keep it from appearing too dominant and flat. White clouds in the sky are no exception. Clouds have a natural rhythm; they should not look like evenly spaced polka dots but rather like free, repetitive shapes. The color of clouds needs to relate to the sky and to the ground as well. The underside of clouds is usually darker and warmer in color because of the reflected light from the ground, while the top side is lighter and cooler because of the atmosphere above.

All the paintings in this chapter are on-location watercolor sketches done without preliminary drawings.

WET-IN-WET RAIN

The rainy soft mood of this subject appealed to me. The weather is drizzly and wet. It is too rainy to work outside so I set up shop inside my car.

PALETTE

FRENCH ULTRAMARINE ANTWERP BLUE BURNT SIENNA

RAW SIENNA PAYNE'S GRAY

To capture the quietly inviting mood of the overcast weather condition, I want my colors to lean toward the neutral hues. I will include Payne's gray, a transparent staining color, in most of my mixes. I plan to use it sparingly so as not to muddy the colors, just mute their intensity.

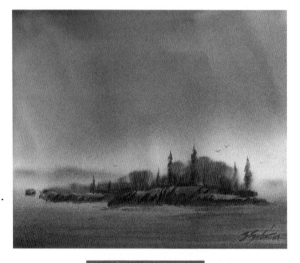

OPEN AIR SHOWER.
8½ × 10″ (21.6 × 25.4 CM),
140-LB. WATERFORD
COLD-PRESSED PAPER.

PAINTING

I wet my paper thoroughly and apply rapid brushstrokes with a 2″-wide bristle brush starting at the top edge of the paper. I paint the sky and then work down right into the water. The gray of the sky is dominated by burnt sienna and the water is dominated by French ultramarine. I paint the sky in slanted strokes to give direction to the falling rain. I leave the horizon area light to complement the brightly colored is-land, my center of interest.

As the paper dries, I paint in the hinted distant hill with a darker gray in a richer consistency. Using Antwerp blue and raw sienna in a thick consistency, I add a few tall evergreens. I apply the rocky ground shape with a dark combination of French ultramarine, burnt sienna, and Payne's gray. I texture the light shiny rocks with my palette knife, pressing down hard on the edge of the knife's heel so that it squeeze-dries its own path. The accumulated paint between the knife-strokes leaves dark lines suggesting cracks in the rocks.

I quickly paint a few ripples into the water area, as well as echo some of the burnt sienna trees to indicate reflection. I add a few distant flying birds and calligraphic tree branches to the dry surface to finish the composition.

STORM CLOUDS

A local storm can appear at any time. The dark clouds of my subject rolled in from behind a mountain and darkened the otherwise clear sky.

PALETTE

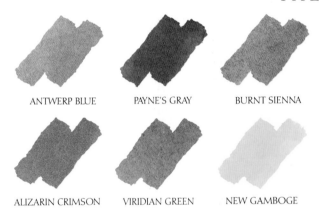

ANTWERP BLUE PAYNE'S GRAY BURNT SIENNA

ALIZARIN CRIMSON VIRIDIAN GREEN NEW GAMBOGE

Antwerp blue and Payne's gray are the cool and dark colors I need to give the stormy condition its necessary strength. Viridian green is a gentle accent color. Burnt sienna, alizarin crimson, and new gamboge supply the hues for the warm shapes such as the forest and the ground level modeling. They also enhance the beauty of the dark colors.

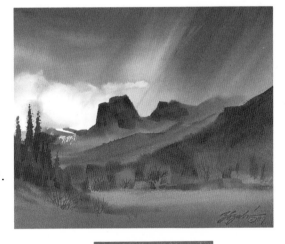

HIGH AND MIGHTY.
8½ × 10″ (21.6 × 25.4 CM),
140-LB. D'ARCHES
COLD-PRESSED PAPER.

PAINTING

I wet the top half of my paper and quickly apply a combination of Antwerp blue and viridian green for the sky. I leave out a few white cloud shapes, and blot off a few edges with a tissue. While this wash is still quite wet, I tilt the paper and paint the hanging rain clouds with Payne's gray.

Next, I proceed with the bright meadow in the foreground using a combination of viridian green, burnt sienna, and new gamboge. My 2″ flat-bristle brush delivers the rich colors very fast, enabling me to continue upward and blend the layers of mountains. I start with the distant, dark mountain with the square shape. I soften the bottom of the shape and then paint the layers in front of it. My colors consist of Payne's gray, alizarin crimson, and burnt sienna.

While these washes are still quite damp, I paint the shapes of distant trees into the damp, dark color with burnt sienna and new gamboge. These colors, though lighter than the background wash, have the ability to push the dark color out of the way and replace it with their own hue.

Next, I move to the left side of the sketch and paint the tall dark evergreens against the dry, light sky. I use a 2″ flat-bristle brush full of Antwerp blue, viridian green, burnt sienna, and Payne's gray. I finish with the details of the shrubs and trees.

BLOTTED CLOUDS

In this painting I push the wet-in-wet technique a step beyond the normal interpretation by blotting out shapes to create the ragged edges characteristic of clouds.

PALETTE

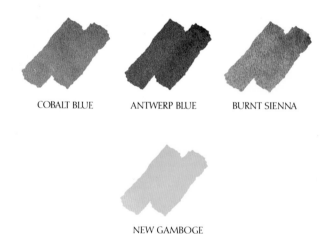

COBALT BLUE ANTWERP BLUE BURNT SIENNA

NEW GAMBOGE

I limit my palette to reduce the risk of using too much color. Cobalt blue and Antwerp blue mixed with burnt sienna offer not only a healthy range of muted blues when the blues dominate, but also a good variety of grays as well when burnt sienna takes over the dominant role. I intend to use new gamboge only on the autumn trees to add a splash of unrelated color to the center of interest.

PAINTING

To start, I wet my paper once only. I don't want the paper to be saturated. I wipe off the excess water by gently sweeping the surface with a limp paper tissue to avoid scratching the surface. Now the paper is barely damp. I quickly paint a wash of cobalt blue and burnt sienna mixture over the sky area.

Simultaneously, I paint in the darker colors of the mountains, allowing the edges to blend just enough to show softness. My colors are wet but not too runny. I use a wet-in-wet technique for the floating fractocumulus clouds. Speed is necessary for keeping the clouds' shapes fresh. There's no time to

waste before I have to use the tissue for blotting the ripped edges of some of the clouds. The small size is not only easier to time right, but my ability to keep a check on all the details during painting is also improved. Before the paint is completely dry, I paint in the edge of the mountain near the top cen-

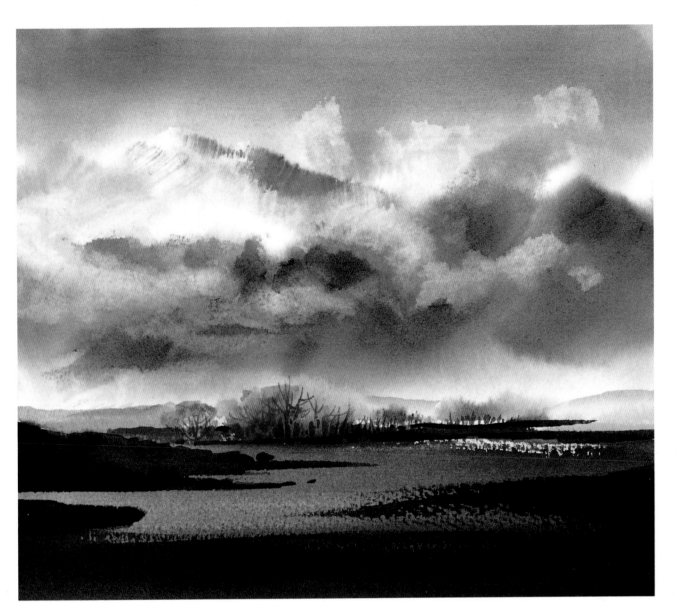

TORN CURTAINS. 8½ × 10″ (21.6 × 25.4 CM), 140-LB. D'ARCHES COLD-PRESSED PAPER.

ter with a 2″ firm-bristle brush loaded with a rich combination of the cobalt blue and Antwerp blue.

The bottom part of the mountains is still wet enough for me to apply the color of the trees. I use burnt sienna and new gamboge, allowing them to ooze into each other freely. My fore-ground area is next. I establish the gray, flat mud with a rich wash of burnt sienna and cobalt blue. Directly below the trees, I charge this gray with the same colors I used for the trees.

After the whole surface is thoroughly dry, I paint in the calligraphic details of the trees and the dark shaded elements of the foreground. I use a dark mix of my two blues and plenty of burnt sienna. Wherever my rapidly moving brush leaves a drybrushed edge, I leave it alone. This is a quick way to hint of texture. After I add my signature to this dark wash, the watercolor sketch is complete.

CLOUDS AT SUNSET

As this sunset condition is starting to reach its climax, I am already set up in my warm car to face it. This condition lasts only about ten minutes, so I must work fast.

PALETTE

PERMANENT ROSE AUREOLIN YELLOW COBALT BLUE

BURNT SIENNA ANTWERP BLUE

As I analyze my subject, I quickly select five colors that will do the best job. These colors are extremely glowing and luminous hues that are naturally suited to complement my dramatic subject. The real challenge in this particular case is keeping the colors smooth and even. I will need to apply my colors darker than natural to keep them brilliant even after they dry.

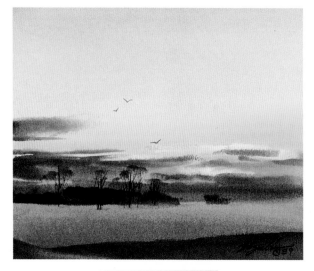

FIRE FLYERS.
8½ × 10″ (21.6 × 25.4 CM),
140-LB. D'ARCHES
COLD-PRESSED PAPER.

PAINTING

I wet the paper and use a 2″ flat-bristle slant brush for the entire painting. With a continuous motion, I paint the cobalt blue part of the sky. I do the same thing in reverse from the horizon up with a very rich combination of aureolin yellow and permanent rose. The two washes blend without a green overlap because cobalt blue and aureolin yellow are both nonstaining pigments. Where I intend to have the strongest color impact, I add a stronger stroke of the same color combination. While these washes are still damp, I wipe off some of the golden edges of the brightly lit clouds.

Next, I rapidly paint in dark clouds using my whole palette but making sure that the cobalt blue and permanent rose dominate. I use the same colors for the glowing field of shaded snow as well.

While my paper is just damp, I add the dark forest in the distance using Antwerp blue and burnt sienna. From memory I spot the middle-ground snowfield with slim, tall deciduous trees and a darker snow heap at the bottom edge. A few birds in the light part of the sky complete the painting.

NEGATIVE CLOUDS

The typical summer sky dominating my subject offers very rich contrast. Low key, high contrasting subjects are full of drama and strong emotional impact.

PALETTE

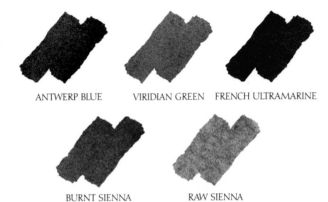

ANTWERP BLUE VIRIDIAN GREEN FRENCH ULTRAMARINE

BURNT SIENNA RAW SIENNA

To prevent the blue sky from looking flat and monotonous, I plan to mix both blues and a little viridian green. These glowing colors relate well and the influence of viridian green helps to echo the green ground colors. The two siennas, with the help of Antwerp blue, are my dark contrasting hues for the ground-level values.

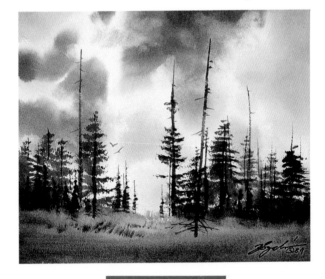

SKYSCRAPERS.
8½ × 10″ (21.6 × 25.4 CM),
140-LB. D'ARCHES
COLD-PRESSED PAPER.

PAINTING

First, I wet my paper. I leave out the white clouds and paint my blues between their negative shapes. The darkest value of French ultramarine dominates the mix near the top. Antwerp blue occupies the middle section of the sky and only a hint is used near the bottom mixed with some viridian green. After establishing the sky, I paint a light gray into the center of the white cloud shapes, allowing the color to blend softly.

After the sky area is dry, I paint the tall evergreens with the tip of my firm-bristle slant brush. My colors are Antwerp blue, burnt sienna, and a little French ultramarine. I paint the fir trees' branches rapidly with the end of my vertically held brush. Before the base of the tree shapes can dry, I add raw sienna, burnt sienna, and Antwerp blue in the foreground and allow these colors to blend.

With the help of my No. 3 rigger brush, I paint the pointed trunks and branches of the evergreens, using burnt sienna and French ultramarine in a dark but luminous value. At the end, two soaring birds add a touch of life to the landscape.

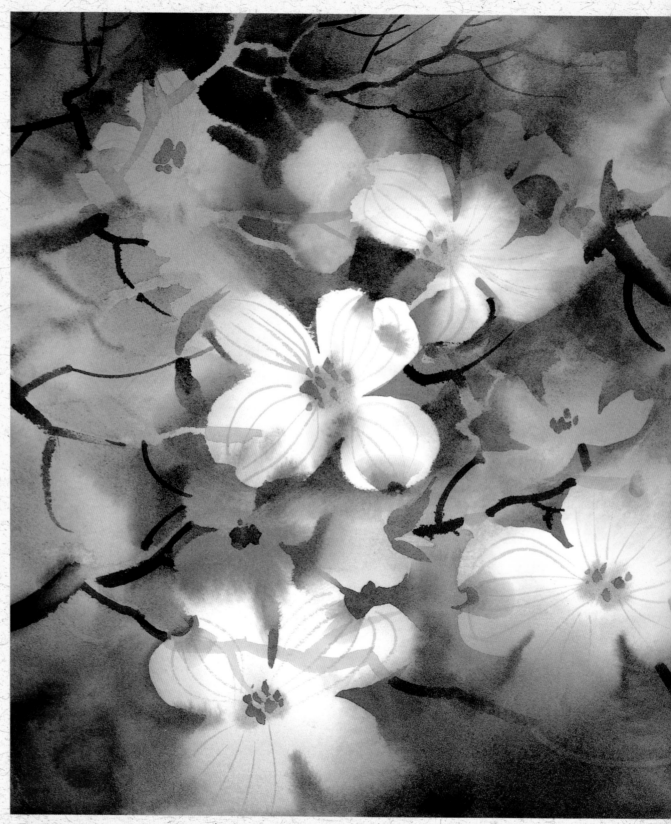

SPRING LACE. 11½ × 15″ (29.2 × 38.1 CM), 300-LB. D'ARCHES COLD-PRESSED PAPER.

FLOWERS AND CLOSE-UPS

When painting flowers, use the most luminous pigments available to best represent their character. Bright colors will look more radiant if they are painted next to darker colors.

The subjects you paint as close-ups—like flowers and rocks—need other elements in the picture to give a sense of scale. A group of rocks, for instance, will look like boulders if a pine tree grows beside them; however, the same group of rocks may look like pebbles if a dandelion appears snuggling up to them.

A cluster of blossoms should be painted as a unit. A mass of apple blossoms is beautiful to behold, but it is the silhouettes the clusters form on the trees' branches that are more important to the composition than each separate little flower.

Light-colored flowers may be masked out or painted around as negative shapes. If a shape is important enough to be masked, it is worth using a good, controllable brush to give precise definition. To protect the brush, rub soap into the bristles before you dip it into the masking fluid.

Texture is more evident on close-up subjects. The more literal and realistic your technique is, the more accurate your texture has to be. Stylized paintings may be executed with less attention to realistic accuracy, meaning that textures may be simplified or eliminated entirely.

Close-up subjects by their very nature occupy a relatively large space in the picture plane. To create the illusion of three dimensions and depth, however subtle, in such a composition, you must pay extra attention to the importance of value, which will allow you to establish the foreground, middle ground, and background. Each of these planes needs to be dominated by a different value.

Choose either a warm or a cool color palette to dominate the temperature of a floral or close-up composition, using its opposite to provide complementary accents.

The background is an essential part of your composition and must be a consideration in your overall design. Use the background to enhance your subject. The viewer should not be consciously aware of the background but accept it as part of the whole work.

As in the previous chapter on skies and clouds, these watercolor sketches were done on location without preliminary drawings.

FLOWERS IN CLUSTERS

The first burst of color after the drab winter days is my subject. I intend to reflect the spirit of rejuvenation in the delicate flower cluster playfully arranged by nature.

PALETTE

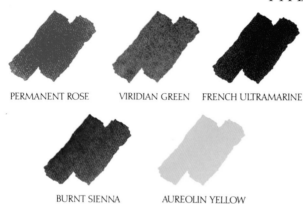

PERMANENT ROSE VIRIDIAN GREEN FRENCH ULTRAMARINE

BURNT SIENNA AUREOLIN YELLOW

These hues are all glowing luminous pigments by themselves. The only combination I have to watch is burnt sienna and French ultramarine. The two mix into a lovely gray, but in heavy consistency they can go muddy.

THE CALL OF SPRING.
8½ × 10″ (21.6 × 25.4 CM),
140-LB. D'ARCHES
COLD-PRESSED PAPER.

PAINTING

I start by saturating my paper with water. I spread water on it until the dull spots disappear and the shine stays even. I begin painting with a 2″ slanted bristle brush. I paint the background area with soft, blurry brushstrokes, creating playful shapes mixed from French ultramarine, viridian green, and permanent rose. While I do this, I make sure not to touch the area where

I intend to paint my blossoms. When I am satisfied with the shapes and the color saturation, I let my paper dry.

At this point, I switch to a ¾″ flat, soft synthetic brush. I sharpen some of the edges and define a few silhouettes of white blossoms. As the character of the cluster begins to show, I move inside the cluster and paint more blossoms using a lot of gray, but I make

sure that the color is applied as a very light glaze. I include a touch of permanent rose in my gray to give the blossoms a pinkish glow.

When I am happy with the loosely repetitive blossoms, I sprinkle a few stamens with the help of aureolin yellow, and tuck the supporting branches between the blossoms using French ultramarine and burnt sienna.

INDIVIDUAL BLOSSOMS

The complexity of the iris makes it a particularly challenging subject. Its delicate petals have to look thin and fragile even though they are relatively large.

PALETTE

NEW GAMBOGE

PERMANENT ROSE

VIRIDIAN GREEN

ANTWERP BLUE

FRENCH ULTRAMARINE

My selected palette is dominated by cool colors. I intend to surround my blossom with cool hues to contrast the warm color dominance in the flower.

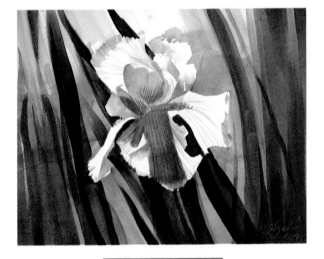

GARDEN DOLL.
8½ × 10″ (21.6 × 25.4 CM),
140-LB. D'ARCHES
HOT-PRESSED PAPER.

PAINTING

I begin with a 3″-wide flat-bristle brush on a dry surface. I paint a medium-value wash of French ultramarine and viridian green around the shape of the white blossom. The hot-pressed paper causes a few hard edges to appear. I quickly blend these edges where I do not want them. I follow this step by painting the orange base color of the flower's interior with new gamboge and permanent rose. The brush-

strokes dry very quickly on the smooth surface, enabling me to glaze a warm gray shadow on top of these colors using viridian green, permanent rose, and a little new gamboge. I apply these glazes one at a time in a single pass with a 1″ soft, flat synthetic brush to prevent the color beneath from smearing. My small painting size makes it easier to control the speed of the glazing.

Using the same 1″ soft brush, I paint in the rhythmical shapes of the leaves. My colors are Antwerp blue, French ultramarine, viridian green, and some permanent rose. I add value to these shapes until their strength is sufficient to make the blossom stand out in contrast. I close off the white space at the top with a light gray wash. I finish with the calligraphic pattern of the blossom's delicate veins.

WILD FLOWERS

This little flower tucked into a dip in the countryside attracted me as a subject. Small jewels of nature are easy to miss. I painted this subject just as it appeared when I happened upon it.

PALETTE

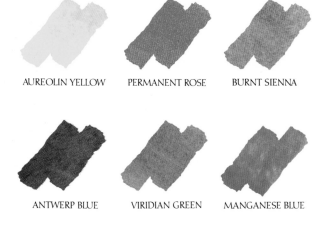

AUREOLIN YELLOW PERMANENT ROSE BURNT SIENNA

ANTWERP BLUE VIRIDIAN GREEN MANGANESE BLUE

As far as the nature of these colors is concerned, manganese blue is the most unusual color among them. It is one of the few colors that comes off completely even after it is dry, simply by loosening the pigment with a little water and scrubbing. It also allows colors that it dominates in combination to lift off more easily than they would by themselves.

PAINTING

I start on a wet paper with a 2″ slanted flat-bristle brush. I paint the background color using all of my chosen palette—aureolin yellow, permanent rose, burnt sienna, Antwerp blue, viridian green, and manganese blue—in a freely blended combination. I change the dominance a little but keep the manganese blue strongest where I'll need help later for the dark shape be-

hind the flower, my center of interest. I cover the greatest portion of my painting surface with rapidly painted wet washes playing the role of complement. The small size of my painting comes to my rescue again. This part of the work is speedy and fun to develop because it is easy to observe. After I finish these washes, I have plenty of time left to detail my center of interest.

As the background is starting to dry, I squeeze out all the excess water from my brush and paint a hint of a few clumps of grass. These brushstrokes of aureolin yellow and Antwerp blue stand readable but somewhat blurred. I also sketch in the three pointed leaves at the same time and just let their edges soften. With my No. 3 rigger, I paint a few recognizable

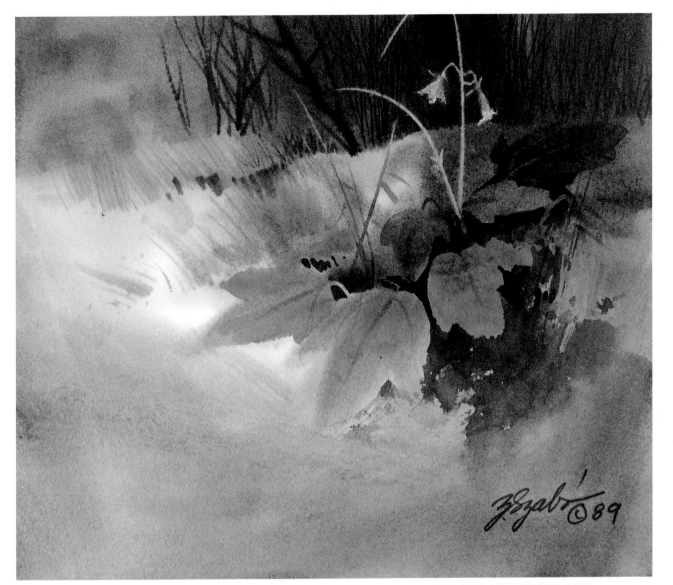

BELLS OF THE LITTLE PEOPLE. 8½ × 10″ (21.6 × 25.4 CM), 140-LB. D'ARCHES COLD-PRESSED PAPER.

trees in the distance, using burnt sienna, permanent rose, and Antwerp blue in a rich consistency. Then I let my paper dry.

My next step is the most interesting one. I use a slim but firm little brush and lift off the dark background color, exposing in white silhouette the little flowers and their stems. I work slowly and loosen the pigment at about a half-inch section at a time. As soon as the color looks wet, I blot it off with a paper tissue. If necessary, I repeat the procedure. Because I expand the shape gradually, I can maintain complete control of its design. After I finish lifting the background color, I paint in the small bell-shaped flowers with permanent rose and manganese blue and the stems with an aureolin yellow glaze.

For my finishing touches, I paint a dark color of burnt sienna, permanent rose, and Antwerp blue below the large leaves and define some of the leaves with sharp edges. At the end of my painting period, I design a delicate network of calligraphic shrubs behind my star flower, adding darker value. I sketch in my signature and the painting is finished.

GARDEN FLOWERS

 My subject is a white gardenia surrounded with much darker foliage, which sets off a rich contrast, providing an opportunity to paint interesting patterns in dark value.

PALETTE

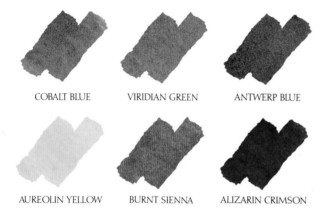

COBALT BLUE VIRIDIAN GREEN ANTWERP BLUE

AUREOLIN YELLOW BURNT SIENNA ALIZARIN CRIMSON

In spite of the simplicity of my subject, I find it necessary to use all of the six colors shown here to avoid monotony. The subtle mauvish grays and a full set of greens can only be achieved from a varied palette.

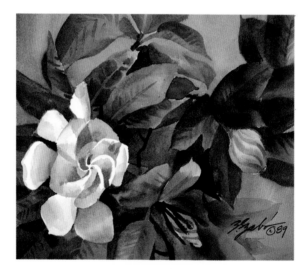

WHITE SWIRL.
8½ × 10″ (21.6 × 25.4 CM),
140-LB. D'ARCHES
COLD-PRESSED PAPER.

PAINTING

I start my work on dry paper using a 2″ soft, flat brush. I paint the blue-gray background leaving out the shape of the flower, the bud, and a few of the lighter leaf shapes. Then I paint in the spinning details of the shaded blossom with several glazes of an alizarin crimson, viridian green, and cobalt blue combination. The petals overlap like those of a pinwheel.

I add the leaves next. I paint their shapes one at a time, mixing new combinations of color for each shape to ensure variety in my colors. When I need to go darker in value, I use alizarin crimson and Antwerp blue. These colors not only can go very dark but also can be warm or cool in color temperature, depending on which hue dominates. On my small paper it is easy to paint the leaf clusters and keep their value consistent. The values of the background and the leaves stay close enough to offer strong contrast behind the white blossom and bud shape. To finish, I texture the leaves with negative and positive veins.

140

GREEN PLANTS

I would not have noticed this plant if the sun were not reflecting off it. The spotlit weed is suddenly in center stage and creates a wonderful center of interest.

PALETTE

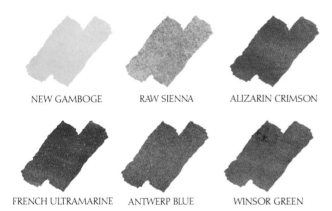

NEW GAMBOGE RAW SIENNA ALIZARIN CRIMSON

FRENCH ULTRAMARINE ANTWERP BLUE WINSOR GREEN

My darkest darks come from two powerful staining colors, Winsor green and alizarin crimson. In perfect balance and rich consistency, these two paints can go blacker than black paint, yet retain their luminosity. These two pigments are my tools for achieving extremely strong contrast.

SUNSHINE AND LACE.
8½ × 10″ (21.6 × 25.4 CM),
140-LB. D'ARCHES
COLD-PRESSED PAPER.

PAINTING

On a dry surface with a 2″ flat-bristle brush, I rough in brilliant yellows, greens, and pale oranges as softly blended background hues. These luminous colors represent brightly lit shrubs and vines. Because I am working on a dry surface with very little water, the washes dry rapidly.

I go to work on the dark background with the same slanted brush loaded with Winsor green and alizarin crimson. I paint the large dark area almost to the edge of my intended vines, covering the paper quickly and evenly. I switch to a smaller ¾″ flat synthetic brush and with the same colors I define the yellow and green plant, using negative shapes. As I travel around and between the leaves, I am able to control the rhythm of my shapes easily on my small paper. As the dark background loses its shine, I lift out the thin curly vines with the sharp tip of my plastic brush handle.

I add some detailing to the shrubs and make a few last minor adjustments to finish the painting.

INDEX

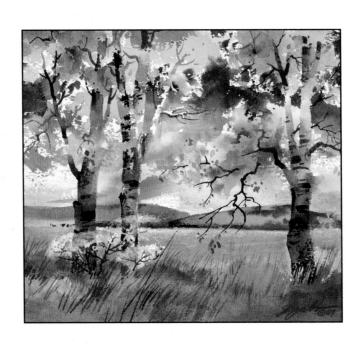

Designer: Howard P. Johnson, Communigrafix, Inc.
Graphic Production: Hector Campbell
Set in Bembo and Diotima